The Secret War
Against the Arts

*'Will you please find out if this person is all right
from the MI5 point of view?'*

… W.H. Auden, C. Day Lewis, Stephen Spender and Doris Lessing

Olivia Manning, Storm Jameson, George Orwell, Felicia Browne
and Julian Trevelyan

Paul Hogarth, Clive Branson, J.B. Priestley,
Sylvia Townsend Warner …

The Secret War Against the Arts

How MI5 Targeted Left-Wing Writers and Artists, 1936–1956

Richard Knott

PEN & SWORD
HISTORY

First published in Great Britain in 2020 by
Pen & Sword History
An imprint of
Pen & Sword Books Ltd
Yorkshire – Philadelphia

ISBN 978 1 52677 031 8

Typeset by Mac Style
Printed and bound in the UK by TJ International Ltd,
Padstow, Cornwall.

MIX
Paper from
responsible sources
FSC
www.fsc.org
FSC® C013056

Pen & Sword Books Limited incorporates the imprints of Atlas,
Archaeology, Aviation, Discovery, Family History, Fiction, History,
Maritime, Military, Military Classics, Politics, Select, Transport,
True Crime, Air World, Frontline Publishing, Leo Cooper, Remember
When, Seaforth Publishing, The Praetorian Press, Wharncliffe
Local History, Wharncliffe Transport, Wharncliffe True Crime
and White Owl.

For a complete list of Pen & Sword titles please contact

PEN & SWORD BOOKS LIMITED
47 Church Street, Barnsley, South Yorkshire, S70 2AS, England
E-mail: enquiries@pen-and-sword.co.uk
Website: www.pen-and-sword.co.uk

Or

PEN AND SWORD BOOKS
1950 Lawrence Rd, Havertown, PA 19083, USA
E-mail: Uspen-and-sword@casematepublishers.com
Website: www.penandswordbooks.com

'My God, when I think what is happening, what is going to happen to art in this country, squeezed between the public and the Government.'

In the Second Year, by Storm Jameson

'Can they hear whispers over their microphones? … Can they hear me at certain moments? Is someone in earphones writing everything down?'

Christopher's Ghosts, by Charles McCarry

Contents

Glossary

ABCA	Army Bureau of Current Affairs
AIA	Artists' International Association
ANC	African National Congress
ARP	Air Raid Precautions
CND	Campaign for Nuclear Disarmament
CPGB	Communist Party of Great Britain
DI	Defence Intelligence
ENSA	Entertainments National Service Association
FO	Foreign Office
GCHQ	Government Communications Headquarters
GPO	General Post Office
HOW	Home Office Warrant
IRD	Information Research Department
ILP	Independent Labour Party
JSM	Joint Staff Mission
KGB	Committee for State Security, Soviet Union
MI5	the Security Service
MI6	Secret Intelligence Service
MOI	Ministry of Information
NKVD	The People's Commissariat for Internal Affairs
PEN	International PEN Club (now PEN International)
PF	personal file
POUM	*Partido Obrero de Unificacion Marxista*
RSM	Regimental Sergeant Major
SIS	Secret Intelligence Service (MI6)
SLO	Security Liaison Officer
UNESCO	United Nations Educational, Scientific and Cultural Organization
Uzzbuzz	US Strategic Bombing Survey
WAAC	War Artists' Advisory Committee
YMCA	Young Men's Christian Association

List of Illustrations

Clive Branson – an early self-portrait. *(Rosa Branson)*

Branson's painting of wartime Battersea. *(Rosa Branson)*

W.H. Auden, Christopher Isherwood and Stephen Spender. *(© National Portrait Gallery, London)*

'Mayday 1938' by James Boswell. *(Sal Shuel)*

A sketch by James Boswell for the Communist Party of Great Britain. *(Sal Shuel)*

An extract from the Intelligence Services' files on the artist Felicia Browne. *(The National Archives)*

The Chaldon Valley, the home of Sylvia Townsend Warner in the mid-1930s. *(Author)*

Sylvia Townsend Warner. *(© National Portrait Gallery, London)*

Volunteers for Spain leaving from Victoria Station. *(University of Bristol Library, Special Collections, DM1532)*

George Orwell (centre, back row) and other members of the Independent Labour Party's contingent to Spain, December 1936. *(© Imperial War Museum HU 51080)*

Wogan Philipps in Spain, 6 June 1937. *(© The Estate of Alexander Wheeler Wainman, John Alexander Wainman (Serge Alternês))*

Clive Branson. *(Rosa Branson)*

Paul Hogarth. *(The National Archives)*

John Cornford. *(World History Archive, Almay Stock Photo)*

Margot Heinemann, writer, academic and loyal member of the CPGB. *(Jane Bernal)*

Civil War Spain, painted by Clive Branson as a prisoner of war, 1938. *(Rosa Branson)*

Major James MacGibbon in 1944. *(Permission of Estate of James MacGibbon)*

Private Boswell, J. (7392959). *(Sal Shuel)*

Dramatis Personae

Valentine Ackland: poet

'When at home she more often wears male clothing in preference to female attire': (Dorset Constabulary, October 1935)

W.H. Auden: poet

'He is an intellectual communist': (MI5, September 1938)

Ralph Bates: novelist

'He fought the Spanish Civil War from a comfortable hotel room in Barcelona': (MI5, May 1938)

James Boswell: illustrator and unofficial war artist

'James Boswell's wise advice to draw anything and everything': (Paul Hogarth, 1997)

Clive Branson: painter, poet and activist

'Communist': (MI5, 1944)

Felicia Browne: artist and sculptor

'Who you may think is worthy of some enquiries': (MI5, May 1934)

John Cornford: poet

'His personal appearance appeared similar to a person who has not washed for at least a week': (Detective Sergeant, Cambridge Borough Police, October 1933)

C. Day Lewis: poet

'*We advise that the Ministry of Information should keep a close watch on him*': (*MI5, January 1941*)

Margot Heinemann: writer

'*A further review of MEPO 38/67 has been conducted following receipt of your freedom of information request and I have today decided that the response provided for these previous requests is still applicable*': (*Metropolitan Police, October 2017*)

Paul Hogarth: illustrator

'*Freelance artist and longstanding member British Communist Party*': (*MI5, 1956*)

Storm Jameson: novelist

'*Communist and pacifist. Unsuitable*': (*MI5, November 1940*)

Doris Lessing: novelist and writer

'*Her communist sympathies have been fanned almost to the point of fanaticism*': (*MI6, August 1952*)

Olivia Manning: writer

'*An authoress of some distinction. She probably has left-wing views … but is not body and soul with the Communist Party like her husband*': (*MI5, December 1947*)

George Orwell: writer

'*This man has advanced communist views … dresses in a bohemian fashion*': (*Special Branch, January 1942*)

J.B. Priestley: writer

'*Has left-wing tendencies but might be used with caution*': (*MI5, May 1939*)

R.D. (Reggie) Smith: BBC producer

'Treacherous and disloyal to his country': (British Legation, Bucharest, January 1948)

Stephen Spender: poet

'It may be necessary to keep a sharper eye on him in future': (MI5, January, 1937)

Randall Swingler: poet

'Wears his hair very long and unkempt. Bohemian type': (Essex's Chief Constable, May 1949)

Julian Trevelyan: artist and poet

'Dear Sir Vernon Kell, I have ascertained that the registered owner of car DFC 667 is Mr Julian Trevelyan': (Surrey Police, July 1937)

Sylvia Townsend Warner: poet and novelist

'Should the Home Office... be told about the nefarious activities of Valentine Ackland and Sylvia Townsend Warner?': (MI5, December 1938)

1

Hogarth and Branson

We are sitting in a German restaurant and my dinner companion has a haunted look in her eyes. It is many years since the Berlin Wall came down, the Cold War melted and the fear of communism gave way to a different public terror. I have just been outlining the nature of this book to her – its litany of surveillance techniques, suspicion and dirty tricks by the British Government's Intelligence Services against an array of artists and writers – and I can sense her looking back into her own recent personal history. 'Do you know,' she said, 'my telephone was tapped for four years?' She had been a whistle-blower, someone unable to turn a blind eye to corrupt practices and, in so doing, she found herself subject to official, clandestine inquiries. Such surveillance is nothing new. When, during the course of researching this book, I sought access to a closed Special Branch file, the request was refused on grounds of 'national security', the official response claiming that it would reveal too much about the secret methods by which perceived enemies of the state are monitored. In the second decade of the twenty-first century, little has changed when it comes to the tried and tested methods of observing those judged to be endangering the nation's security. The system relies on informants, the complicity of postal and telephone services, and footslogging and furtive lurking in shadows by those charged with keeping potential enemies in close view.

In 1935, the British Government was very clear who its internal enemies were. 'It is proposed to make intensive and exhaustive inquiries into the leaders of the Party and those individuals who are known to engage in illegal activities and to act in this country as direct agents of the Comintern.' The 'closest possible touch' with communist activities in vital areas needed to be maintained, both within the government's own agencies, as well as with workers in the railways, docks, mines, power, post and telegraphs. The plan was 'to have every individual Communist in this

country properly taped up in this office'.[1] That aspiration went beyond simply monitoring those 'Reds' who worked in key areas; it suggested that anyone with a left-wing allegiance was fair game. As a result, many of the country's writers and artists had their phones tapped, their post opened and their travels carefully scrutinised over many years. At the same time, as the 1930s unfolded, the groundswell of left-wing opinion grew, while those who worked with typewriter or paintbrush were increasingly drawn towards anti-fascist protest. As the concern about the communist threat became more widespread, so too did the number of personal files about 'subversive' artists and writers in MI5's registry. All that was needed for a new file was an informer's report, or a name fleetingly mentioned in a bugged phone call, or a steamed-open letter.

The two decades between the Spanish Civil War and the Hungarian Uprising – from 1936 to 1956 – saw attitudes to communism alter radically in Britain. It became for many who had been beguiled by the Party's thinking and policies in the thirties, the 'God that Failed'. The poet Stephen Spender was one of the contributors to a book of that title published in the early part of the 1950s. In the space of twenty years, he and many others who had supported the left in the struggle in Spain had turned away from the Party. Those who remained steadfast to it were few and far between. At all events, the insidious campaign by MI5 and Special Branch was unforgiving, dogged, plodding, sometimes misplaced, and potentially life-changing for those under its baleful eye. Some of the files have yet to be released into the public domain; others may never see the light of day. Pages of those that have been released are often redacted, blank pages instead of some words deemed too sensitive for our eyes, despite the passing of six decades or more. This book investigates a selection of those writers and artists whose lives – often interconnected – were gripped by MI5. At its heart are two artists, Clive Branson and Paul Hogarth, whose lives illustrate the times in which they lived with a particular resonance and who deserve to be better known. Both communists, fate treated them very differently ...

* * *

The artist and poet Clive Branson was born in India; he was destined to die there too. His father, Lionel, was a major in the regular Indian

army in Ahmednagar, a military town some 120 kilometres north-east of Poona. The younger Branson would return to Ahmednagar in later life. His full name – Clive Ali Chimmo Branson – had echoes of British imperialism (Clive of India), as well as including his mother's maiden name (she was Emily Winifred Chimmo). He was born on a Sunday, early in the afternoon, on 8 September 1907; spoke for the first time fourteen months later; and took his first uncertain steps on 9 January 1909. Clive's godfather was HRH Prince Alphonso von Bourbon y Orleans, son of the Duca di Galliera, and a direct descendant of Louis Philippe, the grandson of Queen Isabella II of Spain. Some three decades later he would head Franco's air force in Spain's Civil War, while Clive was languishing in a Fascist gaol.[2]

Educated at a preparatory school in Bickley, Kent, and later at Bedford School, where he was a day boy, Clive excelled at cricket, shooting and chess. He was, he confessed, 'the most ill-read boy in the Maths VI at Bedford', but he compensated for that by an ability to 'think visually'. He seemed destined for a conventional enough life, in all likelihood, working for the Hong Kong and Shanghai Bank, but a developing social conscience and a longing to paint intruded. His view of the world when he left school was 'rather religious' and he was 'filled with vague but intense feelings that the world was not what it ought to be'. As far as his art was concerned, he told himself to be patient, to 'observe everything, live and afterwards I'll paint alright'. He was desperate to work in oils and, unable to get any, experimented with watercolours thickened with toothpaste.

As the end of his schooling approached, Branson remained a product of conventional upper middle-class parents, a young man from a moneyed background, courtesy of his wealthy grandparents. When he finally left Bedford, he began working in insurance. He was reluctant from the outset to work in an office and the experience was to prove even more depressing, repetitive and tedious than he had anticipated. Moreover, his work colleagues were equally dull. To kill time he read poetry, slim volumes of verse hidden from prying eyes, a book resting on his lap behind the office desk. It was not, he knew, a situation that he could contemplate continuing into a distant future. He confronted his parents, telling them how much he hated the pointless nature of the work

and how he longed to make a life in art. The family disagreed for three long months, reasoned argument and stout resistance on both sides. The stand-off was only resolved when the Head of the Slade School of Art, who had been sent some of Clive's drawings, insisted that young Branson should indeed follow an artistic career. His parents conceded in the face of professional opinion, promising to provide their son with a small allowance – enough for a struggling artist to get by – and at last Clive felt that his life had truly begun.

Branson was a committed student and worked hard at his art. He read widely too, scribbling detailed notes down the margins of old volumes of Shakespeare and Milton, becoming absorbed in *Paradise Lost*. He was still politically naïve and uncommitted, so much so that when the General Strike of 1926 began, 'he allowed himself to be enrolled as a Special Constable'. It would not be long before he would be embarrassed by his strike-breaking, although with the benefit of hindsight, he came to regard it as 'something of a joke'. As far as his art was concerned, the teaching at the Slade disappointed him and eventually he walked out, choosing instead to paint with untutored and enormous energy while living in 'a small bug-ridden room' in Charlotte Street, near London's Tottenham Court Road. He mixed with other artists; raged at 'the treatment of artists under capitalism', recognising the sobering truth that most good painters lived in poverty. There appeared to be a hard choice between painting 'as you felt you ought' – and starving – or chasing the commercial market.

When he wasn't working, Clive walked the streets, stirred by the poverty and shabby slums. Gradually his view of the world, and how it should be, changed: religion he now saw was simply 'hypocrisy'. He became an 'ardent feminist', while Soviet Russia 'electrified him'. Then, just as his political opinions were drifting sharply left, he came into an inheritance. Suddenly he was 'a young man with substantial independent means', although much of it was tied up in trusts, unable to be accessed. He 'moved to a nicer studio in Chelsea and bought a lot of books', as well as pictures. Having made sure he had enough left to get by, he 'gave the whole of the rest of his first year's allowance to a hospital for crippled children'.[3] He also made a donation towards the purchase of Marx House in London's Clerkenwell Green, the site of what is now the Marx Memorial Library.

The Slade rejected and socialism embraced, Branson was evidently a resolute and tenacious man, characteristics much in evidence once he had fallen in love and encountered the opposition of parents other than his own. 'Tall, fair, [and] good-looking', he had met Noreen Browne at London's Scala Theatre when they were both in an amateur production.[4] Noreen was almost three years younger than him and a granddaughter of the 8th Marquess of Sligo. Orphaned when she was eight, she had only learned of her parents' deaths from the servants and was brought up by her aristocratic, Victorian grandparents in a world of privilege and tradition: decades later, Noreen's daughter, Rosa, would recall her mother complaining that life in those far-off days 'was absolute hell – one had to ride side-saddle!'

The young Noreen Browne had ambitions to become a pianist, but her natural shyness made playing in public something of a trial.[5] The love affair began at a Lyons' Corner House in London, the two of them talking passionately across a café table throughout the night, any shyness soon forgotten. 'Morning broke with us still arguing,' Noreen wrote much later.[6] She was stirred by Clive's ideas, for example, his ardent support for the Soviet Union, something that put him at odds with every one of Noreen's relations for whom the revolution in Russia had been a savage attack on their comfortable, seemingly impregnable, way of life. After that first night together, Noreen and Clive saw each other frequently and, in the spring of 1931, they agreed to get married. Left to themselves, the two lovers would have gone ahead as soon as possible, but Noreen's family objected ('it wasn't the right way to behave') and forbade any idea of marriage until she reached the age of twenty-one.

Instead of driving the couple apart, the ban on marriage merely served to bind them closer together. Noreen thought Clive more alive than anyone she had ever met: he was decisive, always 'impatient to throw away the past and hurry on to the future', hugely enthusiastic, and contemptuous of the conventional role of women as housewives. He was determined that Noreen should pursue her musical career and his own work as an artist he was prepared to sideline, diverting his time and energies to politics instead. Predictably, the obstacles put in the way of the proposed marriage infuriated him, even though the delay was only for a matter of weeks. When Noreen came of age, the wedding duly took

place, although not in church, something that went down badly with both sets of parents.

The newlyweds had greater concerns than family disapproval. Britain in the early 1930s was grappling – with limited success – with political and economic uncertainty, what Noreen would later describe as 'a virtual breakdown of the whole economic system'.[7] The Bransons regarded the Labour Prime Minister, Ramsay MacDonald, as incapable of dealing with the situation, 'the people starving in the streets', indeed, 'poverty in the midst of plenty'.[8] It was dismay at what they saw as governmental incompetence in the face of a desperate need for change that propelled Clive and Noreen into the Independent Labour Party (ILP) in the autumn of 1931. It also persuaded Clive to give up his art and concentrate instead on reading – he began with volume 1 of Marx's *Das Kapital* – and political activism. He 'could no longer', he said, 'stand on the sidelines'. He wrote to the most left-leaning Labour minister, Stafford Cripps, offering his services. Cripps suggested that he become private secretary to Morgan Jones, a Labour MP for a Welsh mining constituency. It was a short-lived position: Clive was already becoming less comfortable in the ILP – too much talk and too little action from its 'vegetarian and Christian pacifist' membership – and he eventually fell out with Jones over the question of India, the MP refusing to make use of a briefing that Clive had prepared, something that provoked 'a frightful argument'. Branson duly resigned and decided to devote his energies to his local community in Battersea. He began a weekly street paper, snappily titled *Revolt*, and sold it door to door, its circulation reaching around 400.

The ILP proved to be a brief interlude. When *Revolt* included a piece that praised the Red Army, the ILP membership objected on pacifist grounds. Where could the couple turn now that disillusion with Labour was overwhelming? Noreen suggested joining the Communist Party, but Clive urged caution, wanting to give themselves some time for considered reflection before making a commitment. A decade later, in a letter home from India, he would remind Noreen that he had first 'started reading' in 1932. Previously he had not considered himself a reader; now he embarked on the works of Lenin. Moreover, he had become 'utterly disgusted' with the 'whole farce of parliamentary procedure' and so, by August, husband and wife had become Communist Party members,

regularly attending branch meetings held in a disused shop in Chelsea. By now, Clive had turned his back on his art and opted for being a full-time activist, 'selling the *Daily Worker* at Clapham Junction, house-to-house canvassing, selling literature, taking up social issues and getting justice done'.[9] Branson's decision to relinquish his career in art and turn to politics was applauded by an old friend from their days together at the Slade. In 1937, the artist William Coldstream wrote in *The Listener* about the impact of the economic slump of the 1930s on art and artists, noting with approval that 'two very talented painters' had abandoned art for political activism – Hugh Slater and Clive Branson, both of whom would go to Spain.[10] Coldstream – who also left the Slade without a diploma – regularly dined with the Bransons and other members of the Euston Group of painters at Bertorelli's in London. In late 1930, Clive had been recruited to help Coldstream with what was the latter's first commission, a large copy of a Claude Lorraine painting. But by the mid-1930s, Coldstream was struggling with his artistic career, and eventually joined the GPO Film Unit in 1934. Encouraged by W.H. Auden, he returned to full-time painting in 1937. Clive, however, remained steadfastly immersed in his politics. He proved an inspirational speaker, addressing groups of workers outside factory gates; enthusing crowds on Clapham Common; and rallying opposition to Oswald Mosley's fascist Blackshirts. When the hunger marchers arrived in Hyde Park, Branson was there to greet them. He continued to be involved in the production and publication of *Revolt*, now under a communist banner; a typical headline read 'THE LABOUR PARTY AND THE TUC ARE JUST LACKEYS OF THE BOURGEOISIE'.

The Bransons lived at 4 Glycena Road, Battersea, in a bay-windowed terraced house on a tree-lined street, near to Lavender Hill. It was a borough with a radical tradition; it had a Communist MP and confrontations with the Blackshirts were frequent. Battersea had become a battleground between left and right. The two of them threw themselves heart and soul into revolutionary politics. Noreen worked for Harry Pollitt, the secretary of the Communist Party of Great Britain (CPGB), as well as undertaking some clandestine tasks on the Party's behalf, travelling to India, for example, with money and secret documents hidden in the false bottom of a suitcase. Her aristocratic pedigree was

useful: who would suspect a young woman in a posh frock, with a cut-glass accent and coming from such a good family? So the secret courier acted the role of an 'hostess' during the long voyage to India, passing the time as if the only things on her mind were dancing and cocktails. She befriended the Ambassador's daughter and, when they finally docked, the Ambassador himself insisted that young Mrs Branson be fast-tracked unchecked through Customs. Once in the sub-continent, she led another kind of double life, covertly meeting up with Party members by day and socialising with the ex-pat community in the evenings; she even danced with the local chief of police. After India, there would be other secret missions, to Moscow and to other secret Party contacts across Europe.

In 1933, Noreen Branson gave birth to a daughter, called Rosa, but christened Mary, since the Bransons were anxious that openly naming their child after the communist Rosa Luxemburg might prove too great a risk so soon after the Reichstag fire in Berlin. The blame for that had been fixed squarely on the communists, and with Hitler's grip on power growing, and the prospect of another war increasing, Clive and Noreen for once opted for caution. When she was just two and a half, Rosa was sent to boarding school, to an institution run by the philosopher Bertrand Russell and his wife Dora. Many years later, Rosa would be told by her mother that the accepted wisdom of the time was to send children away to school – but it may well be that the real reason was Noreen's continuing covert work for the Party.

*　　*　　*

Clive Branson and the artist Paul Hogarth could not have come from more different backgrounds. Branson's upbringing was Home Counties and upper middle class; Hogarth, by contrast, was a butcher's son, born and brought up in the north of England – in Kendal, in the Lake District. He was some ten years younger than Clive, born on 4 October 1917 and named Arthur Paul after his father. Arthur Hogarth senior had rejected a career in farming before emigrating to Canada in 1910, only returning to the UK three years later in order to find himself an English wife. He soon proposed marriage to Janet Barnass from the Westmorland village of Staveley, but her father refused to let his daughter marry until she

was 21 – unlike the Bransons nearly two decades later, it meant a wait of a couple of years, until 1915. In the meantime, the First World War had broken out and Hogarth found himself in the army, serving as a despatch rider with the Royal Engineers.

Paul was born at 28 Caroline Street, Kendal, in a terraced house with its front door opening on to the street, in the third year of the war. He was an only child. In 1921, the family moved to Manchester, where his father initially ran a sweet shop in well-heeled Prestwich, before opening a butcher's in the Manchester suburb of Longsight in 1923. Paul taught himself to draw, sketching with a carpenter's pencil on the paper used to wrap cuts of meat, as well as spending hours contemplating the pictures in Manchester's art galleries. At 16 he won a full-time scholarship to the Manchester School of Art, a prestigious institution on Oxford Road, whose blackened Victorian stone walls were just across the road from All Saints Church. The course, beginning in 1933, was for four years. His parents, however, took strong objection to his chosen career path, believing that he would be better suited to being an office boy. Despite them, Paul read enthusiastically – Somerset Maugham and A.J. Cronin, for example, and then moving on to Gogol, Tolstoy and Zola. It was a habit that baffled his father and worried his mother: 'You'll go bloody mad if you go on reading so much!' – and, at one point, she threw his copy of a Dostoevsky novel into the fire. The two male Hogarths drifted apart, after initially being 'fairly close': Paul would remember that his father 'taught me how to tickle trout in the streams in the Lake District, and how to find birds' nests', but as their paths diverted, 'he ceased to be interested in me'. The feeling was mutual: by the time Paul was in his teens, the relationship had cooled. Hogarth senior was, in his son's view, 'limited', albeit 'canny'. He would never come to accept Paul's success as an artist and 'he would take every opportunity to denigrate what I was doing'.[11] Both his parents chivvied the art school's director about their son's work prospects and the atmosphere at home markedly worsened, to the point where the would-be artist walked out for good. He 'couldn't stand the atmosphere', he wrote later, and so he left, aged 17, having 'found an agreeable hostel in a very unpleasant part of Manchester'.[12] His decision did nothing to mend the relationship with his parents, his mother, for example, remaining dismissive of his way of life. 'If you go

on like this,' she said, 'you'll be a rolling stone that gathers no moss.' (It was a remark that Paul would never forget – he chose Bob Dylan's *Like a Rolling Stone* as his first record when a castaway on *Desert Island Discs* recorded in January 1998.) The difficulties with his parents were never resolved: Paul's fourth wife, Diana, thought Hogarth's father was 'jealous' of his son, although she felt his mother was never less than devoted to him and would regularly send him small sums of money through the post when he was a student.

By the age of 18 he was caught up in student life and politics. He grew his hair long and wore a trademark red polo neck. An avid reader, he frequented Collet's bookshop in the city centre – the shop was known as the Deansgate Bomb-shop – and fell in with an older group, many of them Marxists. 'Few of my generation', he wrote, 'emerged from their student years unscathed by radical politics.'[13] He neglected his studies, drawn into the political activities of Joan Littlewood's 'Theatre Union', for whom he painted stage flats and played some walk-on parts. He learned the skills of agitprop and fell under the influence of people like the artist and activist Barbara Niven, who had 'a powerful and subliminal urge to serve the revolution'.[14] Like Clive Branson, she had abandoned her art and worked full time for the Party. When the civil war in Spain broke out in the summer of 1936, Paul Hogarth dropped out of art school and volunteered for the International Brigade, and was soon on the long journey south, still only 18 years old. 'Spain's future', he wrote much later, 'seemed much more important than my own.'[15]

2

Art and Marx

arly in the 1930s, MI5 took over from Scotland Yard the
responsibility for 'countering Communist subversion'. It
was the result of major concerns about the growing influence
of communism within the British Armed Forces. A naval mutiny at
Invergordon in Scotland in September 1931 was regarded as a warning
sign that could not be ignored: surveillance needed to be stepped up. The
'eccentric, rather sinister' Maxwell Knight was the MI5 man charged
with penetration of the Party.[1] That involved the phone-tapping of
Communist Party HQ (on Temple Bar 2151); the dismissal of communists
working in areas of industry that were regarded as sensitive; and the secret
deployment of agents deep within the Party's headquarters. Knight had
acquired experience of such tactics in the previous decade when he had
been undercover himself, operating within the British Fascisti. The work
had given him a taste for breaking and entering private property.

It wasn't long before the Intelligence Services began to take the
communist threat very seriously, its concern stemming from the rapid
rise in Party numbers. Membership 'more than doubled, from 2,550 at
the end of 1930 to over 6,000 a year later' and continued to grow steadily
throughout the decade, reaching a peak of 16,000 members by 1939.[2]
The thirties was a decade when to be a communist was somehow to be
in tune with the times. According to the spy Anthony Blunt, it was the
end of 1933 when 'Marxism hit Cambridge',[3] while the artist Julian Bell
remarked of the same period, 'We are all Marxists now.' The convicted
spy Wilfred McCartney's remark that he 'became a Communist because
the century became Communist', was true for many others too. Indeed,
it was the last period in history, Cecil Day Lewis observed, 'that anyone
believed in anything'.[4]

Membership of the Party was particularly strong amongst artists and
writers. The reasons were clear: unemployment was rising fast (upwards

of 3 million) and there was no avoiding the fact that fascism was a looming threat across Europe. People were poverty-stricken and hungry. The writer Storm Jameson described the 1930s as seeing 'millions of half-fed hopeless men eating their hearts out'. The result was a 'moral stench which became suffocating'. She saw a lot of the communist writer Ralph Bates in the mid-thirties – 'admiring his books and disliking his gluttony' – and noted his conviction that there would soon be 'a workers' war' in Spain and suggesting that she might have a role to play: 'We shall need a few writers outside. Money and arms more, of course, but – ...'[5] Bates, who lived in Spain, was walking in the Pyrenees when the civil war eventually broke out. He was 'tall, stout, about forty, looking more like a master plumber than a revolutionary leader'.[6] For the novelist Virginia Woolf there were two events that showed that a Popular Front was needed: 'the events at Olympia' – a fascist rally – 'and the Jarrow March'.[7] Doris Lessing's alter ego in *The Golden Notebook*, Anna Wulf, describes how she became a communist because the left 'were the only people in the town with any kind of moral energy' – communists 'took it for granted that the colour bar was monstrous'.[8] Kingsley Amis was another writer who turned to communism during his university days, in his case, at Oxford. Much later he would speak for others when he observed how he 'had had communism – in both senses of the word. I have experienced the ailment and so am immune. And I have also utterly rejected it.'[9] Such certainty did not prevent him having an open MI5 file for almost two decades.[10]

There were also those who flirted with membership of the Communist Party, but never actually joined. The poet W.H. Auden was one such. Although attracted by Marxism, he stood accused by Stephen Spender, for example, as merely 'dallying' in the subject, while Christopher Isherwood thought his Marxist leanings were 'half-hearted and largely to humour (myself) and a few other friends'.[11] Towards the end of 1932, Auden felt able to deny any prospect of joining the Party: 'No. I am a bourgeois. I shall not join the CP.' The following year, the poet Louis MacNeice wrote in a letter to Anthony Blunt: 'Auden turned up again after all and talked a deal of communism.'[12] Evidently, the poet was 'at a loss about what ideological direction to take'.[13] At all events, by then he had become someone of interest to both Special Branch and MI5.

After all, hadn't Auden published a poem with the provocative title 'A Communist to Others'? In February 1934, his name cropped up in an allegedly subversive letter, along with the Labour politician Stafford Cripps, Stephen Spender, John Betjeman, Storm Jameson and Bertrand Russell; thereafter Auden's file was regularly added to over the next two decades.

The 1930s saw not only individual affiliation to left-wing principles, but also the establishment of associations with the same values. The Artists' International Association (AIA), for example, was founded in 1933. The communist artist James Boswell was a founder member. Artists were particularly hard hit by the Depression and received no government help at all – unlike in the United States where Roosevelt's New Deal 'would eventually try to aid artists'. Clifford Rowe – recently returned from Russia – John Berger, Pearl Binder and Misha Black were prime movers in the AIA's establishment, the first meeting taking place at Black's studio in Seven Dials. 'It was all rather leftish stuff and you can imagine how romantic it was from the original suggestion that the Association should be called "The International Association of Artists for Proletarian Art".' A second meeting at Black's new studio in Charlotte Street attracted some twenty-five people and it was decided to adopt the 'Artists' International' tag to echo the 'Communist International'.[14]

In 1935, the association mounted a display of work that demonstrated its political stance: 'Those whom art and politics have put asunder, an exhibition against war and fascism has joined together.'[15] For its inaugural meetings, Boswell and others huddled together in candlelight, sitting on upturned fruit boxes in a dilapidated building near Covent Garden. Under flickering light and ominous shadows, the group argued and plotted. 'We only had the crudest ideas about Art and Marxism,' Boswell wrote, and not everyone was equally committed to the revolution, one woman stumbling out of the gloom in a hurry because 'she could not stand the sight of Lenin's blood running down the walls any longer'.[16] Clive and Noreen Branson occasionally attended, taking part, for example, in the unfurling of a vast banner proclaiming '25 Years of Hunger and War' strung out on the Strand for the Silver Jubilee parade in 1935.

A New Zealander – 'a colonial and proud of it'[17] – James Boswell had come to England in the mid-1920s, aged just 19. He was broadly built

and deep-voiced, with blond, almost white hair and eyes that twinkled. By 1925, he had enrolled as a student at the Royal College of Art – before being summarily ejected in no uncertain terms, warned that he should not contemplate a return until he could produce better work. He was of course not alone in having a troubled relationship with formal art education: both Paul Hogarth and Clive Branson were similarly at odds with their respective art schools. Boswell would return in due course, the recipient of a 'fourth year Exhibition'. Art school, however, had less influence on him than the harsh realities of life in the twenties, its economic turmoil and the hardship that caused. Boswell's emergence as an artist coincided with the Great Depression – something that 'hung over us all' – and he became 'the draughtsman of the history of those years'.[18] He joined the Communist Party in 1932 and threw himself into left-wing activism, 'lithographs and illustration for pamphlets, banners for hunger marches', and the Artists' International. By day, Boswell worked for the Asiatic Petroleum Co. (later to become Shell) as an artist-designer – 'most of the advertising studios then were hotbeds of subversion and the work done in them was not always what it should be'[19] – but he was also frequently to be seen in the down-at-heel streets of London's Kentish Town, working closely with the playwright and librettist Montagu Slater. He drew regularly for the *Daily Worker* and became art editor of *Left Review*. His artwork was instantly recognisable with its 'raw-beef businessmen, civic dignitaries and Special Branch types ... the establishment dummies, county characters and over-fed ladies make you shake your head and say "What a bloody silly society!"'[20]

By 1936, the AIA had over 600 members, its engagement in politics echoed by other organisations: 'Writers Against Fascism and for Collective Security', and the Writers' International. *Left Review* and the Left Book Club were similarly symptoms of the growth of left-wing dissent. *Left Review* first appeared in the autumn of 1934 and MI5 was immediately interested in its contributors. Many of them were familiar, or would become so: Nancy Cunard, Randall Swingler, James Boswell, C. Day Lewis, Tom Wintringham, John Cornford and J.B. Priestley. A conscientious MI5 officer scrawled a handwritten note to a superior to inquire, 'Do you wish any names carded here please?' The Left Book Club, with its 'orange-covered volumes (half a crown a month)', was

founded in 1936 by Stafford Cripps, Victor Gollancz and John Strachey and by 1939 it had some 57,000 members. It greatly influenced the political thinking of that 1930s generation.

<p style="text-align:center">* * *</p>

If writers and artists tended to be towards the left of the political spectrum, MI5's default position was predominantly right wing.[21] Events in Russia at the end of the Great War and in the years immediately thereafter had provoked a strong anti-Bolshevik stance amongst the British establishment to the extent that the future Labour Prime Minister, Ramsay MacDonald, for example, was subject to close and sustained scrutiny. Indeed, he 'had long been on MI5's radar: the service had actually recommended prosecuting him for delivering seditious speeches during the First World War.'[22] MI5 staff tended to be solid Tories – one was the Director of the Conservative Party's Research Department – and the organisation rapidly became 'paranoid about Communist-inspired subversion'.[23] It took very little to trigger the suspicions of the Intelligence Services – being in the company of a known radical was enough, and in all likelihood would result in yet another personal file (PF) being opened. The system of cross-referencing and recording of information was both labour-intensive and meticulous; a squad of clerks was kept busy copying and filing. For example, if the name of someone with a PF occurred in another suspect's filed document, it would be capitalised (e.g. SPENDER), copied and placed in both files.

Knowing or even simply meeting a confirmed communist was a kind of contagion and, as a result, MI5's registry of files grew exponentially. There were also other, more idiosyncratic, suspicious traits, often of appearance or behaviour. Such doubts about people's 'out-of-step' activities was nothing new: as far back as the Great War, the writing of poetry had been thought, by one mail censor reporting to MI5 on troops' correspondence, to be 'an ominous sign of mental disquietude'.[24] In the thirties it was enough that the historian Christopher Hill, for example, had 'the appearance of a communist'; the publisher James MacGibbon was described as wearing a 'light grey tweed suit, bright red silk, loosely knotted bow tie', the underlining of 'bright red' evidently seen

as confirmation of Bolshevik tendencies.[25] George Orwell appeared in 'bohemian fashion'; Stephen Spender was thought to be 'a sodomite'; Sylvia Townsend Warner and Valentine Ackland were 'great readers'; while another writer, Ralph Bates, was deemed to be a potential 'Red' following the discovery at customs of a copy of Stendhal's *The Red and the Black* in his luggage. If personal idiosyncrasies were grounds for suspicion, so too was membership of 'activist' societies. Other factors stirring MI5's interest included a person's race ('the audience appeared to be made of Jewish and intellectual types of communist'); dubious habits ('long finger nails, Turkish cigarettes and black coffee'); and even what an individual wore ('Some [MI5 officers] thought that people who wore jeans were potentially subversive').[26]

Some writers of the time were acutely aware of the shady practices of the Intelligence Services: the 'early poetry of Auden, Day Lewis, and Spender abounds with references to spies and espionage'.[27] That perception was helped by the fact that the use of undercover agents to monitor individuals or organisations was not always efficient or sophisticated. For example, at a Communist Party meeting in 1924, 'the speaker opened a trapdoor under the stage to discover two men taking shorthand notes.'[28] The covert eavesdroppers were duly arrested by the police officers who had been summoned to investigate. It was only later that it emerged that the men who had been arrested were serving police officers themselves. Infinitely more successful was the scheme to place an agent within Party HQ in London. Olga Gray worked for the CPGB in its King Street office from 1931 to 1937, while at the same time reporting back to her bosses in MI5. It was no easy undertaking: Gray found herself increasingly torn between, on the one hand, her duty to submit a steady stream of detailed information to Maxwell Knight, and her growing empathy with those whose trust she was betraying on the other. She was required to report 'evidence of illegal activities, the names of "closed" Party members, communications between underground comrades and any other details about left-wing underground networks'.[29] Eventually the strain proved overwhelming and, in July 1935, she was hospitalised with 'what was later described as a nervous breakdown'.[30] Later she would act as a courier for the Comintern where she proved to be 'intelligent and scrupulous and [with] a fantastic eye for detail' – qualities equally useful

in her work for MI5.[31] Eventually she became Harry Pollitt's secretary, where it is likely that her path crossed with Noreen Branson. Olga Gray was regarded as the government's 'leading pre-war penetration agent in the CPGB', her work rewarded with a slap-up dinner at the Ritz and a cheque for £500.[32]

Home Office Warrants (HOWs) were another important feature of the Intelligence Services' surveillance methods. These involved formal application to the Home Secretary and the use of a secret cell of the GPO known as the 'special censor section', whose function was to open post and bug phones, including the line at King Street. Routinely, a request would be sent, authorised by the Home Office: 'I should be much obliged if you would arrange for a list of daily correspondence going to the following address for the next two weeks.' Informants were encouraged to report on suspects and even rifle through their belongings: 'Owing to their unusual behaviour during the first evening of their stay in the Seven Stars Hotel, Mrs Turner paid a little more attention to their luggage and personal belongings.' Agents, meanwhile, were under strict instructions not to arouse any suspicion in a targeted individual: '[I] need scarcely add that it is essential that he should not become aware that he is the subject of any inquiry.' Passport applications were scrutinised; visas denied; and policemen lurked unobserved in covert surveillance operations. The artist Felicia Browne's house, for example, was watched one summer evening in June 1934: 'PC Bull and I took up observation at 6.45 pm today on 32 Wharton Street.' The two officers had a long wait, until 'at 9.25 pm, the British communist woman appeared ... looking round in a furtive manner.' Those who were followed by a footsore agent as they went about their business were sometimes well aware of their stalkers. The writer Storm Jameson had no difficulty in identifying official watchers: policemen who stood on the fringes of meetings eying the proceedings with 'stolid curiosity', while the Party's Secretary, Harry Pollitt, took some satisfaction in mocking the process. Getting on a London bus on one occasion, he offered <u>two</u> fares to the conductor, the second for 'that man in the front of the bus, because I'm the only person who knows where he's getting off'.[33]

* * *

In January 1935, a letter was received at Communist Party Headquarters in King Street from an address in rural Dorset. Number 24 West Chaldon, not far from Dorchester, was an old, detached farmhouse set back from the road, and the home of two women writers, both communists. 'I have a small racing car,' the letter read, 'and this I could put at your disposal for two clear days a month, with myself as driver.'[34] The letter was written by Valentine Ackland, who with her lover, the poet and novelist Sylvia Townsend Warner, had just joined the Party. They were enthusiastic converts to communism and very aware of their non-working-class background: 'I appreciate how lucky we are, coming newly into the Party,' Sylvia wrote, 'and from such a dubious quarter, middle-class homes and genteel upholstery.'[35] She was 'the daughter of a housemaster at Harrow [and] an authority on Tudor church music'.[36] It had been the trial following the fire at Berlin's Reichstag that had convinced both women of 'the rightness of the Communist cause'. For her part, Sylvia's instinctive leaning towards anarchism chimed with what she saw as 'the anti-authoritarian stance' of the Party. That was enough: 'I became a Communist', she said much later, 'because I was against the Government.'[37]

Within a matter of days of the letter being sent to King Street, both women had been placed under surveillance by MI5. The Service's Director, Sir Vernon Kell, wrote to Major Peel Yates, the Chief Constable of Dorset, seeking assistance from the local police force – help that he insisted should be exercised with caution and discretion. Inevitably, perhaps, Kell assumed that Valentine was male. In due course, a Sergeant Martyn attended a local assize court where the two 'literary ladies' were appearing in a libel case, an action that had been brought as a direct result of their social consciences. They had been outraged by the treatment of young serving women at the village vicarage and had signed a petition seeking a Council investigation. The two women were determined, it seemed, 'to transform a patch of rural England into a little Soviet'.[38] The allegations were 'well-founded and undramatically worded', but the trial went ahead nonetheless. There had been some forty co-signatories to the petition, but only four were named in the case, those deemed to have enough money to pay damages – and that included Sylvia and Valentine.[39]

In his report, Sergeant Martyn was succinct in his description of Sylvia, as well as the couple's car, a two-seater MG, numbered VG 5718. 'Miss Ackland' got far more attention, Martyn painstakingly noting her slim figure, pale skin and 'brown or auburn hair which is Eton-cropped'. Her eyes were blue-grey; her accent 'refined'; and when she spoke it was in a low voice, with a clipped tone. She was dressed in a dark skirt, short enough to reveal 'silk stockings' and 'shapely legs'. He observed too that her wristwatch had a broad band, underlining her evident masculinity. Later that year, in October, Vernon Kell asked Peel Yates whether he could confirm whether the women were engaged in 'subversive activities of any kind' – and were they 'in any way abnormal'? A Sergeant Arthur Young from Wool Police Station duly reported that Ackland 'spends a considerable time shooting rabbits' with a rifle and 'more often than not wears male clothing in preference to female attire'.[40]

* * *

The artist and sculptor Felicia Browne had been under surveillance for much longer than the two newly converted Dorset-based communist writers. Passionately left wing, she too came from a comfortable background. In January 1931, she had been living in Fairfax Road in Hampstead and was seeking to get her passport renewed in order to go on a European trip to Germany, Austria, Hungary and Russia. Her photograph in her personal file shows a rather masculine woman, more Bolshevik war correspondent than artist, with cropped hair, wire-framed spectacles and pallid skin. She is wrapped in a voluminous army greatcoat, like a character in a Russian novel. At one point, she had a studio in Euston Square, which 'was the centre for a "circle" that included the young W.H. Auden and William Coldstream'.[41] Like Branson and Coldstream, Felicia had studied – intermittently in her case – at the Slade. She joined the Party in 1933 and was a member of the Artists' International, 'her heart … entirely with the working class'.[42] Another ex-Slade student, Nan Youngman, believed that 'Felicia was much more aware of the political situation than any of us, she knew what was happening and she was preparing herself for it; she used to go to self-defence classes.'[43] A year after she became a member of the Communist Party, a report on

her activities was prepared by Special Branch and forwarded to MI5. Miss Browne was interested in art and sculpture, Inspector Davies and Sergeant Evans noted, recording the amount of time she spent as a reader at the British Museum. She was, they reassured MI5, 'not associated with the revolutionary element that frequents the museum'. She was now living in London's Bloomsbury, at 9 Guilford Street, just around the corner from Great Ormond Street Hospital. It was decided to maintain the level of surveillance, her post should be opened, read and copied, as it had been regularly over the preceding five years.

Then, in the summer of 1936, MI5 was alerted by officials at the port of Dover that Browne and her companion Edith Bone were about to cross the Channel, planning to drive down through France in their small, blue Austin 7, en route for Barcelona. Bone was 'a different kettle of fish' from Browne: 'hard and politically orientated', she had come to England 'to get away from the secret police that were after her'.[44] Felicia's priority was defending the cause of the Spanish Republic: 'If painting or sculpture were more important,' she said, 'I should paint, or make sculptures.'[45] The watchers in Dover, noting the car's number as it rolled on to the ferry, observed too that Felicia looked older than her 32 years, a woman of medium height and build with brown hair and eyes. She was dressed 'in a grey costume and a black beret'. The two women would arrive in Barcelona after a rural ride in their Austin 7 across France, just as the first shots of the Spanish Civil War were being fired.

'A Bastard of a War'

The civil war that broke out in Spain in the summer of 1936 pitted left against right, the democratically elected Republican Government against the rebel forces led by General Francisco Franco. 'The issues were black and white, what was at stake was a whole way of life,' was how one Spanish writer put it, and left-wing writers and artists in Britain took a similarly clear-cut view of the conflict. The rebels were seen as representing 'a catalogue of conservatism' – monarchists, landowners, financiers, the Church, the army, 'the fascist element, which was bent on the creation of a totalitarian state'.[1] Prior to the conflict, there had been, according to the artist Julian Trevelyan, 'an air of general frivolity about our life in London'. The events in the summer of 1936 changed that – thereafter, he wrote, 'for the next three years our thoughts and consciences were turned to Spain'.[2] It was no surprise when the Artists' International Association immediately backed the anti-fascist cause and, in December 1936, it mounted an exhibition, *Artists Help Spain*, featuring works by Augustus John, Jacob Epstein, Paul Nash, Vanessa Bell, Eric Ravilious and Edward Bawden. As for Clive Branson and Paul Hogarth, they too were committed to the cause from the outset and each would, in time, travel to Spain.

Within two weeks of the war beginning, the fifty-member-strong Battersea branch of the CPGB convened a meeting, which took place at the railwaymen's Unity Hall on the last day of July. The Bransons were both involved: Noreen was secretary of the Battersea branch, while Clive was one of the two principal speakers at the meeting, his talk entitled 'Support Spanish Workers Against Fascism'. He spoke again in mid-September at a meeting convened to protest against the British Government's policy of non-intervention in Spain. More than 400 people attended on that occasion, while another meeting at the Town Hall in November was packed, with a thousand people or more crammed

inside. The Labour MP Aneurin Bevan spoke at the meeting, declaring that 'if Madrid fell to fascism, it would be Paris next, and then London'.[3] An 'Aid to Spain' committee was formed and a week devoted to the cause was held from 6 to 13 December 1936. Meanwhile, a group of women sat in the window of the Party-run People's Bookshop in Lavender Hill, resolutely knitting clothes to send to Spain.

The AIA membership donated money to buy an ambulance 'plus £500 of supplies' and the 'Artists' Ambulance' duly set off for Spain on 15 January 1937. At much the same time, an ambulance went from Battersea, proudly labelled 'From the workers of Battersea to the defenders of democracy in Spain'.[4] Clive Branson was equally proud that one of the local factories, Dorman Lays, 'was the first factory in the country to down tools one afternoon and march in a solid body to the House of Commons demanding "Arms for Spain"'.[5] Branson himself was keen to volunteer, but Harry Pollitt persuaded him that he was needed by the Party in England. 'Put it off for now,' Pollitt said, with a smile, and Clive's request to go early in 1937 was firmly turned down.

Felicia Browne, on the other hand, had arrived in Barcelona just as the war started. With her was 'the Hungarian communist photographer Edith (Ed) Bone'.[6] The two women were given dire warnings by the British Consulate to keep indoors if at all possible; if it was necessary to venture into the tumultuous streets, then the best advice would be to proffer a clenched fist salute, and smile sweetly. In the event, Edith, in the company of the journalist Claud Cockburn, left the city, while Felicia volunteered for the Communist militia. This was early in August. 'I am a member of the London Communists,' she declared, 'and can fight as well as any man.' Three weeks later, on 29 August 1936, in a mission to blow up a Nationalist train, she was shot and killed.

Soon after her death, the Marxist poet and journalist Tom Wintringham wrote to Harry Pollitt in London, suggesting that Browne's sketchbook with some twenty drawings should be sold to raise money and, in due course, the left-wing publisher Lawrence & Wishart published it, with the profits all going to 'Spanish Medical Aid'.[7] Felicia herself was remembered as 'without guile, duplicity or vanity, painfully truthful and honest'. Felicia Browne's death was a profound shock to those who knew her. She had been at the Slade at the same time as Clive Branson,

William Coldstream, Henry Tonks and Nan Youngman. Youngman read of Browne's death 'sitting on a beach in Cornwall'. Horrified, she promptly joined the AIA, feeling that she had begun 'to be aware of living in history', and soon became involved in putting together an exhibition of Felicia's work. She herself 'bought one of the drawings [which had] 3 guineas on the back'.[8]

* * *

Felicia Browne was one of the first artists to head for Spain in that summer of 1936, but others soon followed, or at least tried to travel south. They included the sculptor Jason Gurney, the surrealists John Banting and Roland Penrose, Julian Trevelyan and Wogan Philipps. The latter left for Spain from the port of Newhaven, bound for Dieppe on 17 February 1937, his departure duly noted by Special Branch. Philipps was travelling in a Bedford lorry packed with medical aid provided by the workers of Preston and driving overland to Albacete in Spain. With their usual thoroughness, the police noted the lorry's registration – AER 391 – and passed the information on. Ten years before, Philipps's public-school education and aristocratic background – he had rowed for his college at Oxford – had persuaded him to volunteer in order to help break the General Strike. However, the strike was to change his view of the world, making him what he called 'left-minded'.[9] In particular he was moved by 'the plight of the strikers he met while working as a special mounted constable in the London docks'.[10] Evidently, Clive Branson was not alone in being jolted from a privileged background – both he and Philipps served as volunteer constables, confronting the very workers whose lives they would come passionately to support.

A month after the civil war began, a number of major powers determined to follow a policy of non-intervention in Spain. Some nations chose to flout the agreement – Germany, Italy and Russia – while the French and British were at pains to stand aside as the fighting continued. Later, George Orwell would express the view that 'the outcome of the Spanish war was settled in London, Paris, Rome, Berlin – at any rate not in Spain'.[11] The British Government sought to prevent aid – weapons and volunteers – reaching the Republic and, to help with that, Special

Branch 'forwarded their surveillance reports to MI5, who drew up a huge list of 4,000 individuals suspected of being potential volunteers'.[12] Early in 1937, as a result of the Foreign Enlistment Act, it became illegal to travel to Spain from Britain. Where once would-be volunteers could simply turn up at the Party's King Street office in order to sign on, from February onwards they were told to present themselves at a nearby sandwich bar instead. The stallholder would then contact King Street and, soon after, Clive Branson would arrive to meet and greet them. Part of his role would be to keep them sober for fear of beer-loosened tongues broadcasting a catalogue of intended heroics to the clientele of London's pubs – and a network of informants and agents. This was no easy task and Clive was frequently anxious about what could go wrong. He was also acutely aware of the naïvety of many volunteers, their unpreparedness, evidenced by the blithe assumption that crossing the Pyrenees without sturdy footwear would be just another long walk.

Many of the volunteers were from the north, and London was something of an eye-opener. When Branson got them to the CPGB headquarters, that proved an even more chastening experience. Business was conducted in 'a warren of little offices behind a façade of iron-protected glass'.[13] Having picked a way through the confusion of barrows, lorries, squashed fruit and vegetables, the prospective foreign fighter would climb the wooden stairs to the first floor where he would be confronted by Comrade Robson, sitting stern-faced and implacable behind a roll-top desk. An interrogation would begin: Are you genuine or a mere adventurer? Do you have any political commitments and affiliations? Any military experience? Do you realise what you're letting yourself in for? 'It was a bastard of a war, we would be short of food, medical services and even arms and ammunition,' Jason Gurney remembered being told. Robson was brutally blunt: 'If you're looking for conditions of service, you're not the kind of bloke we want in Spain. So, get out.'[14] If, after that discouragement, you were still insistent on volunteering, you were given just twenty-four hours' notice to get your domestic affairs in order and to make your heartfelt goodbyes.

Under the watchful eye of Clive Branson, the volunteers left from London's Victoria Station, travelling on a weekend ticket since, at that time, a passport wasn't required for such an excursion. Until they were

on board the boat, Clive carefully avoided any kind of contact. The men in his care were what one of them described as 'a mixed bag', many of them working-class men, respectably dressed despite their limited means, sunk in near-silence and trepidation in the third class carriages. 'One of our party,' the International Brigader Bob Cooney remembered, 'was extremely short-sighted,' while another proved to be from a 'highly paid post in a Glasgow engineering firm'.[15] For Branson, the whole operation was always an ordeal, not least because of his concerns about possible interventions by Special Branch officers. On one occasion he was recognised as he passed through the barrier by a communist railwayman who unwisely greeted him with a clenched fist salute right 'under the eyes of a suspicious detective'. An appalled Branson cut him dead, turning his back and walking away.

Once in Paris, the men were briefed in a run-down café, its walls liberally plastered with posters of Marx and Lenin. They were given dire warnings about consorting with the local women, stern advice stemming, not from concern about sexual health, but the likelihood of sleeping unwittingly with a fascist spy. The more hungover amongst the party, regretting the cavalier binge en route from London, nursed aching heads and contemplated an uncertain future. More prosaically, each man was provided with a toothbrush, bar of soap and a comb.

They took the night train from the Gare Austerlitz. Known as the 'Red Train', it left amidst an uproar of applause, shouts and flag-waving, bound for Perpignan in the south of France. From there, the more fortunate took the midnight bus across the border, but for many others there was the grim prospect of a long, arduous climb over the Pyrenees before eventually dropping down into Spain. Bob Cooney described this as a 'heart-breaking' trek, the volunteers shod in alpargatas, 'parched with thirst' and short of breath; their hands were bleeding, cut by unseen rocks; and their grasp of Spanish was limited to *'Brigada Internacional'*, a phrase that could elicit either an embrace or a bullet. By the time the hopeful soldiers were in Spain, Clive Branson was back in London, wondering how much longer he could elude the tightening net of Special Branch.

While Branson was prevented by Harry Pollitt from going to Spain early in the conflict, it was Pollitt's oratory at Manchester's Free Trade

Hall that encouraged a teenage Paul Hogarth to join the International Brigade and head for Spain. He too was interviewed by Comrade Bill Robson at King Street and given the same dire warnings about conditions. On the journey south from Paris, Hogarth was struck by the youthfulness of those around him, 'none were much older than 18'. It took him eleven hours to cross into Spain, a stumbling trek over the mountains in the dark, before eventually arriving at a tumbledown farmhouse with a wind-torn Republican flag flapping over its ramshackle roof. The guards were equally unprepossessing, gaunt and listless, greeting the new arrivals with minimal fuss and miserable rations, 'jaw-breaking lumps of bread dipped in olive oil'. They were taken by lorry to the castle of San Fernando high above the Catalan town of Figueres. With an ancient rifle, Hogarth helped guard food convoys rumbling their way into Spain, rapidly learning that youthful optimism offered little protection against lice, disease and an absence of modern weapons. Eventually he was transported to the International Brigade base at Madrigueras, some 20 kilometres north of Albacete, where he was kitted out in a uniform of sorts – military mostly – and put through a rudimentary training course, which proved 'pitiable in the extreme' according to Tom Wintringham. It was all very unedifying, so much so that Jason Gurney became 'bored with the whole nonsensical business'.[16]

* * *

The writers Sylvia Townsend Warner and Valentine Ackland had travelled to Barcelona very soon after Felicia Browne was killed. Valentine 'longed to join the miliciana, the women combatants on the government side', but a telegram from Tom Wintringham directed both of them to a Red Cross unit instead and he was there to welcome them when they finally arrived in the Catalan capital. Sylvia rapidly fell in love with Spain, struck by the comparison between the 'mealy-mouthed' nature of life in England and the Spanish Republic's anarchic energy. The sign on a Barcelona office building that read 'Organisation for the Persecution of Fascists' seemed somehow to symbolise that wild irreverence.[17] The attitudes of the British communists in Spain were more troubling, both women baulking at the tendency of some Reds to behave like 'members of the Raj in India'. One comrade, it seems, insisted that 'the best way to speak to Spaniards is with a whip'.[18]

By the third week of October, Sylvia and Valentine were back in Dorset, their return prompting a resumption of MI5's surveillance of them, caused in part by a concern about the close proximity of a number of important military installations, the Tank Training Centre at Bovington, for example, as well as the naval cordite works at Wareham. The security operation was complicated by the fact that the local police were 'rather nervous of doing anything ... owing to [Sylvia's] position in the county' – evidently she was 'looked upon in the area as more or less the local squire and [she] moves about the county in well-to-do circles'.[19] Nonetheless, the women's regular visitors from London were kept under close observation whenever they stayed at the Seven Stars Inn in East Burton, or at the nearby Red Lion. The landlord of the Seven Stars was all too willing to cooperate with the Intelligence Services and keep them informed, his political views such that he had instituted a ban on all communists from entering his hotel. His reports noted how these latest 'Reds' kept themselves to themselves; how they motored off after breakfast (in a Standard car – or perhaps a Hillman?); their habit of not returning until early evening, wearing full hiking gear and shorts, but suspiciously with no mud caking their boots; and their tendency to disappear upstairs after dinner and spend hours writing. When they were out, 'their books, papers etc. were carefully locked up and correspondence put away'. To cap it all, the suspected couple were sharing a room but were clearly unmarried. Moreover, the pub's manageress, a Mrs Turner, reported that she had overheard Miss Townsend Warner warning her visitors to be 'very, very careful in what they did and said'.[20] Miss Warner, it seems, was well aware that there were watchers beyond the shadows.

* * *

For his part, Stephen Spender had been under surveillance from the middle of the decade, his phone number (Abercorn 1763) and address (25 Randolph Crescent, London W9) well known to MI5, thanks to Captain Booth at the GPO. When Spender spoke at public meetings, it was the established practice that someone would be noting what he said and ensuring that his file was suitably updated. Then, in January 1937, MI5 was disturbed by a series of intercepted telegrams that suggested a dubious link between Spender and Soviet Russia. A Captain Airy from

Gibraltar's Defence Security Office contacted 'PO BOX 500' in London – MI5 – querying whether Spender was being paid by the Russians to inquire into the whereabouts of the Soviet ship *Komsomol*, which reportedly had been sunk by an insurgent cruiser. Was the poet, in effect, a spy? Sir Vernon Kell replied, avoiding a definitive judgement, while noting Spender's passionate anti-fascism, his powerful verse and the fact that he was 'a person of leisure and private means'.

Spender's mission to Spain – in mid-January 1937 – proved unsuccessful, Franco's troops preventing him crossing the border and reaching Cadiz, so that his search for the *Komsomol*'s fate drew only on hearsay and rumour. He was back in the UK by the end of the month, and, on 7 February, had been debriefed by Harry Pollitt, whose 'friendly twinkling manner' he thought 'paternal'.[21] At this point, Spender had formally joined the Party, marking the occasion by writing an article – 'I Join the Communist Party' – for the *Daily Worker* in which he explained the reasons for doing so and, in passing, revealing that he would soon return to Spain to broadcast 'anti-Fascist propaganda' from a radio station in Valencia. There was a persistent – if implausible – rumour circulating that Pollitt had intimated to Spender that he should 'go and get killed, comrade, we need a Byron in the movement'. It was certainly true that Pollitt encouraged men to face danger in Spain. 'I asked him to go, and explained that it meant facing death,' was how he put it to one such volunteer, but the 'unbridled cynicism' that cast the poet in the role of potential martyr was not Pollitt's way, and Spender, for his part, had a much more powerful motivation: the welfare of his lover, Tony Hyndman.[22] Hyndman had volunteered for the International Brigade, endured the horrors of the battle of Jarama and then refused to obey an order, with the result that he had been arrested. There followed a concerned correspondence between Spender and Harry Pollitt, the essence of which was the urgent need to get Hyndman repatriated. Case officers at MI5 read it all, including the judgement of one informant who reported that 'Harry Pollitt thinks less than nothing of their value to the Party'.[23] It wasn't just Spender; the source suggested that both W.H. Auden and Christopher Isherwood were equally peripheral.

* * *

In the summer of 1937, Sylvia Townsend Warner returned to Spain, this time to attend the 2nd International Congress of Writers in Defence of Culture, which was to be held in three cities – Barcelona, Valencia and Madrid. She thought the British delegation 'depressingly puny and undistinguished', despite it including Ralph Bates, the journalists Frank Pitcairn and John Strachey, and a roll call of poets – Edgell Rickword, Auden, Spender and the novelist Christopher Isherwood.[24] To MI5, most of these names were noteworthy as long-established targets. That fact, together with the government's non-intervention policy, unsurprisingly meant that in July the group was refused visas by the British Foreign Office, its stance being that only 'commercial people' or 'those who were doing work for the Duchess of Atholl's Relief Committee' would be granted visas to travel to Spain.[25] 'Cultural reasons' certainly cut no ice with FO officials and the writers only reached Barcelona through the intercession of Andre Malraux, the French writer making the arrangements to get them to Spain and who met the group at the Gare St Lazare in Paris. It was a daunting journey south and Sylvia fumed at the incompetence and 'God-like' manner of the French organisers – there was too much waiting around, time being killed for no apparent purpose. She felt 'like a kitten doing a cross-country journey in a basket'. Stephen Spender, meanwhile, had, for no obvious reason, taken against Sylvia, while she thought him 'an irritating idealist'.[26] They reached Port Bou on 4 July and were then driven 'in a fleet of cars along the mountainous coastal road to Barcelona'. It was a hair-raising experience since 'the driver of the Rolls-Royce in which they travelled was an enthusiast for speed' and the travellers found themselves casting worried looks at the wrecked motors on the roadside.[27] Despite their fears, the car reached Barcelona safely that night. Sylvia was exhausted, prompting Stephen Spender to sneer at what he characterised as her bourgeois fragility and claiming that her travelling companions sniggered when she argued that 'on behalf of the English', she felt it incumbent to speak up in support of a Mexican delegate who had been travelling for ten days already. For his sake, she pronounced, 'we ought perhaps to stay the night', and so they did, staying at Barcelona's best hotel, courtesy of the Catalan government.

The Congress sessions in Valencia were held in the bomb-damaged Town Hall: it was 'in ruins except for one wing'; the marble stairs had

been repaired with concrete; and 'a bomb through the roof of the hall had narrowly missed two magnificent cut-glass chandeliers'.[28] The air raids, the heat and tiredness were not enough to quench Sylvia's love affair with Spain, its landscape, the people and the cause itself. 'I've never seen people who I admired more. I never again saw a country I loved as much as I loved Spain.'[29] Notwithstanding the bombing, the 'speed and precision' of the 'brilliant' aeroplanes excited her as they prowled over the city, while even the goods in the shops caught her attention: the only shoddy object she saw was a captured fascist flag.

Sylvia's relationship with Spender continued to be uneasy: she felt that he was invariably 'hatching a wounded feeling', while, for his part, he was amused by 'the Communist lady writer' who looked and behaved 'like a vicar's wife presiding over a tea party given on a vicarage lawn'.[30] Her hat, her smile and her lofty opinions all irritated the poet. At one point, he travelled by car from Valencia to Barcelona with 'a lady novelist and her friend, a poetess' – Warner and Ackland granted anonymity – while Spender sat in the front alongside the driver, 'a genial, violent man' who had shot five people dead in the Catalan capital – and 'boasted about it'. Sylvia, who claimed that she 'had seen no evidence of behaviour on the Republican side which was not perfectly nice', looked at Spender with 'stupefied indignation' when she and Valentine were told about the driver's killings; they 'looked at one another and then moved away without a word'.[31]

The British writers' delegation left Spain on 13 July and the two hostile delegates went their separate ways – Warner to Dorset, Spender to 'a small house near the Kentish coast' for the summer – no doubt with considerable relief on both sides.[32] Spender's considered view of the Congress was that it had produced 'a deep dissatisfaction' in him, provoked by the sight of 'distinguished intellectuals who had just been on a luxury tour of a war-shattered country, screaming to get into their sleeping cars'.[33] His feelings would also have reflected events earlier that year and his growing disillusionment with communism. It was a dream destined to fail.

For the People of Spain

Like many other writers, the journalist Nancy Cunard travelled to Spain in 1936 because she felt that she 'could not morally do anything else'.[1] In common with Sylvia Townsend Warner, she promptly fell in love with Spain, both with the 'revolutionary atmosphere' pervading Barcelona and the heady political cause that lay behind it. She would ever afterwards remain firm in her belief that 'the Republican side was the side of the people, freedom and revolution'.[2] Cunard travelled widely and worked hard, filing reports on the situation in Spain for a variety of newspapers, including the *Manchester Guardian*, the *New Times*, a paper run by Sylvia Pankhurst, and the *Associated Negro Press*, for which she wrote two or three times a week. It was her association with this latter cause that had brought her to the attention of the Metropolitan Police: Special Branch duly opened another file.[3] By the spring of 1937, in addition to her journalism, Nancy was working on a project entitled *Los Poetas del Mundo Defienden al Pueblo Español*,[4] which comprised six leaflets of poetry inspired by the civil war. They included poems by Auden, Lorca, Pablo Neruda and Randall Swingler, who would later become a close friend of Paul Hogarth. Then, in the summer of 1937, she circulated a letter to 'the Writers and Poets of England, Scotland, Ireland and Wales' asking whether they were for or against Spain's Republican government. As she put it: 'Are you for, or against, Franco and Fascism?'

The responses – nearly 150 of them – were published as *Authors Take Sides* in November's *Left Review*. It sold some 5,000 copies in a fortnight, at sixpence each; of these, 2,000 were bought at WHSmith, underlining the magazine's broad reach. The vast majority of the responses (127) supported the Republic; sixteen (including those from T.S. Eliot and Vita Sackville-West) were neutral, while just five (among them Evelyn Waugh and Edmund Blunden) declared for Franco. Sylvia Townsend Warner's reply was typical of the left-leaning majority, writing that she was 'for

the people of Spain, and for their Government, chosen by them and true to them. And I am against Fascism, because Fascism is based upon mistrust of human potentialities. Its tyranny is an expression of fear.' The counterview, while only held by a small minority, was sometimes equally passionate. For example, Ezra Pound responded: 'Spain is an emotional luxury to a gang of sap-headed dilettantes.'[5] George Orwell, who returned from fighting against Franco in late June 1937, responded furiously, with 'one of the most intemperate paragraphs he ever committed to paper',[6] demanding that 'this bloody rubbish' should no longer be sent to him. 'This is the second or third time I have had it,' he wrote. 'I am not one of your fashionable pansies like Auden or Spender. I was six months in Spain, most of the time fighting, I have a bullet hole in me at present and I am not going to write blah about defending democracy or gallant little anybody.' He would subsequently 'hold the convenors of *Authors Take Sides* in the deepest contempt'.[7] For example, Orwell was scathing about Spender's Spanish war, writing at the end of his response: 'Tell your pansy friend Spender that I am preserving specimens of his war heroics' – he was anticipating a time when the poet would be ashamed of his conduct during the war. Then, Orwell wrote, 'I shall rub it in good and hard.'

Orwell regarded both Spender and Auden as 'parlour Bolsheviks: young men playing at radical politics'.[8] In common with others, Auden had been drawn to Spain, immediately empathising with the Republic's legitimate cause when the rebellion began, but was unsure how best to contribute – should he fight, carry a stretcher, or drive an ambulance? He told friends that he had finally come down on the side of the latter. He left for Spain, from Victoria Station on 12 January 1937, travelling on the Paris boat train, 'looking most sinister in a Teddy bear coat, cloth cap and glasses' according to William Coldstream, who had travelled to Victoria to see him off.[9] His departure had been splashed across the newspapers, although he had wanted to keep the trip out of the public eye. He met up, as planned, with Christopher Isherwood in Paris and then headed south for Spain. The next two months are shrouded in uncertainty, the mystery exacerbated by his sparse written accounts – it seems he sent no letters – and his reluctance to talk about his experiences afterwards. After some time in Barcelona, he travelled south to Valencia, where he stayed at the

Hotel Victoria along with the world's press corps, whose headquarters it was. The foreign correspondents, he thought, were as 'conspicuous as actresses'. His plans to drive an ambulance for the Spanish Medical Aid Committee were thwarted, however, leaving him idle and frustrated; he would explain the fact by claiming later that he had never been a Party member and that the Communists were 'running everything': hence his willingness being met with a stern and chilly reluctance. Instead, according to Isherwood, he worked briefly as a propaganda broadcaster for the Republic. He also wrote a piece for the *New Statesman*, giving his impressions of Valencia. The pro-Franco poet Roy Campbell was predictably dismissive: 'The most violent action he ever saw was playing table-tennis at Tossa del Mar on behalf of the Spanish Republicans, apart from the violent exercise he got with his knife and fork.'[10]

At all events, Auden was back in London on 4 March 1937, resolutely taciturn about what he had seen and done, and greatly disillusioned. His silence was fuelled in part by the realisation that to speak out would aid the Franco cause.[11] Although he was disgusted by the politics in Spain, and the closed churches and absence of priests in Barcelona, which had 'profoundly shocked and disturbed' him, he did not wish to damage the Republic's continuing struggle. There was a further mystery: why did Auden's name not appear in the detailed list MI5 had drawn up on the British in Spain? Had the system of surveillance, with its growing network of meticulously cross-referenced files, failed for once?

* * *

Both George Orwell and his alter ego, Eric Blair, had been subject to sustained attention by the Intelligence Services from the late 1920s onwards. By March 1936, the Special Branch file on him was extensive, covering his Indian birth; his schooling, including the fact that he had spent four years at Eton (from 1917 to 1921); his service with, and subsequent resignation from, the Indian Police Service; and his growing literary reputation. All that was unexceptional, but there were also other, more suspect, details that revealed what the authorities saw as Orwell's dubious contacts and unconventional politics. The level of suspicion is illustrated by the numbers of copies of his passport photograph in his file (six), and the careful, detailed description of him – 'height 6

foot 2 inches, eyes grey, hair brown, tattoo marks on backs of hands'. Special Branch evidently wished to ensure that its informants and agents could be certain of their target's identity. Orwell, it seems, merited close attention thanks to his apparent subterfuge: his co-habiting with a Mrs Obermeyer, who was 'reported to have left for Russia on 11 June 1932', and his association with Francis Gregory Westrope, a Hampstead bookseller with a long history of involvement with the ILP – which Special Branch characterised as holding 'socialist views', having 'intellectual' pretensions and possibly 'handling correspondence of a revolutionary character'.[12] Moreover, Orwell had evidently told his 'intimate friends' that he had left the Indian Police because 'he could not bring himself to arrest persons for committing acts which he did not think were wrong'. Then there was his activity in France. An anonymous informant – the name is redacted in the Blair/Orwell file – reported to Scotland Yard's Captain Miller that 'Eric Arthur Blair' was a 'single man' living in Paris, eking out a 'precarious living'. He had arrived there in June 1928, Miller was told, where he had taken an 'interest in the activities of the French Communist Party', something that had already attracted the attention of the French authorities. He had 'offered his services to the *Workers' Life*, the forerunner of the *Daily Worker*, as Paris correspondent'.[13] Then there was the fact that his publisher was Victor Gollancz, a firm 'which specialises in left-wing literature'.

Police interest in Orwell was heightened by his trip north to undertake research for *The Road to Wigan Pier*, the book that laid bare the bleak nature of post-Depression England. He visited Wigan, Barnsley and Sheffield, focusing in particular on the level of poverty in the north. On 22 February 1936, Detective Constable John Duffy of the Wigan force prepared a report on 'Eric A. Blair or George Orwell – six foot, slim build, long pale face' – drawing attention to the writer's collection of 'an amount of local data', as well as his links with the local Communist Party. DC Duffy's senior officer, Detective Inspector Cockram, added a note suggesting that Scotland Yard should be contacted in order to discover 'whether [Blair] is known to be associated with the Communist Party', an association of which both MI5 and Special Branch were already very well aware. Inevitably, when Orwell left for Spain at the end of 1936, his name was one of those added to the card index of 'members and supporters

of the International Brigade who came to MI5's notice'. Once in the Republic, his fellow volunteers were curious about his adopted name: why 'George Orwell?' The erstwhile Eric Blair explained: 'I wanted a working-class name. George is good working class, as you Geordies ought to know, and, of course, you've heard of the Orwell – a good Suffolk proletarian river.'[14]

* * *

Paul Hogarth was one of those 'members and supporters of the International Brigade' who travelled to Spain and whose name was recorded on MI5's blacklist. Thirty-two years later, he would appear on the British radio programme *Desert Island Discs*. Asked about his involvement in the Spanish Civil War, and having chosen the stirring voices of the Quinta Brigada as one of his eight records, he looked back at his volunteering with dismay; 'I must have been barmy,' he said. In his later years, Hogarth would blame the 'irresistible' power of 'youthful idealism'. Explaining his reasons for becoming a communist, he attributed it to the affection he received in the Red community, something 'that I didn't have', he said, 'in my family life'. He was not alone in that regard, it seems: for Sylvia Townsend Warner and Valentine Ackland, 'the Communist Party fulfilled some of the functions of a large extended family'.[15]

As the war in Spain ground on, in Britain there were increasing protests about how young many of the volunteers were, although in Manchester, the Hogarths knew nothing of their teenage son's whereabouts. The series of defeats suffered by the Republican forces through the spring and summer of 1937 finally resulted in 'a group of youthful and underage volunteers' being repatriated. Paul Hogarth was one of those, returning not to the north of England but to London, where he resumed life as an art student, at St Martin's College. Instead of the heat and dust of Spain and the war's confusion, he found himself in the tranquillity of art school, with its canvases, life models and the comforting smell of oil paint. He hitchhiked around southern England to earn some money, taking casual employment as a farmhand, newspaper seller, and kitchen porter 'at various Lyons' Corner Houses in the City and West End'.[16]

Through it all, he remained a staunch member of the Communist Party of Great Britain.

Clive Branson was also in London in the latter part of 1937, but while Hogarth had resumed his art studies, Branson was no nearer returning to painting. Instead he continued to help volunteers heading for Spain, his activities increasingly attracting the attention of Special Branch, whose monitoring had become all too obvious. 'For about a week,' Noreen wrote later, 'we had plain-clothes detectives watching the house and following Clive.' Eventually, CPGB officials at King Street accepted that Branson should be allowed to take the Red Train south alongside the other volunteers. He 'was at last free to fulfil his dearest wish'.[17] Branson left for Spain at the beginning of January 1938, slipping away just as the police net closed in, Special Branch officers arriving for him a mere two days later, although the incident was sufficiently vivid for Rosa Branson to remember her father escaping out of the back window of the house at the very moment the police officers were hammering on the front door.[18]

Unlike some of those who had gone before him, Clive Branson was wise enough to equip himself with a stout pair of walking boots since he knew that the climb over the Pyrenees into Spain would be slow and painful; bitterly cold too, since he was making the trip in deep midwinter. By this time, the Republican forces were in retreat and optimism was in short supply – as were the means of waging war. After a 'slow and dreary train journey through the night' from Valencia, Clive arrived in the training camp in Albacete, the same camp where Paul Hogarth had been based eighteen months or so before.[19] The five weeks Branson was there proved a hand-to-mouth existence, just as grim as Comrade Robson had warned successive cadres of men over many months back in King Street. The men were given ragbag uniforms, making do with whatever fitted, but, more disturbingly, weapons were only noticeable by their absence. The International Brigader Fred Copeman – a veteran of the Invergordon Mutiny – later recalled that there were 'six weapons between seven hundred men'.[20] The camp was primitive, the men billeted in unprepossessing huts, sleeping in three-tier bunks, and the food was unappetising. Another Brigader, David 'Tony' Gilbert, remembered that the meat was so tough that it was assumed to be donkey.[21] Time seemed

to have ground to a halt, a feeling made worse by a diet of protracted political discussions.

Eventually, Branson was sent to the front 'to join a regiment which formed part of the British Battalion'. He was put in charge of twenty men, all of them poorly equipped and with rifles in very short supply.[22] Even Branson himself was without a rifle. An Italian offensive sliced through the front line and, in the chaos, Clive became cut off from his own side, with the deafening sound of heavy machine-gun fire and exploding bombs on all sides. He began to run, a desperate and aimless sprint through olive groves and craggy outcrops of rock, without map or compass. He was alone, with just two words of Spanish (*Brigada Internacional*), and utterly lost; he was duly reported as 'missing'. Over the next eight days, stubbornly trying to get back to headquarters, he ate just twice, once when he came across a deserted field kitchen and on the other occasion when some peasants took pity on him and gave him some eggs. The roads were full of refugees, invariably under heavy fire, so he decided to shun the temptation of the open road and make his way through the mountain passes. Hungry and exhausted, he finally got back to the Republican lines after eight days of desperate journeying.

It was now the end of March 1938, the nights still cold and the onslaught of the Nationalists unremitting. After four days of rest, Branson was back in the front line, caught up in what became known as the battle of Calaceite. 'Tony' Gilbert was also at Calaceite and was ambushed on what had seemed a clear road by Italian tanks and infantry hidden amongst the surrounding olive groves. Both he and Branson were obliged to surrender, 'due partly to treachery and partly to confusion', and taken prisoner, together with 100 members of the Attlee Company, 'cut off to a depth of seven miles'.[23] Years later, in a letter to Noreen, Clive would describe the moment: 'I was very frightened, because so helpless. We sat surrounded by barbed wire, on a dry river bed. And I watched two little clouds, like pearls, low and still, settle above the horizon.'[24] Branson's rifle was taken from him – the weapon he had only recently received – and he was marched through files of jeering Italians. He, like the other Britons, was reflecting on whether they would be shot out of hand. Instead they were taken to Saragossa and paraded in triumph in front of the world's press, a propaganda coup to demonstrate the Republic's weakness and Franco's

gathering, decisive power. It was the most 'supreme disappointment' of Clive Branson's life.

The meeting between pressmen and shabby prisoners was a stilted affair – the reporters uneasy at what was clearly a cynical publicity exercise, while for some of the latter, the priority was cadging cigarettes. One prisoner, Morien Morgan, was given nearly a full packet by the *Times*'s correspondent, presumably Kim Philby – but Clive managed to pass a message to Alexander Clifford, the Reuters correspondent. 'My name is Clive Branson. Will you please get a message to my wife?' In due course, the *Reuters Review* reported the meeting: 'Mr A.G. Clifford was able to render a service to the wife of a British volunteer, Mr Clive Branson, recently captured by General Franco's forces.'[25] The news duly appeared in the British press and Noreen, much relieved, was able to get some money sent to Spain for her husband to buy some 'creature comforts'. She wrote later that she first read a headline in the *News Chronicle* that said 'Guns not guts give Franco his victory, say prisoners'. Typically, Branson used the money from England to buy large supplies of cigarettes, which the non-smoking artist donated to his fellow prisoners. Following Clive's appearance in the papers, his imprisonment was noted by one of his contemporaries at the Slade: on 6 April, William Coldstream wrote to a friend confirming that it was indeed 'our … Branson whom Franco captured! I wonder if he is still wearing his school blazer with the brass buttons.'[26]

Branson was held at the forbidding monastery of San Pedro de Cardeña for three long months. Some 9 miles from Burgos, it was 'a decaying palace', gloomy and primitive, its grim exterior enough to banish any semblance of hope as the prisoners were herded through the towering wooden gates.[27] On the monastery's exterior walls was an engraved relief of a Spanish crusader's lance splitting a Moor's neck, an irony that did not go unnoticed by at least one prisoner, bitterly conscious of the numbers of Moorish troops on the Fascist side. San Pedro 'was a terrible place' with 'no furniture, no chairs, no beds, just bare boards'.[28] With over 600 prisoners from twenty different countries, the prison was very overcrowded. They were all incarcerated in one long dungeon of a room, its walls impenetrably thick, with a stained floor of cold stone. Rats lurked in the shadows and the air was rank and thin. There was only one

tap; the windows were unglazed slits; there was no soap and the toilet was a gaping, evil-smelling hole in the floor. The prisoners' boots and clothes were seized and replaced with smocks, trousers and alpargatas, and the men slept huddled together, without blankets. Later they were separated out into several floors in one wing of the sprawling building. Blankets were eventually provided, but were alive with lice. Sleep did not come easily – the lice were too voracious and fleas added to the misery ('we were alive with them'). Once Branson lay awake listening to a nightingale singing, a sound that left him aghast at his own loss of freedom. Most nights he spent scratching his crawling skin and contemplating the stars. Dysentery was rife as well as malaria, scurvy and enteric fever. Food was 'dreadful': breakfast was 'basically tepid water with a few stale breadcrumbs floating on it, and with a touch of garlic added to give it some flavour'.[29] The bread they were given had to last for the rest of the day. The poor diet resulted in the majority of prisoners developing body ulcers.

The English prisoners were better treated than most, although the Spanish guards could be brutish and callous. Moreover, while the oversight of the prison was Spanish, the authorities 'received plenty of "advice" from the Gestapo', whose personnel were frequently to be seen in the camp and who would regularly take individual prisoners away to be 'interviewed' – an interrogation from which, according to Branson's fellow prisoner Walter Gregory, 'none of the interviewees ever reappeared'.[30] The presence of the Gestapo was clearly a factor in the German inmates being treated more brutally than other nationalities. Their fingerprints were taken, presumably with a view to their eventual return to the Reich, sinister additions to the Gestapo's files of subversive anti-fascists and their blacklisted potential victims. Clive Branson would long remember the melancholy sound of a German comrade singing in San Pedro, his voice heavy with longing for some provincial German city.

Clive was questioned too, his interrogator asking him to explain why he had come to Spain and clearly expecting yet another prisoner's assertion about his political views, the predictable standby: 'Because I am a Communist.' Clive contemplated lying, since he knew that Reds were routinely shot and thinking that he might thereby 'cheat the bullet'. What made it worse somehow was that the man conducting the interrogation

wasn't Spanish, but another foreign volunteer just like him, albeit with an entirely different view of the world.

In a situation where malnutrition, disease, bitter cold and loss of freedom were inescapable, someone with a steely presence and boundless optimism was very valuable. Branson was one such: he was 'tremendously inspiring', according to one prisoner, 'legendary for his ability to keep people's spirits up despite the degrading conditions'.[31] For example, there was the time when he changed the mood during a particularly wretched day at San Pedro when all the prisoners were at the lowest of ebbs, cold, hungry and desperate: Branson changed things in an instant. 'Right,' he said, out of the blue, 'let's have a feast!' and he proceeded to draw on the prison wall in charcoal, quickly sketching what each man nominated as his favourite food. 'He even drew a plate of ham and eggs for one hungry comrade.'[32] He was invariably cheerful, proactive in terms of what might be done, and consistently helping others to make the best of the situation.

Time passed slowly; the guards patrolled and shouted; the prisoners counted the days, plotted escape, made chess pieces, wrote and dreamed of home; peeled potatoes; stood close to the barbed wire and forlornly watched the slow drift of cloud or river, both of which were moving while the POWs remained static. Every time a single aircraft droned overhead on its passage across the Spanish landscape, travelling to some other place from a distant airfield, it was a sharp reminder of their unchanging incarceration. Clive's salvation was poetry. He wrote about his fellow-prisoners: 'these men are giants chained down from the skies, to congregate an old and empty hell.' He wrote of how a passing storm cleared the air; the howling of dogs at night; the brutal intensity of the sun; the glint of bayonets and how 'clouds pass and fine weather and with them the liberty we long for'.[33]

It was summer before Branson was moved on from San Pedro, to a *campo de concentracion* in Palencia, 55 miles south-west of Burgos. It was Italian-run and less savage than San Pedro, and prisoners were now able to receive and send letters. Branson wrote home, describing the weather ('A very strong wind has been blowing for the last few days and the nights are bitter cold'); his health ('I am keeping pretty fit', although 'owing to glare and the strain from drawing', his eyes were troubling him); and above everything, how much he ached to be home ('But oh to be in England').

After the British ambassador intervened on his behalf, Clive was able to send some paintings back. He sent portraits he had drawn of fellow inmates – fifty-four of them – which were subsequently distributed to the prisoners' families. The regime might have been less inhumane in the new camp, but there were still unpleasant incidents, for example, when Branson was ordered to copy a large signature of Mussolini under a belligerent right-wing slogan daubed on a wall. His response pulled no punches, his anti-fascism steadfastly intact:

> For years I've trained, burnt out my sight, not spared
> My health, my strength, my life's too tender flame.
> I strove to heights no former vision dared –
> To scrawl in black this Fascist's bloody name.

Behind the prison wire, the interned are invariably wary of those confining them. Imagine Branson's reaction then when the Italian officer in charge, having ordered a regimented line-up of all the camp's inmates, demanded that 'the artist' step forward. It was framed as a polite request, but Clive was distinctly uneasy nonetheless, as he stood alone, one pace ahead of the rest. What relief it was to be given, not solitary confinement or a beating, but an art commission, the Italian asking if he would be kind enough to paint a set of pictures of the camp. Having agreed, he was taken to Burgos, under armed escort, to buy materials – canvases, paper, pencils and paint, predominantly yellows and blues (covering the essentials of sun and sky at least). Branson went on to produce four large pictures for the Camp Commander, which, in due course, found their way to Italy. Clive added a few lines of gentle, admonitory verse:

> These drawings needed a little freedom,
> The eye and hand of man enjoying life.
> Great art demands fulfilment of a dream
> Of human peace and friendship, no more strife.

The strife was set to continue for some while yet, the Republic increasingly forlorn in its struggle, but a prisoner exchange involving Italian and British prisoners that autumn secured Branson's freedom. By the end of October

1938, he was back in England, Noreen meeting him on the evening of the 25th in the smoky confusion of Victoria Station. To her surprise, her husband looked fit and well, suntanned and showing the benefits of the better conditions at the Italian camp where the chance to swim in the river and the better food had made for a marked improvement over the squalid hellhole of San Pedro. Branson's six months or so of captivity had not diminished his political commitment, nor his support for the Spanish Republic, which continued until the bitter end.[34] Its eventual defeat was a devastating blow and left him suffering from insomnia, while an intense anger at the British Government's neutrality haunted him for years. Not everything, however, was a cause for despair – he had begun painting again, as if to make up for so much lost time.

* * *

Felicia Browne had been the first left-wing artist to be killed in Spain, but she would not be the last; others who were similarly on MI5's watch list also died, of whom perhaps the most notable was the poet John Cornford. He was an activist as well as a poet who 'seemed almost like a different generation' from the 'Auden-Spender-Day Lewis set', writers who were 'amateurs, gifted fellow travellers but not quite serious'.[35] He was 'already aware that Auden and Spender knew even less' than he did about 'the reality of exploitation and struggle'. These two, according to Cornford, may have turned against their class but 'they [were] still writing for it'.[36]

John Cornford had come to the attention of Special Branch as far back as March 1933, the result of information gained surreptitiously – a card index secretly accessed at *Labour Monthly*, for example, and steamed-open correspondence between Cornford and Esmond Romilly, a nephew of Winston Churchill, and a known communist.[37] Seven months later, Cambridge Police drew up a report on Cornford for the Borough's Chief Constable, which was duly forwarded to Sir Vernon Kell at MI5. The police had been summoned to Cambridge railway station to check out a man reported as being 'in possession of a quantity of cash, and in a most unclean state'. The man was 19, the reporting detective sergeant noted, about 5 feet 10 inches in height, clean shaven and with a 'fresh complexion, auburn hair waived [*sic*]'. He looked like a tramp, unwashed,

in dirty clothes and wearing farm labourers' boots. On being questioned, it emerged that the young man was 'Jack' Cornford, the son of Professor Francis Cornford, Fellow of Trinity College, whose substantial house – Conduit Head – was in a private cul-de-sac off the city's Madingley Road. Francis Cornford was also subject to surveillance: one of the letters in John's MI5 file notes his father's Personal File number. When the police turned up at the Cornford house, his mother confirmed that her son 'associates with known members of the Communist movement'. She was not surprised by the events at the railway station since 'she had expected something of the sort to happen', given John's preference for scruffy clothes.[38]

John Cornford went up to Trinity College Cambridge in the autumn of 1933 on a History scholarship and soon became a prominent member of the university's Communist branch. In October 1934, he met fellow Cambridge student Margot Heinemann on a picket line at a bus garage to which she had cycled. They went for a coffee together. She was struck by his strength, his full head of black hair, his grey polo neck sweater and his 'slightly scruffy' looks. They became lovers. Heinemann – Cornford's 'glorious girlfriend', as one International Brigader remembered – came from a comfortably off family of German Jews and, before Cambridge, had gone to Roedean School. Her mother was a 'drawing-room socialist' and a convinced pacifist, but Margot had turned to communism, prompted by her hatred of fascism and her wish to devote herself 'to creating a society without poverty and exploitation'.[39]

Cornford continued to be kept under a watchful eye, Special Branch reporting, for example, that he was a speaker at a peace meeting at World's End, Chelsea in September 1935 where he was heard arguing the case that the Suez Canal should immediately be closed. The following year he was arrested for causing an obstruction while distributing trade union leaflets outside the Lucas factory in Birmingham and, on 9 April, he was found guilty and sentenced to either a ten shilling fine or seven days in prison. A note attached to Cornford's file reveals that this report was 'lent to us (MI5) for a short period in 1967 by the Mid-Anglia Police in order that we might supplement our information on pre-war communism at Cambridge'. Three decades after Cornford's death, the Intelligence Services felt compelled to dig ever deeper.

The poet Louis MacNeice had given Cornford a lift from Cambridge to Birmingham for the trial. A close friend of the art historian (and spy) Anthony Blunt, MacNeice was greatly impressed by Cornford, finding him 'clever, communist and bristling with statistics' – he was 'the first inspiring Communist' MacNeice had met.[40] The previous day, MacNeice and Blunt had been planning their trip to Spain together in the forthcoming Easter vacation. When it came to the actual visit, what struck the two men about Spain was the 'Hammer and Sickle scrawled over' the country. It seemed to Blunt that if Spain went communist, it was inevitable that France and Britain would follow, heralding a brave new world. His imagining of a series of dominoes tumbling as Europe readily embraced communism was thwarted by the fascist rebellion in Spain and within months the country was at war with itself. John Cornford lost little time in setting off for the fighting, although he was not 'off to Spain to kill a Fascist or three', as some said. Rather his visit was a 'casual and impromptu' one, Cornford simply wanting to find out what was happening in the country. He was given a press card by the *News Chronicle* but soon after he crossed the Spanish border he realised that 'a journalist without a word of Spanish was just useless'.[41] He travelled to Barcelona, which, like others before him, he found inspiring and where, 'almost on an impulse', he joined the POUM (*Partido Obrero de Unificacion Marxista*).[42]

As for Margot Heinemann, she was taken aback when she heard that he had joined the militia; after all, the couple had planned a holiday in the south of France and she found herself there, uncertainly 'waiting for him to come back'.[43] At that stage, Cornford was not anticipating that the war would drag on, but it was soon clear that it would be anything but a short-lived skirmish, a realisation that left him feeling 'very depressed and isolated'. He 'had fully expected war to be nasty, (but) the reality was even worse'.[44] By August 1936, he was realistic enough to write a letter to Margot including his 'last will and testament'. He told her how much he loved her and that she had been 'the most perfect experience' of his life. His only other love, he wrote, was the Party.[45]

By this time, Cornford was longing to return home, but was uncomfortably aware that if he attempted to leave, he might well be arrested as a deserter. That worry was removed by succumbing to a bout

of dysentery, leaving him looking 'thin, yellow in the face … very tense and excited, talking a great deal'. He was invalided out of Spain, his return to England approved by Tom Wintringham, who asked him to take an 'uncensored report' to Harry Pollitt in London emphasising the 'most urgent' needs of the English contingent in Spain.[46] Margot was by then teaching in a school in Bournville and living in the Edgbaston area of Birmingham, and it wasn't long before Cornford travelled north to see her. They met in her school lunch break and later, in a letter to her parents, she reported that he was 'looking a bit peaky but otherwise pretty well'. He had already resolved to return to Spain, this time with a group of friends whom he planned to recruit and whose travel costs Harry Pollitt had promised the Party would meet. The new recruits were particularly useful since they 'had learned to handle machine guns in their school cadet corps', though ironically, Cornford himself had only learned to shoot by hunting rabbits. He and his group of International Brigade volunteers duly departed for Spain on 5 October.[47]

Back in Spain, and now with the 5th Regiment Popular, he wrote to Margot from an address in Calle Salamanca, Albacete. His letters now were invariably written in pencil on scraps of paper torn from exercise books; they were often grubby, sometimes folded into four quarters and, on one occasion, stained with what looked like trench mud, or perhaps dried blood. He told her that he was with 'a really tough crowd' in grim conditions, with 'three shithouses for 700 men'. He went to a bullfight, but thought it 'dull, bloody and unaesthetic'. Cornford was sure that the struggle would continue for a long time and he was philosophical about his prospects: 'There's only one thing really bad can happen, that is to be killed, and that's not too bad.' The worst thing, he wrote, 'is the cold. It freezes every night, and we sleep in the open sometimes without blankets.'[48] He warned Margot that she should not 'believe any reports of my death unless they come officially from brigade headquarters'.[49] By the last week of December 1936, he was fighting on the Cordoba front – they had left Albacete on Christmas Eve and by 27 December (Cornford's 21st birthday), were caught up in an attempt to capture the Nationalist-held town of Lopera. There is no certainty about how John Cornford met his death on that day.[50] Was he shot in error by Republican sentries, or did he die trying to recover the body of the writer Ralph

Fox, or was he shot by a rebel sniper?[51] One of John's comrades, Bernard Knox, remarked that 'John had been so gloriously alive, so smiling, so confident', he had thought him immortal. Other contemporaries thought him a 'Real Communist' and 'a serious person, a rigid disciplinarian'. He and Margot had been 'very close and intending to marry'. Sadly, none of her letters appear to have reached Cornford, while most of his only arrived after he had been killed.

After John's death, Margot Heinemann left Birmingham and moved to London, where she worked with Noreen Branson at the Labour Research Department. They became good friends and neighbours. She believed there was a close connection between John Cornford and Clive Branson: 'The main point I make about both [of them] is the importance of Marxism and of action to making their poetry.' She herself was important in that regard too: John Cornford's poem 'To Margot Heinemann' acquired greater poignancy after his death – and a wide readership too: 'Very few Party homes, right up to the 60s, would not have had this poem somewhere in the house.'[52]

> Heart of the heartless world,
> Dear heart, the thought of you
> Is the pain at my side,
> The shadow that chills my view.[53]

* * *

On 4 February 1937 – some five weeks after Cornford had been killed – the Birmingham Chief Constable wrote to Sir Vernon Kell at MI5: 'I draw your attention to the *Daily Mail* of 3rd February, 1937, and also to the *Daily Worker* of the same date, recording that Cornford was killed on the Cordova front on the 28th December last.'[54] The correspondence has the feel of a chapter being emphatically closed. From that point, Cornford's Personal File turns its attention to John's younger brother, Christopher, a letter from Kell to the Chief Constable of Cambridge dated 7 May 1940, referring to the 19-year-old as 'an extremely active Communist', thereby consigning Christopher Cornford to the full weight of MI5's long-term interest.

The Artist Who Sometimes Wears Sandals

On 28 March 1937, the artist Julian Trevelyan was driving through Hammersmith in west London, a loudhailer clamped to the car's roof broadcasting pleas to contribute to 'Aid for Spain'. There were also boards tied to the vehicle's sides proclaiming 'Hammersmith Ambulance for Spain. Final rally at 8 p.m. Help us to get that £500.'[1] A local policeman on the beat was alert enough to note down the car's registration, DPC 667, and the result was a police caution for Trevelyan and yet more detail added to his MI5 file. That logged his address: Durham Wharf, Hammersmith, London W6; his age ('27, looks about 35'); and his idiosyncrasies ('sometimes wears sandals'). It recorded his 'Party name' – Pascoe – and that Esmond Romilly had made contact with 'Pascoe'.[2] His background and behaviour – his looks even – clearly marked him out, it would seem, as a subversive in MI5's eyes, a view further evidenced by the fact that he was fostering an orphan from Spain. Moreover, the artist described himself as a 'Surrealist' and had appeared with three other artists – Roland Penrose, James Cant and F.E. McWilliam – at a May Day rally in 1938, all of them 'dressed up as four Chamberlains, complete with top hats and umbrellas' and proclaiming that 'Chamberlain Must Go!'[3] McWilliam occasionally 'bestowed Nazi salutes on the watching crowd' and the masquerade also included 'a giant gilt birdcage, inhabited by a bleached skeleton'.[4]

Julian Trevelyan's experience of the Intelligence Services' sustained scrutiny mirrored that of many other artists and writers. For example, Special Branch officers were present when Ralph Bates spoke at the Maxim Gorki Memorial event in London's Conway Hall on 27 June 1936, where it was noted, with some unsavoury disdain it would seem, that 'the audience appeared to be made up of Jewish and intellectual type of Communists'.[5] The portfolio of Bates's suspicious activities held by MI5 grew steadily: there was a selection of his photographs on display at

a Spanish exhibition in London's Ludgate Hill; a flight in April 1937 from Croydon Airport to Paris – noteworthy since he was en route to Spain; his reputation as 'an extremist speaker'; and his apparent involvement in ensuring that a donation of $15,000 from a wealthy American was received by Harry Pollitt.

Suspicion was contagious. The writer J.B. Priestley had, in the immediate aftermath of the Spanish Civil War, tried to raise funds for the Anglo–Iberian Society in order to provide 'social and cultural amenities for exiled and refugee Spaniards'. That file note was typical of the memoranda faithfully placed by MI5 clerks in a manila folder containing Priestley's activities; these dated back to 1933 and some correspondence with Nancy Cunard. Special Branch records were invariably at pains to log the connections between those it deemed worthy of note. A list of those acting as patrons of the Anglo–Iberian Society, for example, included a number whose capitalised names revealed that they too were judged worthy of their own, separate file: Victor Gollancz, Philip Guedalla, Julian Huxley, Augustus John and Harold Nicholson MP.[6] Supporters of the Spanish Republic were inevitably fair game. For example, Stephen Spender's many public statements about Spain invariably provoked official interest: '26.10.36 – Speaker at a meeting held at the Conway Hall W.C. by the People's Front Propaganda Committee [a pro-Communist organisation that endeavoured to obtain support for the Republican Forces]'. The artist and journalist Hugh Slater, a contemporary of Clive Branson's at the Slade and someone else with Spanish connections, was subject to regular observation by anonymous 'informants' who kept MI5 briefed on his activities and whereabouts: 'Slater is understood to have said that he was also being sent to Gibraltar on an important mission for the Communist cause' – this on 10 March 1937. Slater's reputation amongst the Intelligence Services was unashamedly negative. He was 'educated and plausible' and 'not of the usual communist type'; but, in fact, another 'subversive'. At one point, a misprint had his name recorded on file as 'Hugh Hater': was that the result of a moment of carelessness from a harassed typist, or an anarchic piece of sardonic wit from a disaffected agent?

At all events, MI5's Major Vivian firmly believed that 'an international criminal conspiracy' of this level of magnitude needed fighting tooth and

nail; it was seen as a conspiracy of informal links and relationships, but also involving a string of committees and associations judged to be fronts for Soviet propaganda, or pro-communist thinking. Friends of the Soviet Union; the Society for Cultural Relations with Soviet Russia – the list was extensive and MI5 was never less than suspicious of such organisations. The innocuously titled 'United Front', for example, it saw as 'a tactical manoeuvre devised for the purpose of bringing liberal-minded persons and "advanced thinkers" into touch with communists, and ultimately under their leadership'.

* * *

After Clive Branson returned from Spain, he took up painting again, often working on landscapes of a rural, peaceful England. His daughter, Rosa, remembers a tranquil time characterised by 'daddy painting and mummy playing the piano'. Nonetheless, the peace was a fragile one and Branson's life was not confined to tranquil domesticity. For example, after speaking at a communist gathering on Clapham Common on a pre-war Sunday afternoon, he found himself 'charged with using insulting words at a public meeting'. It made the newspapers when this 'painter's mate of 310a Battersea Park Road' – 'painter's mate' indeed! – spoke to the crowd about the government's inadequate air raid precautions. He claimed that 'the people in the City' and, in particular, the responsible government minister, Sir John Anderson, were to blame, while the victims were ordinary people. Someone in the crowd objected and the police promptly arrested Branson 'to prevent a breach of the peace', despite the testimony of witnesses who backed the artist: the man who had objected was a 'crank', one said, while another argued that the crowd only became angry when the police moved to arrest the defendant. Unsurprisingly perhaps, Branson was found guilty and fined £5, plus costs, the alternative being fourteen days in jail. That same year, ironically, on 21 August 1939, Noreen was appointed an Air Raid Warden in the London Borough of Battersea, while Clive continued to paint, depicting 'his surroundings in Battersea in a style that had much in common with that of the worker artists of the period'.[7]

With the prospect of a world war growing more likely, Paul Hogarth was working at an agitprop studio in the East End. His political beliefs, like Branson's, were in no way diminished by his experiences in the Spanish war and he was at the same May Day demonstration at which Julian Trevelyan and others played the part of surreal Chamberlains. He lived in a small attic in Guilford Street, the same street in Holborn where Felicia Browne had lived – and been closely watched – a few years previously. 'It was a run-down neighbourhood of lodging-houses and cheap hotels.' He ate at the Working Men's Dining Rooms nearby – 'thick pea soup for a penny, egg and chips for sixpence, and a pint mug of strong tea for two pence' – and, as Hitler's shadow became more menacing, he earned money – £3 a week – by digging trenches in Russell Square, buying paper, pencils and paint with the proceeds. Then, in January 1939, he left for the south of France – near Aix-en-Provence – where, 'heavily under the influence of Cezanne', he tried to capture the essence of the Provençal landscape.[8] He was still there when news came through of the German invasion of Poland.

Blacklist

MI5, once stirred into action, rarely let go of a suspect, even though the target might long since have drifted away from the Red Flag: 'Once a case is opened, it can never be abandoned. The file must be completed' – an observation about the Russian NKVD, but true of other secret agencies too.[1] That applied even when the Party had become disenchanted with someone. Stephen Spender's standing within the Party never recovered from his determined campaign to get Tony Hyndman repatriated during the Spanish Civil War: he was thought to be someone who 'would put a personal (and sexual) interest in a deserter above duty to the Party'.[2] Moreover, he had resigned from the Party very soon after joining, an about-turn that smacked of the quixotic in many people's eyes: Storm Jameson, for example, was less than impressed, quoting in the first volume of her autobiography the example of the 'unknown writer' who had been 'talking about the benefits to a writer of joining the Communist Party. (He joined it himself – for a few days.)'[3] W.H. Auden was another whose influence in Party circles had declined during the second half of the thirties and Special Branch had taken note of a piece that appeared in *Left Review* in the autumn of 1937 indicating a change in the magazine's editorial policy whereby 'in future less space will be afforded to Stephen Spender, W.H. Auden and others in which they can discuss abstract theories'. It seems that the Party now sought 'a more practical approach … to questions affecting the working class'. For some people, this confirmed that intellectuals were becoming persona non grata in the Party.

As for Auden, by the end of the decade, he had changed his views of socialism and was infinitely more cautious about his stance: 'Never, <u>never</u> again will I speak out at a political meeting,' he declared and, while he believed socialism to be 'right', he thought 'the theory and practice of revolution to be wrong'. For a man who was arguably the 'nominal leader

of the writers and poets whose politics and consciences' had taken them to Spain, this was a startling admission.[4] MI5, though, still unrepentantly characterised him as 'an intellectual communist'. As a result, his file remained 'live', although much of it concerned Auden's wife, Erica Mann, whom he had married in New York to allow her to acquire British citizenship. She was the daughter of the writer Thomas Mann and had been obliged to leave Germany. It was very much a marriage of convenience: Auden wrote to Spender intimating that he hadn't seen 'her till the ceremony and perhaps I shall never see her again'.

Auden left England for the United States in January 1939, together with Christopher Isherwood, a departure that, for Storm Jameson amongst others, was 'a tremendous blow', an unduly urgent escape, it seemed, as a war grew closer.[5] He did some teaching (in Southborough, Mass.) before heading for New Orleans by Greyhound bus. He travelled on through New Mexico, arriving in California early in August 1939. The political situation back in Europe left him 'Uncertain and afraid/ As the clever hopes expire/ Of a low dishonest decade', while the view of Auden and Isherwood's exile back in Britain was negative in many quarters. Cyril Connolly described the pair 'as ambitious young men with a strong instinct of self-preservation and an eye on the main chance'; Evelyn Waugh satirised them in his novel *Put Out More Flags*; and a question was asked about the pair in the House of Commons. Auden, meanwhile, defended his position, writing to Spender in November 1940 that if he believed he could be competent as a soldier or air warden he would not hesitate to come back to England. In fact, he remained in the States until the spring of 1945, when he returned to Europe as a temporary major in the US Army, working on an investigation of the effects of bombing on the German population. His comments about post-war Britain – its lack of central heating and the ghastly food ('No, I won't stay and eat: I simply can't stand British food') – did not go down well.[6] MI5's interest by then was low-key – but only until he was caught up in the scandal arising from Guy Burgess's defection to the USSR in the early summer of 1951.

* * *

Even in 1936, when the forces of communism and fascism had come head to head on the battlefields of Spain, official attitudes to communism in

the UK were sometimes ambivalent. For some, a communist past was something that could never be set aside or forgiven: George Orwell, while researching *The Road to Wigan Pier*, met a seaman called George Garrett who, after serving in the navy, and being torpedoed, had only been able to work for nine months over the preceding six-year period. It was disturbing, Orwell thought, that Garrett was unable to find work since he was blacklisted wherever he went as a communist. 'Who could trust a working-class Red?' seemed to be the line. On the other hand, clever graduates of Britain's elite universities were regarded as ideal potential recruits for the Intelligence Services. That led to an attitude of negligent bravado amongst those upper crust spooks making decisions about who should join them. A potential recruit for MI6, in 1936, was told that communism was 'a form of undergraduate measles and not to be taken seriously'.[7] Then, a month before the war broke out in 1939, the Soviet Union had agreed a pact with Nazi Germany, an agreement that left the British Government stunned, its foreign policy certainties shattered. As a result, it was evident that subversives on both left and right could in no way be ignored and so the surveillance of Britain's home-grown communists would have to be sustained and the phalanx of suspect artists and writers needed to be kept under close scrutiny, their lives restricted.

The outbreak of war had a deleterious effect on the arts and meant that left-leaning writers and artists faced a conundrum – what to do in a country engaged in all-out war? Opportunities had suddenly collapsed: the AIA surveyed its membership soon after the declaration and discovered that that 'some 73% of artists had either lost their jobs or had their commissions revoked'.[8] As well as a sudden decline in commissions, there was growing evidence that writers and artists were facing a series of barriers to making any meaningful contribution towards the war effort. While as early as 6 October 1939, a month after hostilities started, Orwell's wife, Eileen, had successfully found work with the War Office's Censorship Department, the writer himself was not so lucky. There was no work for him at all, it seemed: 'I have so far failed to [find any],' Orwell wrote in a letter to Leonard Moore, taking some consolation from the fact that at least it gave him time to finish a book and sort the garden out – 'we shall be glad of all the spuds we can lay our hands on

next year.'[9] Orwell had been in London when war broke out, but had returned home – the Post Office Stores in Wallington – within a matter of days, although Eileen had remained in the capital. He had been away for a week and a half and the garden's weeds were 'terrible'. Along with many other people, Orwell's future was now deeply uncertain. His first thought, however, was the garden: 'the early potatoes harvested and the windfall apples made into apple jelly';[10] that done, he wrote to the powers that be seeking to make a contribution to the war effort. Just a few years after fighting in Spain, Orwell was clearly unfit for military service, his lungs too damaged, despite being only 36. But surely there must be some contribution he could make?

It wasn't just a question of Orwell being ostracised, denied the chance to serve, but there was also evidence of harassment. For example, in August 1939, Orwell had been disturbed when all his 'books from the Obelisk Press ... [were] seized by the police, with a warning from [the] Public Prosecutor that I am to be prosecuted if importing such things again'. It was evident that his letter to the publisher had been opened and left him wondering 'whether [it was] because of the address or because my own mail is now scrutinised'. A few months later, two detectives came to Orwell's house 'with orders from the public prosecutor to seize all books which I had received through the post'.

What followed were two years that he would come to regard as the grimmest of his life. Sustained writing proved impossible and other work was in short supply, and dispiriting. 'Everything is disintegrating. It makes me sick to be writing book reviews at such a time.'[11] He was struggling financially and locked in combat with the tax authorities. Orwell's first visit to Lord's cricket ground for nineteen years, on 12 June 1940, saw him sign up for the Home Guard (or the Local Defence Volunteers as it then was). He rapidly reached the rank of sergeant, although 'there was considerable official suspicion of Left-wing Spanish veterans'.[12] Through that period, writing for *Horizon* magazine – 'the literary sensation of the Phoney War' – proved useful and brought him closer to its 'co-ordinator', Stephen Spender. Four days before, on 8 June, he noted in his diary that Spender had recently asked him if he felt that over the past decade he had been better than the Cabinet at foretelling events.

* * *

Even before the outbreak of war, Spender's way of life had been restricted as a result of his short-lived flirtation with communism. A government-imposed 'British Empire endorsement' meant that he was no longer able to travel abroad. Then once hostilities began, he was uncertain about what he should do in the war; frustrated by the absence of opportunity; and feeling as though he could no longer write. 'Words seem to break in my mind like sticks when I put them down on paper.'[13] Months passed and, as the progress of the war deteriorated, he felt increasingly aimless. No call-up came and, in common with George Orwell, with whom he had become friends, he wondered why the two of them had been ignored. Were they too old perhaps? Or was their health a cause for concern? Or was it their politics that was responsible? Spender had applied for a job as a translator at the War Office as early as 12 September 1939, encouraged by the fact that a printed slip from the Ministry of Information the previous day had informed him that 'he was on a list of writers who may be used later'. But nothing came of it, despite his fluent German; on the contrary, he was soon rejected for any kind of active service, having failed an army medical – colitis, poor eyesight, varicose veins and a persistent tapeworm all too much for the medical officers to grade him as anything better than 'C'.

Time passed: Spender got divorced and remarried; taught briefly at Blundell's School in Tiverton, Devon; and eventually, after having his medical status upgraded to 'B', he began work with the National Fire Service. In September 1941, he was allocated to the Cricklewood substation as a 'lowly fireman, first class', earning £2 a week, where he found himself 'cleaning up lavatories, spittle off duckboards'. It was humiliating, less for himself than for his art since he soon came to recognise an uncomfortable truth – 'that this was the only use they could put poetry to'.[14] Unsurprisingly, preoccupied as he was with combating the Luftwaffe's attempts to set London ablaze, he came to regard 'the arts in England during the war' as 'a little island of civilisation surrounded by burning churches'. Spender stayed with the Fire Service until June 1944. From time to time he was invited to lecture: to the Freie Deutsche Kulturbund – the Free German League of Culture – in March 1941, for example, when his words were carefully noted by a watching agent. Spender was still a man whose file could not be closed. He argued that

'a lot of good stuff had been written' during the period of the Spanish Civil War, but nothing at all in the present conflict, since writers were 'suppressed if they tried to tell the truth'.[15]

* * *

In the spring of 1940, George Orwell, like many others, anticipated that the German invasion was imminent and the prospect left him deeply pessimistic about his own fate and that of others whose political views were judged dangerous. Being 'Red' had long been inextricably linked with 'illegal'; after all, he wrote, 'it was always the seller of, say, the *Daily Worker*, never the seller of, say the *Daily Telegraph*, who was moved on and generally harassed'.[16] He noted in his diary that 'all the "left" intellectuals I meet believe that Hitler if he gets here will take the trouble to shoot people like ourselves and will have very extensive lists of undesirables'. There was talk too that a campaign was under way to have the surveillance records held by Scotland Yard destroyed. 'Some hope,' Orwell observed. 'The police are the very people who would go over to Hitler once they were certain he had won.'[17]

Orwell was also greatly exercised by the signs that others were being equally shunned. J.B. Priestley was 'shoved off the air, evidently at the insistence of the Conservative Party', in October 1940. Priestley's 'left-wing tendencies' became too much as the progress of the war deteriorated. Priestley had come to official attention as a result of his objections to the 'Sedition Bill', legislation put in place in 1934 as a result of the Invergordon Mutiny. He took the view that the Act when it became law would place unacceptable restrictions on people's liberty. 'If', he wrote, 'we allow this ugly tangle of searching and spying and denouncing to be forced upon us, we slip backwards hundreds of years.'[18] Britain would become 'smaller and less important'. Just before the outbreak of war, Priestley was vetted by MI5 at the request of the Ministry of Information who were, it seems, reassured that he had 'left-wing tendencies but might be used with caution'.[19] As a result, he was able to broadcast on the radio for the BBC in a series of pieces entitled *Postscript*. These talks proved immensely popular in the aftermath of Dunkirk (in June 1940), to the extent that Graham Greene, for example, remarked that Priestley was

second only to Winston Churchill as a leader in the country. It was not to last, however; members of the Cabinet objected and Priestley was obliged to cease broadcasting. 'This is my last Sunday *Postscript*,' he announced on 20 October 1940. 'The decision was mine and was in no way forced upon me by the BBC. My relations with the BBC are excellent.' Many listeners suspected otherwise.[20]

* * *

Eventually, in late August 1941, George Orwell found work with the BBC, something that predictably sparked exchanges of memoranda amongst security officials, and redoubled surveillance. For example, when Orwell sought to give a contract to the Indian writer Mulk Raj Anand, 'a very delicate source' reported the fact, prompting consternation within both Special Branch and the India Office. The former produced a report that noted Orwell's 'advanced communist views' and described him as having been 'a bit of an anarchist in his day'. MI5's Wendy Ogilvie dismissed that judgement in a tart internal memo, declaring that Orwell had 'undoubtedly strong Left-wing views but he is a long way from orthodox communism'.[21] A reading of his diary would have confirmed Miss Ogilvie's judgement: Orwell was sufficiently 'unorthodox' to label Stalin as a 'disgusting monster'.

MI5's caseload of artists and writers under surveillance continued throughout the war years, despite the greatly increased pressures arising from the conflict. Many were 'blacklisted' and judged to be unsuitable for war work, sometimes on the flimsiest grounds, or worse, quite wrongly. When Storm Jameson was being vetted for government work, for example, she was summarily dismissed as 'Communist and Pacifist. Unsuitable,' despite the fact that, while her pacifism was undeniable, her communism was a figment of official imagination.[22] In fact, she believed it to be 'the most rigid dogma the world has ever seen', evidenced arguably by 'the ugliness of the Party's tactics in Spain'. She had 'no delusions about the doctrine of Communism as practised in Russia'.[23] Indeed, Jameson was among those who felt that Priestley's opinions were 'too left wing' when it came to 'what people deserved after the conflict'.[24] Nevertheless, while MI5 had 'nothing definite against Miss Jameson', they believed

that 'it would have been more fitting if another writer of eminence had been selected'. There was a clear official policy to push those regarded as suspect politically to the sidelines. The poet C. Day Lewis, for example, was judged harmless enough so long as he remained merely an officer in the Home Guard, 'but this would change as he pushed to find more definite work in the MOI in 1941.'[25] Other communists or fellow travellers were similarly treated. The theatre director Joan Littlewood, for example, was blocked from working with the Entertainments National Service Association (ENSA).

The artist/farmer Wogan Philipps, who had drawn official attention to himself by driving an ambulance in Spain, and who had returned from the country 'a true blue, hundred per cent communist' according to his then wife, the novelist Rosamond Lehmann, even ran into difficulties when he tried to sign up for the Local Defence Volunteers (what became the Home Guard).[26] Philipps's politics were a problem for the Intelligence Services and his neighbours in the rural community in which he lived. In July 1940, the police in Henley, Oxfordshire, had written to the 'Chief Security Officer, Oxford' reporting that Philipps had refused to stand up for the singing of the National Anthem in the White House inn in the Oxfordshire village of North Stoke. Instead, Philipps and his friends had responded to the show of patriotism by giving a loud rendition of *The Red Flag*. A local JP, John Wentworth Culme-Seymour, was sufficiently disturbed to write to MI5 with his concerns. Philipps had long been regarded with suspicion – disdain even – by some of his more Tory neighbours. How could a man with an Eton and Magdalen background – the son of Lord Milford – be a damned commie? One estate manager thought him 'useless'; another described him as being of 'very untidy appearance usually wearing brown tweed jacket, brown corduroy trousers and gumboots'.[27] Wogan's marriage to Rosamond Lehmann had ended – her subsequent relationships included Day Lewis and Goronwy Rees, both of whom figure in MI5 files, Rees because of his connections with Anthony Blunt and Guy Burgess. As for Wogan, he had remarried. The new Mrs Philipps had previously been Lady Huntingdon. By 1942, they were living together at Butlers Farm, Colesbourne, near Cheltenham, and she was deemed suspect too, what with her frequent correspondence and packages from America, one of which 'contained, amongst other things,

a pair of red silk stockings!' according to a Gloucestershire Constabulary officer.

Even when Soviet Russia became an ally, Britain's Reds did not escape suspicion and surveillance. In January 1944, for example, a wiretap on Noreen Branson's number (Primrose 5035) revealed that she thought that Wogan Philipps was 'like a puzzled sheepdog', – they had met when she had been on the same 'ARP Coordinating Committee for a time'. Later that year, the poet Randall Swingler was prevented from transferring to the Intelligence Corps. A phone tap revealed that he was in Palestine and wanted to join Intelligence but 'the bastards won't let him go'. Lieutenant Colonel J. Baskervyle-Glegg, MI5, insisted that Swingler 'should not on any account be accepted for Intelligence work or have access to secret information'.[28] As late as 1948, he was prevented from working 'as a lecturer to the Forces'.

Randall Swingler was not the first writer to be thought too radical to be left alone in a lecture room full of soldiers. Sylvia Townsend Warner was also judged unsuitable to be employed 'as a lecturer to troops'. A file note dated 11 January 1943 took issue with an earlier decision to accept her application 'since the Internal Security point of view rests with me' and 'I can only say that I do not consider this young woman is at all suitable as a lecturer to the troops'. (This 'young woman' was 39 at the time.) The objection was the result of 'Miss Warner' having 'been known to us for nearly six years as an active participant in left-wing activities'.[29] Certainly the level of detail about Sylvia's whereabouts and activities remained considerable long after her involvement in Spain. MI5 knew about the attendance of Sylvia and Valentine Ackland, for example, at a Writers' Congress in the United States in the summer of 1939 – Sylvia had spoken at an anti-fascist conference in New York. In addition, Sylvia's correspondence with both the Party and with magazine editors was copied; cheques for donations to left-wing organisations were photocopied; and cablegrams delayed and scrutinised. The local police were invariably on the case, Dorset's Chief Constable keeping Brigadier Harker at MI5 informed.

Sylvia and Valentine returned to the UK in late October 1939 and 'were issued with gas masks, tried them on, saw ourselves as snouted pigs' and, once back at home, 'groped in semi-darkness because of the

blackout'.[30] Later, survivors of the Dunkirk exodus 'sat on the lawn offering daisies to our rabbits or watched the trout in the river'. There had been some uncertainty about the soldiers' arrival, which was delayed, Sylvia thought, due to the fact that 'the billeting officer has probably been assured that we are dangerous fifth columnists'.[31] Her own opinion, she told Valentine, was that the neighbours had long believed that the two women's views were 'uncongenial and reprehensible'. Some months after the two writers moved to Winterton in Norfolk in July 1940, Dorset's Chief Constable, Major Peel Yates, wrote again to Brigadier Harker at MI5 to let him know that they had left his patch, although he was careful to point out that with regard to 'the two ladies mentioned [Warner and Ackland]', there was 'not the slightest evidence that they are or have been politically active in the Maiden Newton district'.[32] They were, he wrote, keeping themselves to themselves, enjoying a 'quiet and secluded life', although if truth be told, Sylvia was saddened by the fact that she could no longer walk over the sand dunes to the sea because of the wire and mines. It was, she thought, 'a mutilation'.

It took more than the temporary move away from Dorset and the sight of one or both women gazing sadly out across the North Sea to erase MI5's default instinct for doubt and distrust. Years of suspicion counted for more than any apparent drift away from communist activity. The past could not simply be set aside, and anyway, there would always be another piece of evidence that could be used to justify the continued surveillance. For example, Peel Yates reported that Sylvia had told one of his police officers that she and Valentine had both been in Madrid and Barcelona during the civil war, engaged in Red Cross work.[33] Again, when Valentine Ackland sent a cable to the American poet and activist – and briefly Valentine's lover – Elizabeth Wade White in New York on 4 May 1941, it ended with a mysterious reference: 'ALL WELL SOLOMON SEVEN VERSES SEVEN EIGHT.' It was enough to alert – and alarm – the censor. The cable was delayed and the 'Plain Code Section's' advice sought as to whether the brief communication was in fact a coded message. Mr Albert Foyer of the Plain Code Section, having checked the relevant verses in the Old Testament, took a deep breath when he read 'thy stature is like to a palm tree and thy breasts to clusters of grapes … like clusters of the vine and the smell of thy nose like apples'. He took the

view that there was no harm in the telegram, although he thought it was 'possibly rather unpleasant'.[34]

The two women moved back to Dorset in November, living in the village of Frome Vauchurch, and the surveillance continued through the war years. For example, on 29 March 1944, when the chalked graffiti 'OPEN THE SECOND FRONT NOW!' was beginning to fade, and the invasion preparations were filling the south coast with noise, dust and apprehension, Sir David Petrie wrote to Peel Yates, pointing out with some concern about Valentine being 'employed in the Civil Defence office' in Dorchester. As a member of the Communist Party since 1935, 'she is not a person who should be employed on highly confidential work'.[35]

* * *

Paul Hogarth was also manoeuvred into the war's backwaters. He was called up soon after returning from France to England in September 1939, and, 'feeling belatedly patriotic', and wanting 'to be of some use', he applied for a transfer from the infantry unit to a unit working on camouflage, a logical niche for someone with an art training. He reckoned without the army's capacity for cussed misjudgement. It didn't take very long to realise that he was 'classified as a member of the awkward squad'.[36] A supercilious officer with an aristocratic drawl dismissed his application out of hand, beginning with a barb directed at another, more famous Hogarth. 'Despite your name, there's nothing in your file to suggest you would be suitable for such a transfer.' He was summarily dismissed, an attempt to make a case rudely cut short by an army sergeant's roared 'SHUN!' and a chivvied quick march out of the CO's presence. That was not the end of it: when a gunnery instructor asked if any of the trainee recruits knew anything about the intricacies of a Lewis gun – how to strip it down and assemble it – Hogarth unwisely raised his hand, laying bare his contentious past. Army regulars were well aware that a working knowledge of such a weapon might just possibly have been gained in military service with the Territorials, but more likely, it revealed a recent experience with the Irish Republican Army, or the International Brigade. Paul was rapidly discharged, after just seven months in uniform. He felt humiliated and 'completely left out of everything'.

Trying to make sense of it all much later, Hogarth decided that his ejection from the Army was down to 'a spy network based on former members of the International Brigade. If you had been a communist and you'd had military training, you were very much persona non grata.' It was certainly the case that the government's policy was to sweep recruits with backgrounds like Hogarth's to one side, since 'the presence of such men in the Army would obviously be highly undesirable from the point of view of morale and discipline'.[37] Inevitably, by taking such a mulish line, 'the British intelligence service deprived the army of the most battle-hardened anti-Nazis the country possessed'.[38]

Judged to be too subversive to fight Nazi Germany, Hogarth found himself instead at the mercy of the London Labour Exchange, which in turn despatched him to the Design Research Unit, where he worked as a 'brush-hand on their industrial camouflage contracts' in west London. Later, he was recruited by Carlton Studios to illustrate various propaganda projects for the Ministry of Information, 'exhorting civilians to dig for victory' and other earnest survival techniques for the Home Front, as well as handbills to be jettisoned by the RAF over enemy territory.[39]

* * *

Lying behind Hogarth's rapid removal from the army was the British Government's long-standing concern about 'agitators who subverted the troops' during the Russian Revolution – the Invergordon Mutiny fuelled that idea.[40] Once the war began, the doubt was compounded by the perception that the CPGB was pursuing a policy of 'revolutionary defeatism', a consequence of the pact between Soviet Russia and Germany. Through the war there would continue to be doubts about the loyalties and undercover activities of British communists: MI5's Jack Curry, in reviewing the work of 'F' Division in combating subversion, concluded that it wasn't possible for the Intelligence Services to stop members of the Communist Party from accessing important secret work or gaining positions of trust and leadership. The problem lay with those communists who were fitted for secret work as a result of their technical ability and knowledge.

If MI5 trod with care and was hamstrung at times in their dealings with British communists in sensitive positions of trust, it was unforgiving

in its sustained pursuit of those on the fringes of the war effort. It was loath to let go of a suspect; nor did it easily discard its prejudices. Those writers and artists who had triggered suspicion were kept under review. Ralph Bates, a writer and veteran of the war in Spain, was the subject of a flurry of activity and memoranda in 1941, despite being thousands of miles away in Mexico. A letter was sent to the Secret Intelligence Service (SIS), dated 22 May that year: 'I happened to notice Ralph Bates has just written a novel which was extremely favourably reviewed in *The Times Literary Supplement*. I think that our records make clear that both Bates and his wife belong to that type of literary "leftist" which is in sympathy with the Communist Party, but does not take the final step of joining.'[41]

George Orwell's political stance also continued to trouble MI5 officers. On 4 February 1942, a letter was sent to Inspector Gill at Special Branch querying his sergeant's view of 'Blair's "advanced Communist views"'.[42] It emerged that 'the good sergeant was rather at a loss' as to the most fitting way to describe Orwell. He was, the ruling went, someone 'who does not hold with the Communist Party nor they with him'. Clearly someone who could, as Orwell did in 1941, describe communists as 'neurotic or malignant types' was far from an advocate for the Party – although he would assert later, in 1945, that he had no alternative but to 'belong to the Left'. The uncertainty about Orwell's politics, however, was not enough to call off MI5's watchers.

The sharp contrast between Orwell and the 'good sergeant' in Special Branch epitomises the chasm of difference between those in the arts whose instincts were to the left and the archetypal right-leaning member of the Intelligence Services. Agents were 'a mixed lot in civil life, solicitor, bank employee, hotel manager, journalist, commercial travellers, music publisher'.[43] They needed observational skills; discretion so that 'informants themselves should be given no idea that they are furnishing information which is required for an official enquiry'; the ability to be patient and oblivious to monotony. They were 'born not made'; of average height; inconspicuous, with good hearing; and active – able, for example, to jump from a moving bus in pursuit of a target on the run. Men were preferred since 'women when watching alone or in pairs are handicapped by unpleasant attention paid them by the opposite sex'. Agents needed dogged perseverance; respect for the old school tie; a

reliance on Tory values and an aversion to socialism, let alone red-blooded communists. The left-wing poet Randall Swingler questioned why it was that 'communism and not fascism was connected with sedition'. It was a good question of the sort that those on the left frequently posed, but significantly an agent put the query on file, objecting to its fundamental assumptions. When communists asked such questions, many in MI5's employ smelled treachery.

'Are You For Stalin or For Us?'

On the first day of June 1940, a furniture van from Edwards' Removals stopped outside Mistletoe Cottage in the Berkshire village of Inkpen. It arrived promptly at nine in the morning and the two removals men climbed out of the cab. Jack Reeves, the driver, and his assistant, Richard Barnes, were both appropriately dressed in old clothes for the job ahead, the loading and transporting of Jean and James MacGibbons' furniture and household effects to their new house at number 4, Stuart Road, Wash Common, a red-brick semi-detached house near Newbury. The MacGibbons were both communists; Jean had gone to the Royal Academy of Dramatic Art, and would become a writer, initially under her maiden name of Jean Howard – Rosamond Lehmann would be supportive of her fledgling career – while James had worked for Putnam & Co., the publishers, and having lived for a time in Berlin, had acquired fluent German, a factor in his recruitment by the Army Intelligence Corps. He was also loosely connected with the Artists' International and would become a long-standing friend of the artist Julian Trevelyan, who described James as 'the nicest man in the world'.

Jean and James had been members of the CPGB since June 1937 and James had acted as secretary of the Barnes branch in London. The struggle against fascism in Spain had been a powerful factor in the couple joining the Party, and both of them believed that communism offered the best hope of a different, better world. 'It was the feeling', James later recalled, 'that we were part of a movement that would change the world that kept us going.'[1] Despite the strength of his communist views, MacGibbon had volunteered as soon as the war had broken out and had been commissioned soon after, this despite the fact that the couple had been subject to the attentions of the Intelligence Services since April 1938.

One of the removals men, Richard Barnes, was clearly an observant man – indeed, decidedly inquisitive. He eyed with interest the parcelled-up

books and James's official-looking brown leather despatch case, but made no comment. He and Reeves began to sweat as the sun climbed in the June sky and the two men methodically shifted furniture and belongings. Finally, with everything stowed, the van pulled away for its short journey east towards Newbury. Mrs MacGibbon and one of the couple's children sat alongside the driver in the front, and Barnes, James and the other MacGibbon child were on the tailboard at the back. The children were soon dropped off at a neighbour's house and the adult MacGibbons were reunited on the front seat, while the taciturn Richard Barnes remained, alone now, in the lorry's rear. Jack Reeves seemed intent in delaying the resumption of shifting furniture and the removals van puttered along the country road, while its driver took in the views of the Berkshire fields. For his part, Richard Barnes got to work, glad of the time that Reeves's laggardly driving had given him.

He started with the books. Bound up tightly with string, only the spines were open to view, but these Barnes found damning enough: 'a number were in foreign languages with titles such as *Marxism*, *Trotskyism* and one mentioning the word *Hitler*.'² It was just a matter of moments before the brown despatch case, about which MacGibbon had seemed anxious – had it been loaded alright? – was opened. Inside Barnes found a cheque book; a bundle of documents relating to the purchase of the house in Stuart Road; and a clutch of notebooks, each full of pencilled notes written in some unknown language. Barnes smiled to himself and then looked up anxiously at the heads and shoulders of the three figures in the cab, moving slightly as the van lurched and rolled. He turned the pages quickly, registering with satisfaction the lists of cities and towns, the names of which he recognised as German. Aah! For a moment, he felt he had lost track of time and, flicking through more pages, he looked up to see that outside the van's windows the fields were being replaced by suburban housing. He was running out of time. Then the van jolted to a stop. By the time Reeves and the two MacGibbons climbed down, young Barnes was sitting in the middle of the MacGibbons' worldly possessions, a picture of innocence, apparently on the verge of nodding off in the summer heat.

Once the unloading was underway, Barnes could resume his search. He concentrated for the most part on the books – more Marxism, he

noted, pursing his lips. There was also a collection of Ordnance Survey maps, 'enough to cover the major part of the country'. The MacGibbons were keen – too much so, Barnes thought – to help with the unloading. Later, they drove over to a house in Stanford in the Vale, collecting more furniture and a further consignment of books, 'all dealing with Socialism, Communism and left-wing activities'. Barnes by now thought he had got the MacGibbons 'bang to rights', but it didn't stop him accepting a lunchtime beer, and some bread and cheese. The proffered cigar and a share of the £1 tip he declined. Work done, Reeves and Barnes took their leave. Jack Reeves drove the van back to the company yard, while Richard Barnes – DC 59 of Newbury Police – returned to the station, discarded his shabby working man's clothes, and, before the day was over, sat down to type out his formal report for Superintendent Lambourn.

Barnes's report was detailed, drawing particular attention to the number of books in the MacGibbons' possession (upwards of a thousand), many of which Barnes judged to be seditious; James MacGibbon's unlikely commission in the Intelligence Corps – how can that be right, given his pro-Soviet stance? Then, even more unsettling was Jean MacGibbon's alleged comment that 'it would be a good job if Hitler did win the war', which Jack Reeves claimed to have heard her say. She had followed that up by declaring that Hitler's victory would wake the nation from its slumber – it had 'been asleep for the last 500 years', she said. She meant, her son Hamish believed, 'that people who appeased Hitler or who approved of the Nazis would soon be shaken out of their complacency' should the invasion happen and Britain be faced with German occupation. Barnes's version of events was damning enough to ensure that MI5's Lieutenant Colonel E.H. Norman issued an instruction to the effect that MacGibbon 'should be very thoroughly investigated with a view to ascertaining whether he is a desirable person to be employed as an Intelligence Officer or perhaps to hold a commission at all'.

A follow-up visit to the house in Wash Common soon followed, just when 'the family were due to join Jean's parents for a holiday in the Lake District', a break for fly-fishing and golf.[3] This time it involved a uniformed police constable, his wife and two detectives arriving at eight o'clock in the morning. While the two detectives searched the house for incriminating documents, the constable's wife sat with the

family through an anxious breakfast, presumably 'to ensure that they did not hide anything'.[4] The search completed, the MacGibbons were ushered into their own sitting room and confronted with what the police evidently thought was damning evidence: an official history of the CPGB; a book with a German text about the artist Bruegel; a German political magazine and 'a novel by Colette'. The search missed the 'tea-chest full of pamphlets from the CP days in Barnes' in the garden, but nonetheless, the family's peace of mind must have been in short supply, both during the journey towards the northern fells and when the holiday itself began at the Shap Wells Hotel. It was clear that there would be serious repercussions of some kind, and, indeed, it wasn't long before a telegram arrived requiring James to report to the War Office with immediate effect.

In London, MacGibbon was interviewed by Major Johnstone from MI5's B1 department whose responsibility was counterespionage and countersubversion. He began by enquiring why James had not reported the fact that his house had been searched. 'I had no idea to whom I should report this,' MacGibbon responded. Given Second Lieutenant MacGibbon's public school (Fettes College) and Oxford University background, Johnstone was not minded, it seems, to labour the point. A gentleman's word should be trusted without question – 'one of the reasons why Kim Philby and others were able to get away with such damaging espionage for so long'.[5] Eventually, Johnstone brought the interview to a sudden conclusion by asking what he saw as the fundamental question: 'Are you for Stalin or for us?' to which James responded, 'For us, sir.'

'"Shake on it, old man," was the reply.'[6] They clasped hands and parted company, both men thankful for the balm of their shared values.

* * *

Major Johnstone's readiness to accept MacGibbon as a well-brought-up chap whose education and class guaranteed patriotism, and who would never contemplate an untruth, exposes a fundamental weakness in MI5's culture and ways of working. That flaw partially explains the irony that, while it accrued long lists of left-leaning individuals – including many artists and writers, it was blind to the treachery of the

undercover communists from the well-heeled middle class within its own ranks. MI5 'unerringly focused its attentions on innocent people or small and unimportant spies, and missed those who mattered.'[7] Kim Philby, for example, had been a Russian agent since 1934, convinced that his 'life must be devoted to communism'.[8] It took nearly twenty years before his duplicity was exposed. It is not as if his left-wing beliefs were difficult to uncover: he had graduated in 1933 from Trinity College, Cambridge and then gone to Vienna, where he had acted 'as a courier for the underground Austrian Communist Party' and had a passionate fling with a communist divorcee.[9] He had his first meeting with his Soviet controller the following year. Thereafter he was at pains to suggest that his politics had drifted towards the right. By the time of the Spanish Civil War he was able to present himself as a foreign correspondent for *The Times*, covering the war from the Nationalist side, during which time he was decorated by General Franco. In July 1940, Philby was recruited by the SIS, an appointment that was an indictment of the vetting process whereby a Russian agent (Guy Burgess) could successfully recommend another agent (Philby) for secret work within the British Intelligence Services. Philby would discover later that MI5 had been asked about his background and had reported back – after checking its voluminous registry (2 million cards and 170,000 personal files) – that he was 'clean', and with 'Nothing Known Against'. Soon Philby was working as an instructor for Special Operations Executive and by the autumn of 1941, he was securely established within Section V of MI6.

Guy Burgess, another member of the 'Cambridge Five' ring of Soviet spies, was recruited by the Russians in the same year as Kim Philby – and by the British Secret Service in late 1940, thanks to the intervention of the art historian Anthony Blunt. Burgess had been at Trinity College, Cambridge as well and had been one of the hundred or so Trinity students who had joined in a hunger march from the north. John Cornford's girlfriend, Margot Heinemann, whom Burgess had known before their student days, described him as 'wearing a Pitt Club yellow scarf, singing "One, Two, Three, Four. Who are we for? We are for the Working Class"'.[10] When Blunt supported Burgess's recruitment, he was, in a way, returning a favour, since it was Burgess – described by the novelist Anthony Powell as 'a BBC fairy of the fat go-getting sort'[11] – who had introduced him to

the Russian agent Arnold Deutsch three years previously. Burgess was 'outrageous, loud, talkative, indiscreet, irreverent, overtly rebellious' and a man who drank 'like some Rabelaisian bottle-swiper' nursing an 'unquenchable thirst', and whose 'sexual life' was 'sordid'.[12] Given the scope for dangerous indiscretion his debauched behaviour suggests, it is remarkable that Burgess remained under the radar for so long and in such trusted positions. Later in the war, for example, he worked in the Foreign Office with wide access to Foreign Office communications. Moreover, Burgess's brother, Nigel, was an officer in MI5 and worked in 'F' branch monitoring Party activities.

Anthony Blunt was in Military Intelligence early in the war and joined MI5 in the summer of 1940, this despite the fact that he, alone of the Cambridge Five, had attracted the Security Service's attention before the war. A Home Office Warrant had uncovered the fact that he had given a lecture at the Marx Memorial Library in London, in which he had revealed enough to suggest that he was, at the very least, a sympathiser for the communist cause, a fellow traveller. Moreover, he had been expelled from a military training course in September 1939 when evidence emerged of his past communist associations.[13] At one point during the war, he served on the Advisory Committee of the Artists' International and, before the war started, he had lectured for the AIA and written for *Left Review*. And yet, he would assume responsibility for the B6 section at MI5, the department charged with surveillance, its 'thirty-eight "watchers" trained to follow suspects without being spotted'.[14] There were also connections going back years between Blunt and many left-wing writers and artists. For example, the poet Gavin Ewart, when he went up to Cambridge in 1934, was advised by Stephen Spender that he should 'try and meet Anthony Blunt', declaring that Blunt was 'the most amusing man in Cambridge'.[15] Wisely perhaps, Spender, in the years after Blunt's fall from grace, claimed he didn't know him well; indeed, he didn't like him much either.

Donald Maclean, who would later defect with Burgess to Soviet Russia, was another ex-Trinity College man recruited by the Russians, also in 1934. He was firmly established in the corridors of power during the war, able to keep Moscow in close touch with London's policies from his position working on economic warfare matters within the Foreign

Office. The last member of the Cambridge Five, John Cairncross – also a Blunt recruit – worked in both the Treasury and, later, the Foreign Office. During 1942 and 1943, he worked at Bletchley Park and then joined MI6 in 1944.

It was the 1950s before the truth began to emerge – a decade when MI5 'bugged and burgled [their] way across London at the State's behest, while pompous bowler-hatted civil servants in Whitehall pretended to look the other way'.[16] There were no official suspicions of any of the Five until 1951. For more than a decade, the Intelligence Services were blind to these well-connected, well-educated, well-heeled double-dealers, while at the same time continuing to keep the peripheral and innocent under investigation. The guilty men 'could have stood in Piccadilly Circus and screamed that they were communists to no effect', so far out of sight of the law were they.[17]

Artist and Soldier

Unlike the communists lurking within the British establishment, Clive Branson made no secret of his allegiance to the Party. He was outspoken, passionate and consistent in his criticism of the government, its leaders and the nature of capitalism, which he saw as 'a very wrong system which cannot be justified by any logic or reason'. Clive was a highly visible figure in the Party, 'selling the *Daily Worker* at Clapham Junction, house to house canvassing, selling literature, taking up local issues, and getting justice done'.[1] He was also a savage critic of the British Army. In 1937, he had written an article on 'The Army and Democracy' in which he excoriated the service, arguing that it was being prepared 'as a weapon to be used by a handful of persons against the British people'. He didn't stop there, declaring that: 'the only education which the British "Tommy" receives is at the hands of the *Daily Mail*'; that the army's officers were 'almost 100% Fascist'; that Prime Minister Baldwin was a 'friend of Fascism' worldwide; and that 'Fascist literature is allowed free circulation in the armed forces'. Any literature with a democratic slant, he wrote, was dismissed as 'sedition'. Branson proposed 'A Programme of Action', which, among other things, envisaged the formal election of a proportion of army officers and would require that each army canteen should have a manual of military law placed within it.[2]

Ironically, four years after his brutal condemnation of the British Army, Clive Branson had become a soldier serving in its ranks, based at Perham Down camp, close to Salisbury Plain. He was with the Royal Armoured Corps in 'C' Squadron, 54th Training Regiment. Despite his military service in Spain, army life in wartime Britain came as a shock, a stultifying existence, which he fought against by playing chess – 'to get my mind off this bloody hole' – and reading. Copies of both *Left Review* and the *New Statesman* were greeted with relief. 'You are such a dear,' he wrote to Noreen on 20 March 1941 after she had sent him copies of

both: reading, he told her, was the one thing that 'keeps one's feet on the earth!' He wrote again a few days later, acknowledging the two letters from 'little Rosa' and recounting the conversation he had had with the regimental sergeant major, who was keen to see Branson promoted. That prospect immediately raised the spectre of politics, the RSM asking if Branson was aware that he knew all about his political record. 'Yes, sir,' Clive said, eyes front. 'Do you know that Southern Command know?' the RSM persevered. Branson knew that those at Command HQ knew all too well. 'Yes, sir,' he replied, hoping his reply revealed nothing of his innermost thoughts on the question of his own promotion, or indeed, the need for profound change in the country as a whole.

There was no slackening of Clive Branson's political certainties: Soviet Russia he believed to be 'a living, shining example to the people of the world'. Closer to home, he remained angry about the army's dead hand over its troops and the blight it placed on his own spirit. Beyond that there was a deep anxiety about Noreen's safety in north London as the Blitz continued through the spring of 1941. He ended his letter as he often did, sending all his love before adding a defiant '¡*Salud!*' together with a sketch of an International Brigader's clenched fist. There were at least some compensations in the landscape surrounding the camp and in his love of painting, to which he had returned after the civil war and to which he longed to devote his time.[3] 'Oh, the countryside and the sky!!' he wrote in April, 'the hills and the trees – their colours – look so rich, and above, this fat pigment skies full of blues, whites and silver.' A few weeks later, and after a couple of lunchtime beers, he painted through the afternoon, absorbed in the tranquil peace of Warren Hill overlooking Perham Down.

Over the longer term, though, the army always had the capacity to spread despondency or foster disaffection. It might cancel leave, perhaps, or insist on some fatuous drill or aimless task or other, or find some other way of curtailing an individual soldier's sense of freedom or independence. In the summer of 1941, for example, Clive sought permission to spend some of his time in camp sketching or painting. The response was bureaucratically philistine: he was 'put in charge of distempering the walls of the Squadron office'. Overall, it was an aimless, inconsequential existence dominated by guard duty, sock darning, button sewing or sorting laundry.

The unremitting tedium of Perham Down continued throughout that summer, the inactivity in stark contrast to the seismic change in the politics of the war. Beyond the confines of the camp, on 22 June 1941, the Germans launched a sudden attack on Russia, ending the bizarre communist/fascist pact. Inside the camp though, little changed: on 20 July 1941 he complained to Noreen about both the boredom and the isolation: 'I have been stuck in this fucking hole doing nothing,' he wrote, laying the blame on 'the stupid ignorance of an old Major who ought to have been discharged on a 10-shilling-per-week pension years ago'. Lassitude, tinged with anxiety about what might lie ahead, dominated each day, while the pleasures of 'walking, riding on a bus or sitting on the cricket ground at Winchester' were becoming illusory. The fact that Branson, unlike many, had already experienced modern warfare only made matters worse. The prospect – and the memory – haunted him. 'You can have little idea of how frightened I am of once again being in action,' he had written early in June. It didn't help that the Valentine tank – the weapon he was being trained to fight with – was '16 tons and a killer', but with no guarantee as to whom it might kill. The general view of 'the lads' in Branson's squadron was that 'it can be guaranteed to kill the fucking crew'.

The summer drifted towards autumn. Branson's anger at the conduct of the war grew steadily, in particular at what he saw as Russia's isolation while the German tanks blazed their way towards Moscow. 'It seems that Britain will fight to the last Russian,' he wrote, blaming Churchill, whom he regarded as 'utterly loathsome'. Early in October he told Noreen that he had never 'dreamt I should be condemned to anything like this'. Only his art, his family and the natural world offered any hope or consolation: 'at least I am an artist and the world is very beautiful.' He was, he told Noreen, learning 'so much about outdoor colour'. With the autumn came news of another artist with a communist background: he received a letter from James Boswell – 'It was very nice of him to write,' Clive told his wife – and then, soon after, the news that he was to be posted to Warminster in Wiltshire. The purgatory that was Perham Down was over.

Branson took pleasure in his gunnery training at Warminster camp, the precise mechanics involved, what he called 'the sheer joy in making one's mind tune into mechanical movements', and by 5 December he had

successfully completed the course. For her part, Noreen, in the midst of her eminently sensible and detailed letters about whom she had seen and what she had done, reassured him about her steadfast feelings for him – ('I love you so much'); teased him ('I am not having an affair – I thought I wouldn't – it's too much trouble'); and raised the possibility of an alternative to tank warfare – she was, she told him, glad that he was enjoying painting and suggesting that he 'might be a war artist yet'. Then, on 7 December 1941, Japanese aircraft bombed the US navy at Pearl Harbor and the war's balance of power changed again. That same day, Clive had presciently written home: 'All I hope is that the Japanese smack at us or America.'

Early in 1942, Branson decided to pursue the possibility of becoming an official war artist. On 26 January, during a period of leave, he wrote from his north London home (Flat 37, 99 Haverstock Hill) to the secretary of the War Artists' Advisory Committee, E.M. O'R. Dickey, seeking his advice and help after one of the attendants at the National Gallery's War Artists' Exhibition had given him Dickey's name and contact details. 'I have some paintings of war subjects which I would like to submit for inclusion,' Clive wrote, referring to work he had completed before he had been called up to the Royal Armoured Corps, when he 'was exhibiting regularly at various galleries'.[4] Would it be possible, he asked Dickey, 'to do paintings of life' in the Corps? As things stood, the only subject matter the army would allow him to draw were landscapes, hills and woods with not a hint of the military to be seen.

Dickey replied promptly on 28 January, but was cautiously non-committal, evidently using a tried and tested formula for such inquiries, but it was enough to encourage Branson's hopes. The recent exhibition in London, Dickey wrote, comprised work that had been either commissioned or bought 'on the recommendation of the Artists' Advisory Committee'. However, that did not in any way preclude submissions and the committee 'as a rule meets weekly' and would be 'particularly glad to have an opportunity to see pictures by artists who are serving in the Armed Forces'. By the time Dickey's reply was delivered, Clive was back in barracks and so it was Noreen who replied on her husband's behalf, submitting three paintings for consideration: *Bombed Out* and *The Torn Balloon*, as well as a small street scene. A week or so later, Dickey wrote

again, the committee having met and agreed that Colin Coote, its member from the War Office, should write to Branson's commanding officer 'to ask him to give you such facilities for sketching as may be consistent with your military duties'. Soon after, having ascertained that the paintings shown in the National Gallery exhibition were offered for sale, Clive put prices on two of his three submissions (12 and 10 guineas).

Nonetheless, the correspondence ended in disappointment. Dickey's letter of 23 February left perhaps a glimmer of hope in its final sentence, but overall its message was clear. 'The Committee', he wrote, 'regretted that they were unable to make any recommendation for either of your pictures,' although, if Corporal Branson at some point would 'do some service subjects', they would welcome a chance to see them. As so often in those difficult times, however, the war had a way of intervening to dash individual hopes and plans. Within a few weeks, Branson was at sea, part of a convoy heading east, returning him to the land of his birth. Some three decades after he had left India, he was to see that country once again.

'Slimy with Self-Deception'

James Boswell, whose letter had so cheered Clive Branson in the autumn of 1941, was another artist with a communist background seeking to be accepted for work as an official war artist. Like many artists, the outbreak of the war had suddenly threatened his livelihood. His work at Shell had dropped away and he was obliged to settle instead for a routine of sketching sandbags strewn around banks, smouldering piles of rubble, and the bloated outlines of barrage balloons drifting over London's skyline. He was by then working for the organisation Air Raid Precautions (ARP). From time to time other opportunities came up: for example, in February 1941 he illustrated text written by Randall Swingler for the first edition of *Our Time*. But then, soon after, he was called up: Private James Edward Buchanan Boswell, Royal Army Medical Corps, and posted to No. 1 Depot, Church Crookham near Aldershot. He was ill-suited to army life, its red tape, blimpish officers, and the same crushing of the individual soldier's spirit that had troubled Clive Branson. After radiography training on London's Millbank, Boswell was sent to Peebles in Scotland for more training, what he termed 'manoeuvres and day-to-day time wasting'. A commission from the War Artists' Advisory Committee (WAAC) seemed to offer an escape from such torpor.[1]

An immediate issue for the committee was Boswell's membership of the Communist Party: did that provide sufficient reason to disqualify him? In the autumn of 1941, James made an initial contact with the committee and, on 9 October, its secretary, E.M. O'R. Dickey, wrote back, informing him that the committee had met the previous day and had agreed that Boswell's commanding officer should be contacted so that 'you should have such facilities for sketching when you go overseas as it may be possible to give you'.[2] Boswell was soon to be posted to West Africa, it seemed, and the committee would be pleased to receive any drawings that he was able to send back. A fortnight later, Boswell's wife

rang to report that James's anticipated posting had been changed: no longer the prospect of African heat and uncertainty, but a continued stay in Scotland instead, a transfer to the 73rd General Hospital, Peebles. What did this mean in terms of the 'arrangements … being made for him to have facilities' for his art? Boswell himself wrote in early December: he had applied for an exchange of personnel, so that he could go to Africa after all – but the request had been refused, with no explanation for that refusal, nor indeed for the change of posting itself. Boswell's politics, however, were well known.

The committee – or the civil servants servicing it – might have baulked at confirming official war artist status on a man with a communist history, but it remained keen to secure some of Boswell's output. In April 1942, Dickey wrote to him again, seeking to buy, at the committee's behest, three of his watercolours, namely *Crewe 2 a.m.*, *Sick Parade* and *The NAAFI*. The price would be 15 guineas for all three paintings, whose subject matter in each case was the sombre nature of army life, featuring crowds of listless soldiers in dark huddles. That request for work that showed the reality of wartime soldiering might have surprised Boswell, but it was the committee's interest in his three sketchbooks that caused him more anxiety. Would he be willing to part with the set of books – for a fee, of course? On 3 May, Boswell replied: he was pleased to have sold the three watercolours, but very reluctant to let the sketchbooks go, since they were useful in 'working up' his sketches into finished pieces, and 'they have a possibly exaggerated sentimental value for me'. Every drawing, he wrote, came from his own direct experience. There was another worry too: his letter concluded with a warning that he was now serving under a new colonel who might well require some official notification of Boswell's continuing need for 'facilities' for his artwork.

Such caution – arising no doubt from knowing all too well how the army worked – about his new colonel's willingness to accept the existing arrangement for Boswell's art proved entirely justified. A few weeks later, James wrote to the committee secretary asking that an official request be sent to the punctilious colonel to grant the very 'facilities for sketching' that had long been agreed. He was, he said, 'feeling very unsettled', and had drawn nothing at all for some time. 'Unsettled of Peebles' was soon to turn to 'Sweat-soaked of the Middle East'. He arrived in the

desert in September 1942 (by which time Branson had been in India for three months). For both, the heat and dust and poverty were profound shocks. Boswell found himself in 'what sounds like the hottest and most unsavoury part of Iraq'. On 30 September, Elisabeth Boswell wrote to the WAAC: her husband was 'not enjoying' the experience, beset by the legions of flies, the heat (which left men sweating 'like rashers in a frying pan'), and the unremitting tedium. She also indicated that James would now be willing to release his sketchbooks, a change of mind prompted, his wife thought, by having 'lost any sentimental feelings he ever had about his training!' An apologetic Elisabeth Boswell was unused to negotiating on her husband's behalf, and afraid that her letter was 'not very business-like'. She had, she said, 'never had to cope with these things before he went abroad'. There followed a lengthy correspondence, the upshot of which was agreement on the original offer of 30 guineas for the two books – the committee was unwilling to sink to what might be construed as an unseemly auction.

Boswell's posting to Iraq proved challenging. The war here was a battle against boredom rather than the Germans and, to cope with it, the troops did 'all the things that soldiers have always done – drink, gossip, fight, [and] sleep as much as we can'. They felt isolated ('Fifty miles out here is as good as fifty years'), in what seemed like the 'middle of nowhere with barbed wire perimeters and ruler-straight roads leading to vanishing points on featureless horizons'.[3] The searing heat and the clouds of dust were sapping and the men battled with 'heat, dust and boredom', scarcely comforted by their pin-up calendars and mugs of tea, while the war happened far away.[4] Boswell's work as a radiographer, however, was relatively undemanding, most cases at the hospital in Shaiba being limited to dysentery and heatstroke. That left him ample time to sketch, and the result was a series of powerful drawings that caught the bleak misery of both time and place: demoralised men in sweat-stained uniforms; barbed wire and sand; the unseemly nature of army existence – its shared showers, cooking in bulk, killing of time, mutual gloom. Colour was largely missing and the darkness of the sketches, the lowering skies, hint at a land without hope.

By the time Boswell returned to the UK he had produced enough work for an exhibition at London's 84 Charlotte Street: *On Duty in the*

Desert – Watercolours and Drawings by James Boswell, which opened in mid-May 1944. That year Boswell was commissioned as an officer, initially to second lieutenant, and then rising to major by the end of the war. His communist past was evidently no barrier to promotion, perhaps because he had let his membership lapse. By then he had left his work as a radiographer, working instead for the 'Army Bureau of Current Affairs' (ABCA), an organisation set up to boost the morale of troops as well as educating them. The move away from medicine put Boswell in a position where he could have a significant influence on soldiers' thinking: ABCA 'encouraged the groups to discuss subjects which Churchill believed soldiers should not think about, let alone discuss among themselves'.[5] Arguably, it had an impact on the result of the 1945 General Election, which was won by Labour. One would have expected official action to prevent left-wing officers being given such an opportunity, but for some, there was carte blanche, with one government agency ignoring the work outcomes of another – the continuing surveillance by the Intelligence Services blithely ignored when other agencies chose to do so. Despite the experience of many others, promotion for those with a leftist past happened, something that was more likely when the suspected Red was wearing an officer's uniform. James Boswell was one communist who benefited; so too did another James, Major MacGibbon.

MacGibbon had joined department MO3 of the War Office in the spring of 1941, not long before the German attack on Russia turned the latter into allies of the West. Despite that shift in circumstances, some intelligence officers remained wary of the Russians, believing that 'it would be no bad thing if the Russians were defeated while serving to wear down German military capability'.[6] MacGibbon rejected such attitudes, taking the view that the overall war effort was what mattered. 'I never felt that I was acting for the Communist Party, as indeed I wasn't,' he told his son, Hamish. 'It was to help the war effort.'[7] As the war unfolded, he would be working on the preparations for the invasion of France, which eventually took place in June 1944. He was, as a result, in a position where he acquired information of considerable value to the Russians.

An anonymous letter had alerted the Intelligence Services to the fact that James MacGibbon and his wife were active communists. There were reports later that he had made 'anti-British remarks' and was 'on

friendly terms with pacifists'. By 1944, MI5's Brigadier Sir David Petrie
was anxious to obtain specific information about Major MacGibbon:
his foreign origins and/or associations; the nature of his services for
HM Forces and/or Government; and any evidence of subversion or
criminal activity. MacGibbon met secretly with a Russian attaché and
subsequently, 'whenever he could when he was on night duty [he] sat in
the War Office Map Room and took copious notes.'[8] Very aware of the
risks, he would invariably hide his incriminating notebook and pencil in a
pocket if any unexpected noise disturbed his careful transcription. Then,
at the end of June 1944, he was posted to the Joint Staff Mission (JSM),
'the British team briefing the Combined Chiefs of Staff in Washington',
where he soon made contact with another Russian handler, recognisable
he was told by 'his yellow boots'.[9]

Many years later, James MacGibbon's son, Hamish, would be shown
'a row of twenty filing boxes containing hundreds of MI5 and Special
Branch records on our parents going back to the 1930s'. The surveillance
continued into the mid-1950s, manifesting itself in the usual range of
MI5's techniques, so that 'every letter to our house and James's firm was
opened and copied', every phone call was monitored and, nearly every
day, MacGibbon was 'tailed by a team of "watchers"'.[10]

*　　*　　*

If you were an artist or writer with left-wing opinions, MI5's antennae
were likely to be alerted, their interest even extending to those who had
some connection, professional or political, with the suspect. For someone
like Randall Swingler, with his multifarious roles – book critic/literary
editor of the *Daily Worker*; co-organiser of the Writers' Group; editor
of *Left Review* after the poet Edgell Rickword resigned in 1937; friend
of Nancy Cunard; in-demand speaker; supporter of Unity Theatre, and
so on – it was inevitable that his life would be under sustained scrutiny
and his contacts duly monitored. From 1941, the level of surveillance on
him was heightened, his background, opinions and activities followed
assiduously. With military service likely for this well-known and
influential communist, the welter of memoranda and correspondence
amongst the desk-bound at New Scotland Yard and MI5 mushroomed.

Eventually, it was decided that Swingler should 'be placed on the special observation list'. Then, on 28 August 1941, he received his call-up papers, informing him that he should report to Catterick in North Yorkshire, several hundred miles from his Essex home.

That same year, Stephen Spender was subject to careful vetting to ascertain whether it was safe to let him travel to Ireland where he had been invited at the instigation of the poet John Betjeman who was working for the Ministry of Information. Spender had been invited to Trinity College, Dublin to speak, and approval was only given after he had provided a wide range of information – all obsessively filed – describing his height (6 feet, 3 inches); his address (Wittersham, Kent); his job (co-ordinator of the magazine *Horizon*); the date and place of departure (4 November 1941, Liverpool). He was obliged to provide two referees and he named Sir Kenneth Clark, Director of the National Gallery and Chairman of the War Artists' Advisory Committee, and the MP, Harold Nicholson.

Spender spent nearly three years as an auxiliary fireman, from September 1941 to June 1944, initially at Cricklewood and then, from January 1942, in Hampstead. Thereafter he worked for the Foreign Office's Political Intelligence Department, in London's Bush House, the peacetime home of the BBC's World Service. It was mundane work – compiling background information on the history of Italian fascism for the British force occupying Italy.[11] The fact that he was working for the government did not curtail his willingness to criticise aspects of its culture; nor did it keep MI5 at bay: it faithfully recorded the fact that Spender was a co-signatory of a letter to the *Manchester Guardian* protesting at police raids on the premises of the Freedom Press. Police operations like this were a 'prelude to further and wider persecution, both of individuals and of organisations devoted to the spreading of opinions not shared by authority'. The letter went on to call for an inquiry into Special Branch activities, contending that they were of 'great potential danger to the freedom of the country'. Overtly declaring fundamental doubts about the role of the Intelligence Services was an infallible way of guaranteeing continued scrutiny, something that, in Spender's case, would only increase after the German surrender and the onset of the Cold War.

Spender was still at Cricklewood Fire Station when, at the end of January 1941, J.B. Priestley was commissioned by the BBC to do a

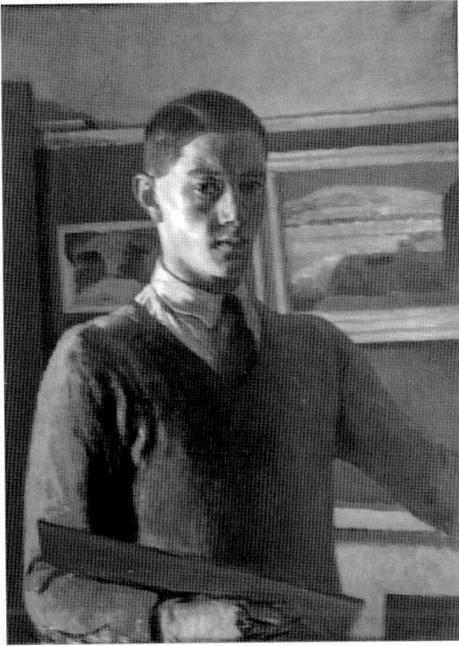

Clive Branson – an early self-portrait. (*Rosa Branson*)

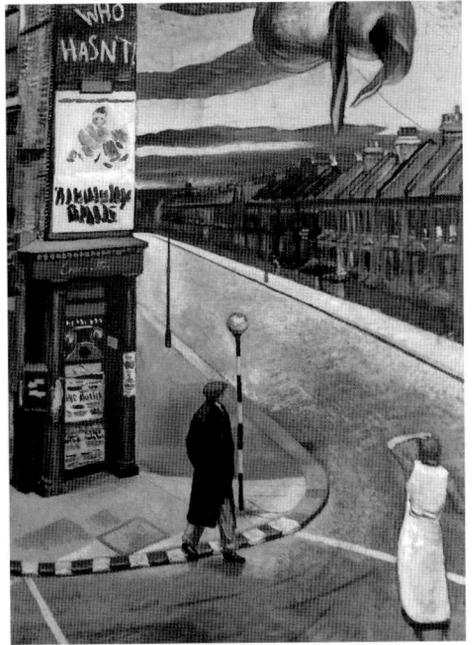

Branson's painting of wartime Battersea, a punctured barrage balloon overhead. (*Rosa Branson*)

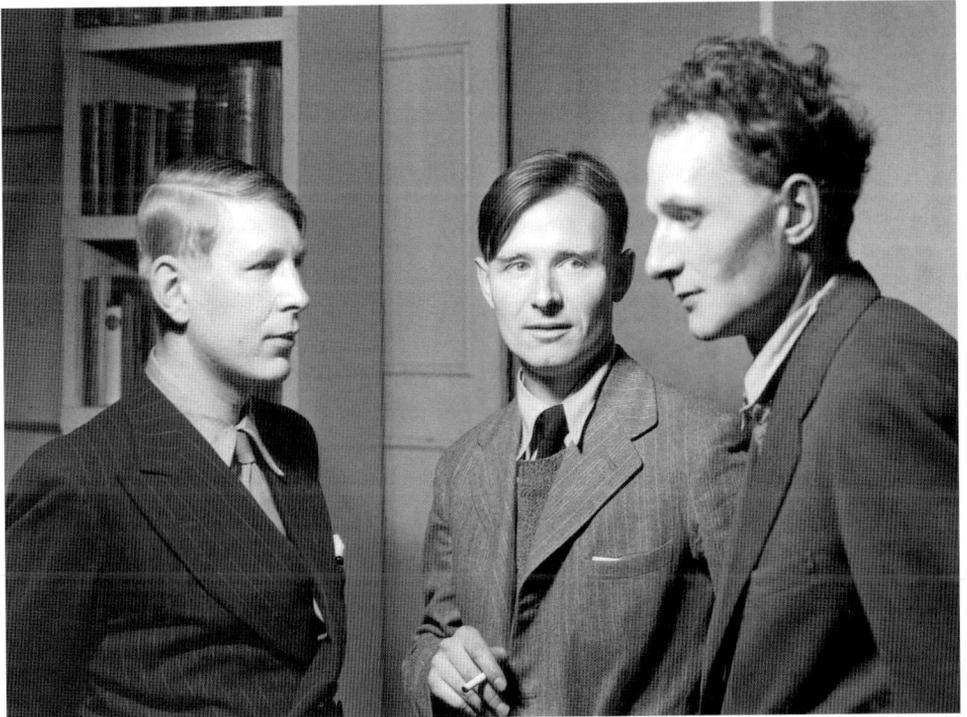

Discussing 'abstract theories'? W.H. Auden, Christopher Isherwood and Stephen Spender. (© *National Portrait Gallery, London*)

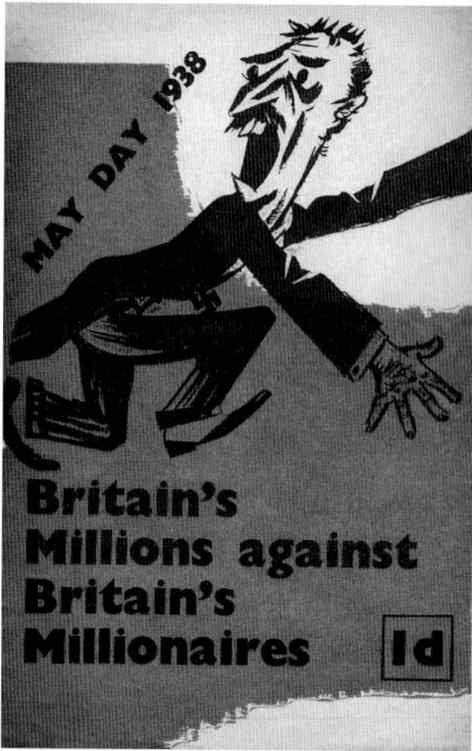

Mayday 1938: published by the Communist Party, this was James Boswell's unforgiving sketch of Prime Minister Neville Chamberlain. (*Sal Shuel*)

The Secretary of the CPGB, Harry Pollitt, gave evidence to the Arms Inquiry Commission on 23 May 1935. James Boswell's sketch was published by the Party that year. (*Sal Shuel*)

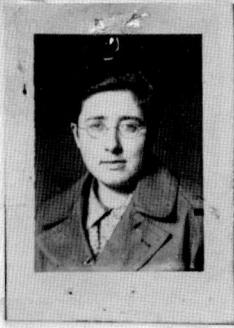

NAME. Felicia Mary BROWNE.

Date. 21st January 1931.

Address: 10 Fairfax Rd., Hampstead, N.W.6.

Born: 18th February 1904: Thames Ditton.

Description: Height, 5'6"
Eyes, hazel.
Hair, brown.

Occupation: Artist.

Date. 21st January 1931.

Passport No.: 320156 (replacing Passport No.
408595 - mislaid)

Renewal: 10.2.32 to 21.1.36.

For the purpose of
visiting Germany, Russia,
Austria, Hungary, and
other countries. Is a
member of the Society for
Cultural Relations and may
accompany other members
of the Society on a tour
to Russia this year.

(S.C.R. 1, Montague St.)

Endorsement B.E.

Address on renewal: 25 Fitzroy Sq.,
W.1.

'Particulars' on the artist Felicia Browne kept by the Intelligence Services. This file note was recorded in July 1933. (*The National Archives*)

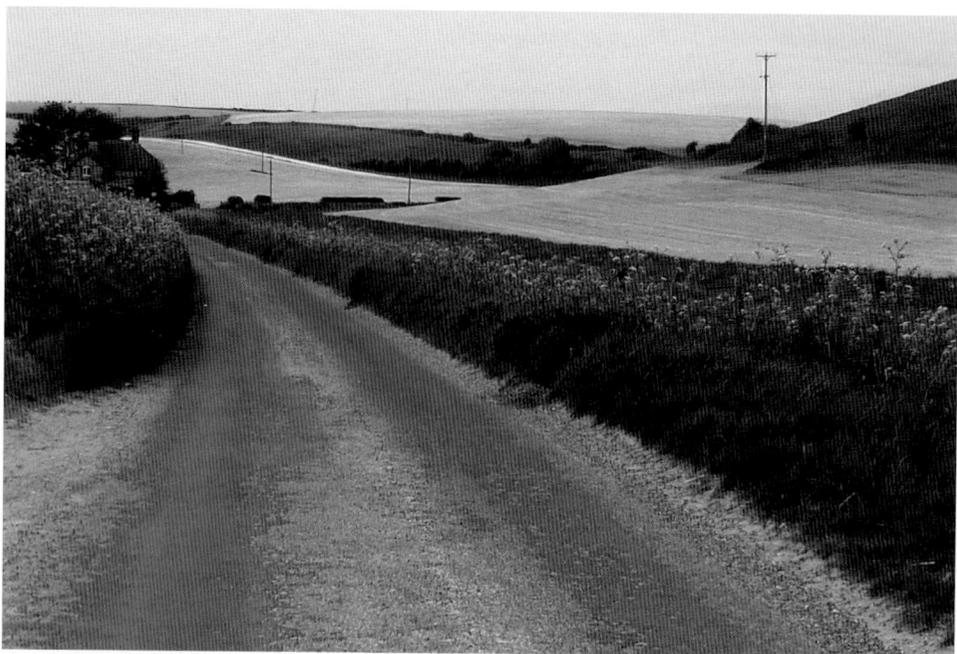

An unlikely setting for communist activities: the Chaldon Valley, looking back towards the village of West Chaldon, the home of Sylvia Townsend Warner in the mid-1930s. (*Author*)

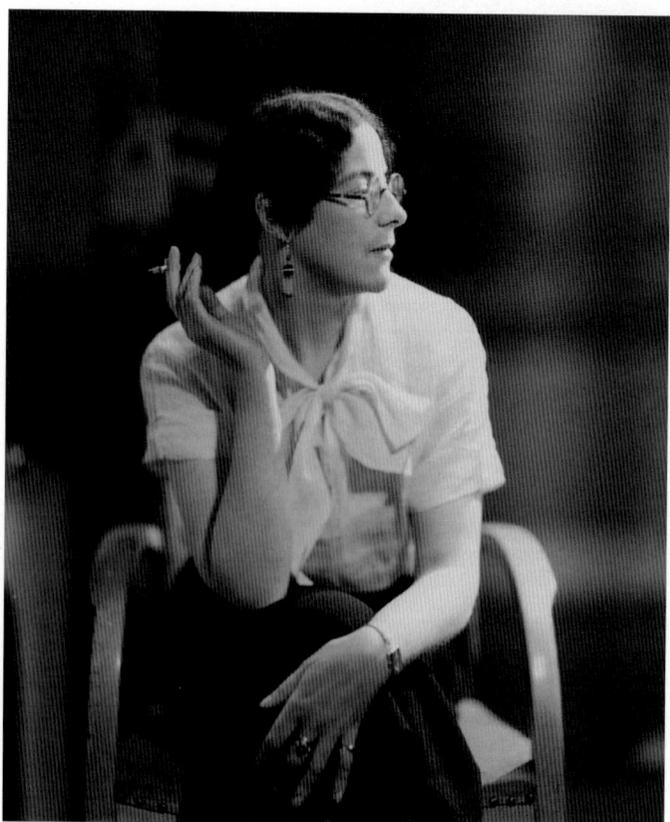

Sylvia Townsend Warner.
(© *National Portrait Gallery, London*)

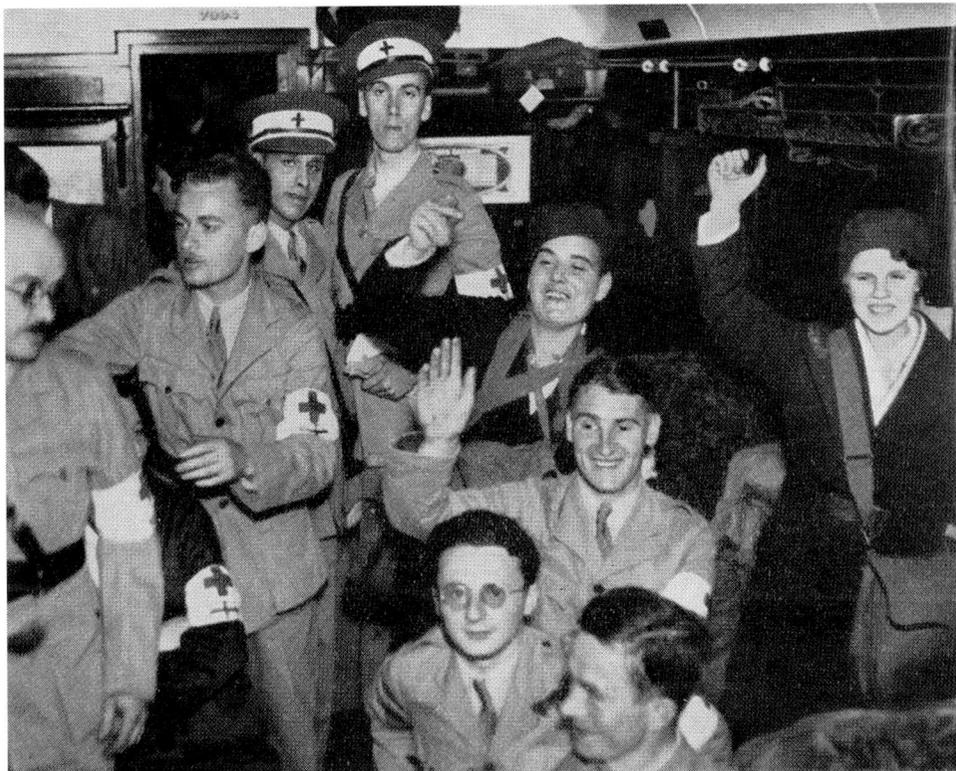

Volunteers for Spain leaving from Victoria Station on 23 August 1936. (*University of Bristol Library, Special Collections, DM1532*)

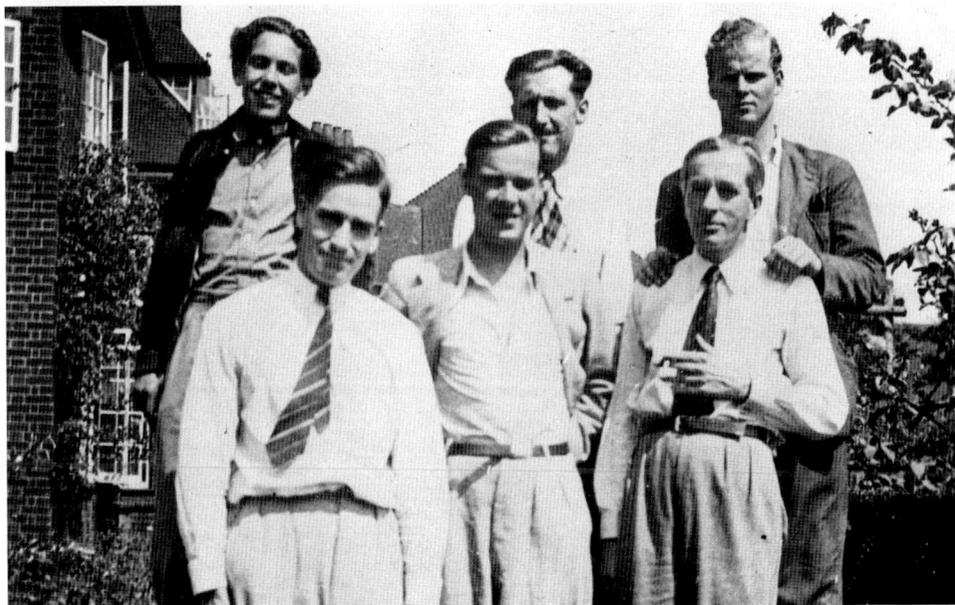

George Orwell (centre, back row) and other members of the Independent Labour Party's contingent to Spain, photographed in a garden shortly before leaving England, December 1936. (© *Imperial War Museum HU 51080*)

'Artist and philosopher': Clive Branson. He might have added 'poet, activist and Spanish Civil War veteran'. (*Rosa Branson*)

Wogan Philipps, photographed at the Valdeganga de Cuenca Hospital, Spain, on 6 June 1937. (© *The Estate of Alexander Wheeler Wainman, John Alexander Wainman* (*Serge Alternês*))

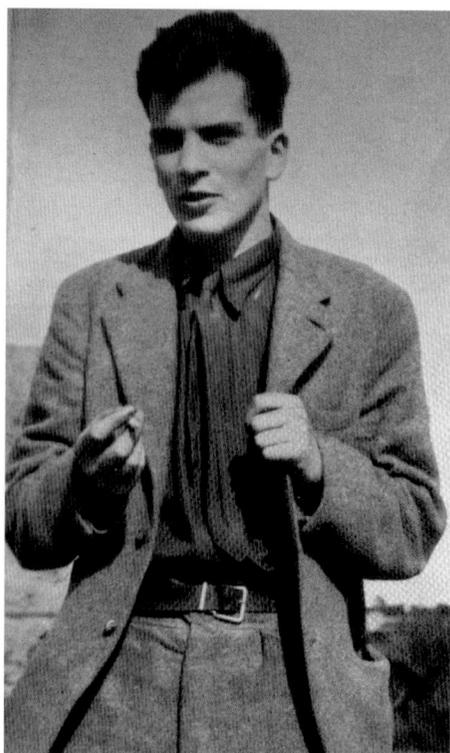

Paul Hogarth: the Artist as Reporter. (*The National Archives*)

John Cornford, poet. (*World History Archive, Almay Stock Photo*)

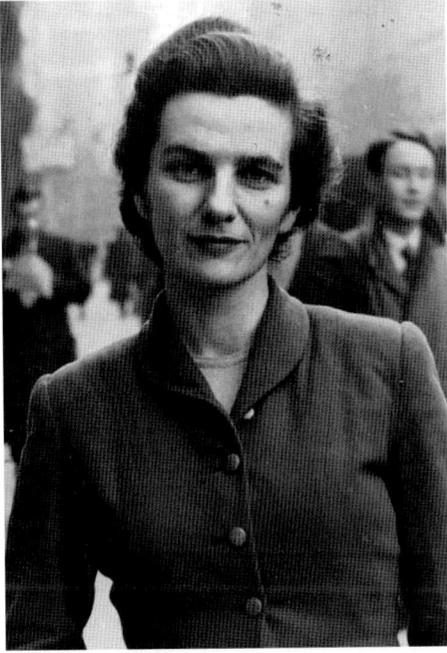

Margot Heinemann, writer, academic and loyal member of the CPGB. This photograph was used when she stood as a Communist at the 1950 General Election. (*Jane Bernal*)

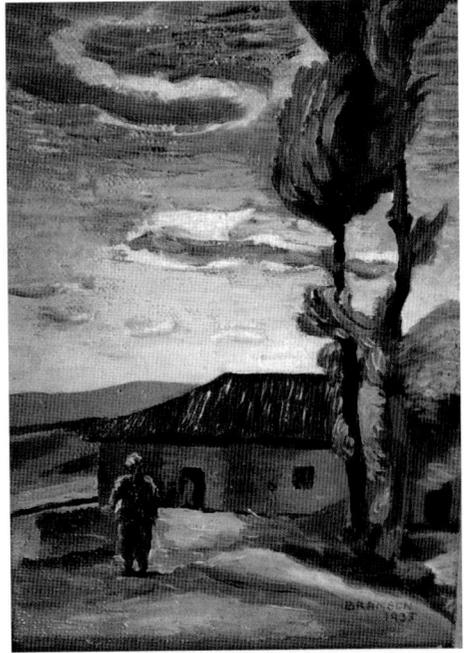

Civil War Spain, painted by Clive Branson as a prisoner of war, 1938. (*Rosa Branson*)

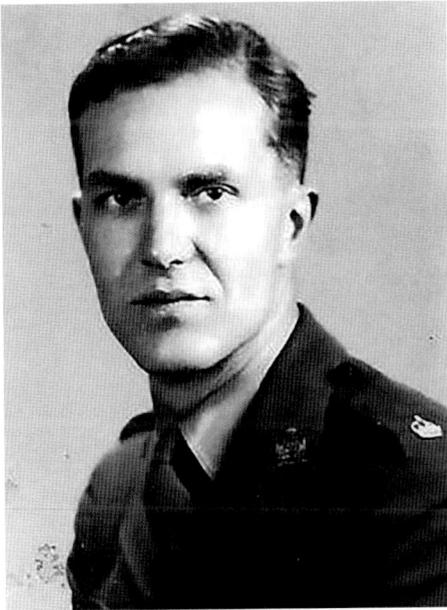

Major James MacGibbon in 1944. He would be under surveillance until the mid-1950s, followed at times by a team of watchers. (*Permission of Estate of James MacGibbon*)

Private Boswell, J. (7392959), photographed in Perth, Scotland. (*Sal Shuel*)

Noreen Branson (far right) and Margot Heinemann (centre), photographed in the Heinemann family garden in West Hampstead, London, during the war. On the left is Margot's brother Henry with his wife, while Margot's sister, Dorothy, is second from right. (*Jane Bernal*)

The poet Randall Swingler, who 'ran headlong into the BBC's communist cell problem'. (*Andy Croft*)

Novelist, Nobel Prize winner and MI5 target, Doris Lessing. (© *National Portrait Gallery, London*)

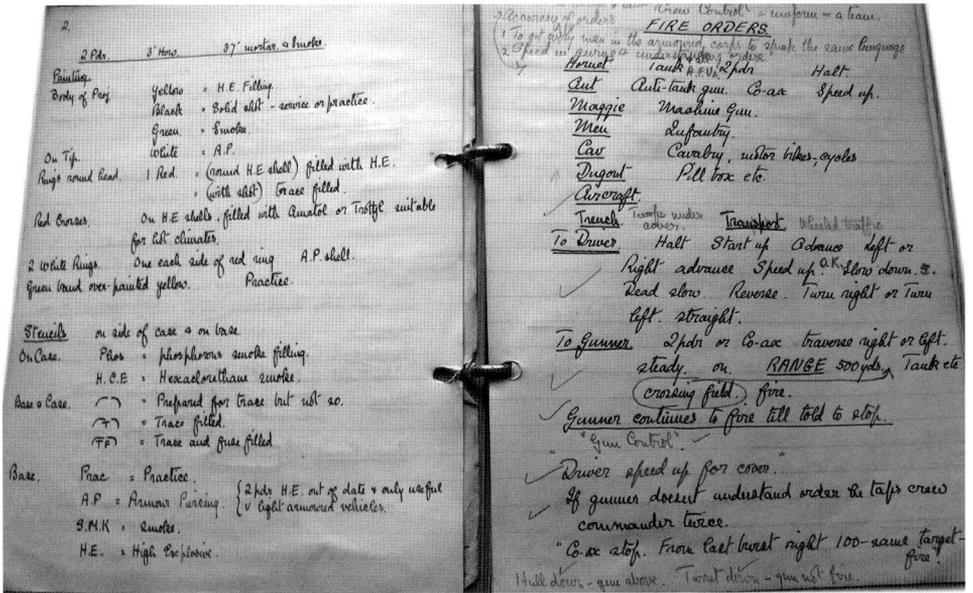

The artist as soldier: Clive Branson's gunnery notebook. (*Rosa Branson*)

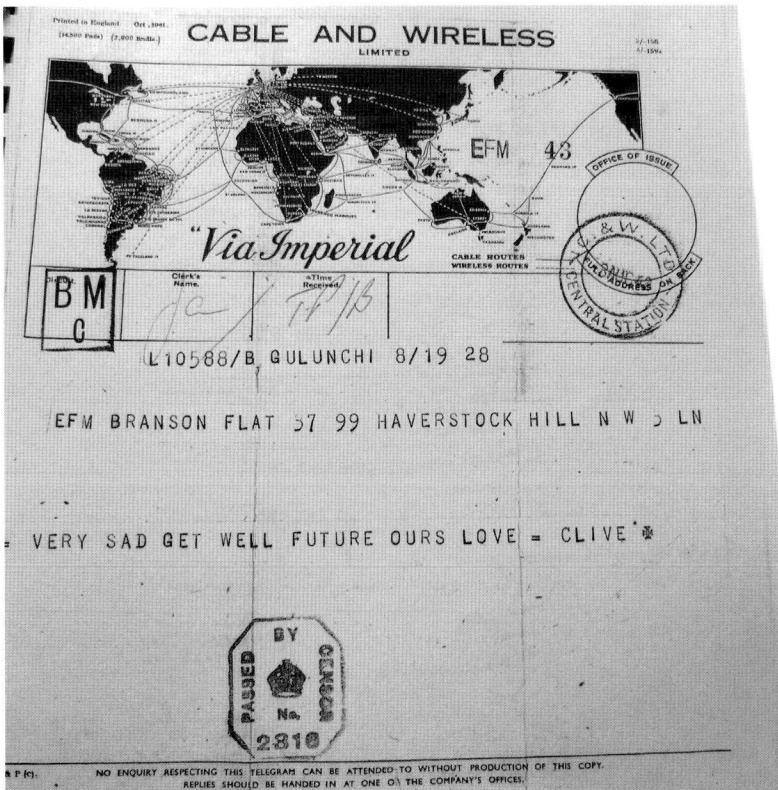

Few words, but heartfelt nonetheless: Clive cables from India consoling Noreen after the loss of the baby. (*Rosa Branson*)

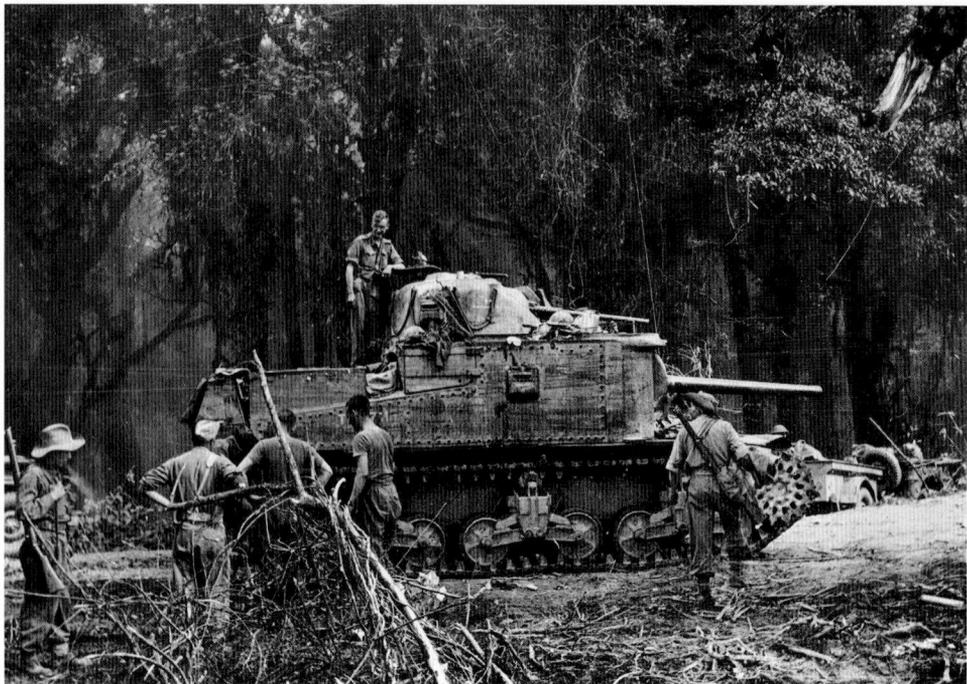
Tanks of the 25th Dragoons in the Burmese jungle. (© *Imperial War Museum HU 87183*)

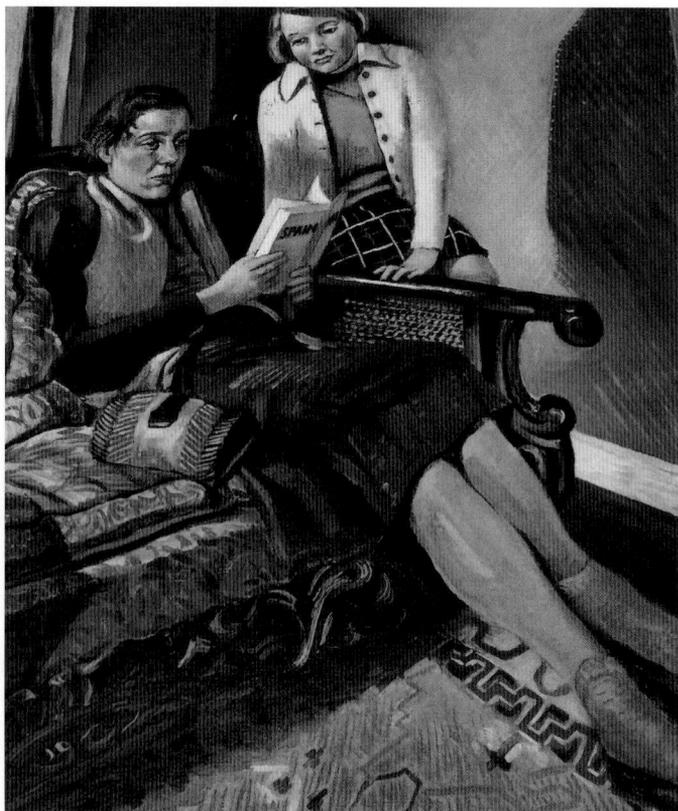
Clive Branson's painting of
Noreen and Rosa Branson.
(*Rosa Branson*)

Paul Hogarth's resignation from the Party preserved in MI5's files 'bizarrely daubed with a red stain like dried blood'. (*The National Archives*)

from Paul Hogarth Red House Lt Maplestead Halstead Essex Halstead 2946

Dear John Gollan: 29.iv.57

I, like so many others, were expecting a more statesman-like approach at the Congress which would have done much to restore unity in the party; instead, an attitude of evasion and vindictiveness prevailed. Why you cannot see the immense benefit of having an EC representative of both viewpoints is beyond me.

After the Congress I no longer feel I can remain in the party; this is no light decision since I have been a member since 1936. But, as many others have, I have been made to feel that there is no real and effective place for artists and writers in the movement; the most objectionable personalities have been in charge of this work too long and they have successfully stifled our wish to help, our iniative and confidence.

This is not a renunciation of my belief in Socialism; I will continue working along the same lines as I have always done but as an unattached humanist.

In 1957, Paul Hogarth resigned, declaring himself an 'unattached humanist'. (*The National Archives*)

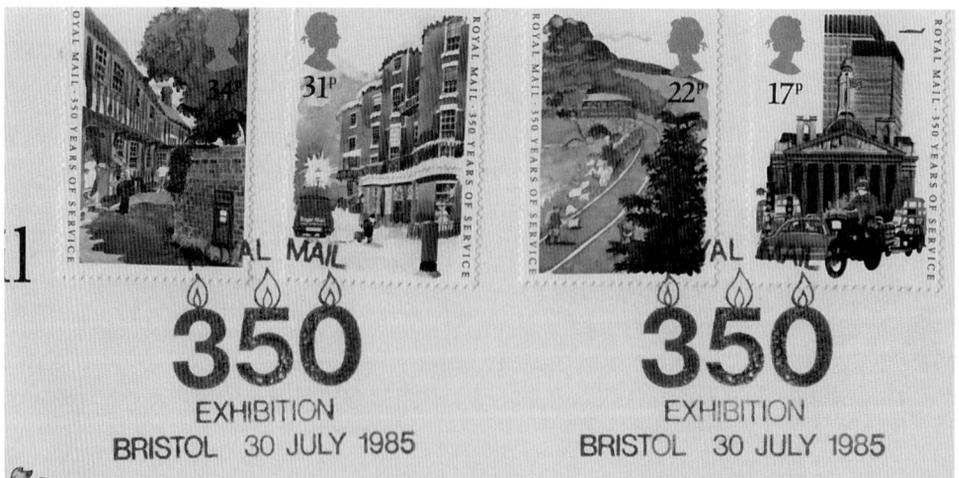

Paul Hogarth's designs for the Royal Mail to mark its 350th year. (*First Day Cover design* © *Royal Mail Group Limited*)

Hidcote Manor · Hidcote Bartrim · Chipping Campden · GL55 6LR · UK

☎ +44 (0)1386 438930 *Fax:* +44 (0)1386 438786 *VAT Reg.* No: 417 6465 39

Dear Pat & Mike 16·IX 97

The 1994 Château (?) Croix Chenièr is — to put it mildly — SUPERB!

Many thanks indeed for such a wonderful present!

Love

P.R.

A thank-you note sent from Hidcote Manor, Gloucestershire, with a characteristic Hogarth sketch. (*Mrs Pat Tayler*)

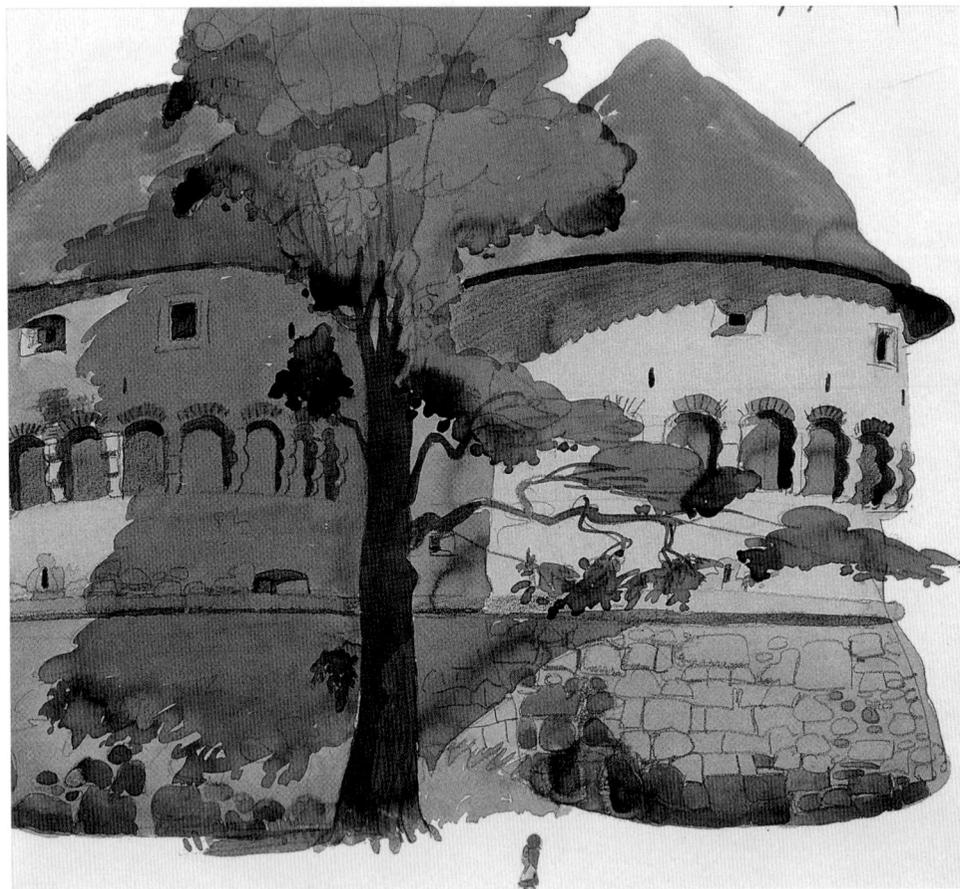

A typical watercolour by Paul Hogarth, the artist–reporter. Painted in 1995, the writer and artist John Berger wrote to Hogarth three years later, using the picture as his headed notepaper. (*Manchester Metropolitan University Special Collections*)

Hogarth at work. (*Diana Hogarth*)

Hogarth shortly before he died. He had 'seemed agitated and keen to get back to his painting'. (*Pat Tayler*)

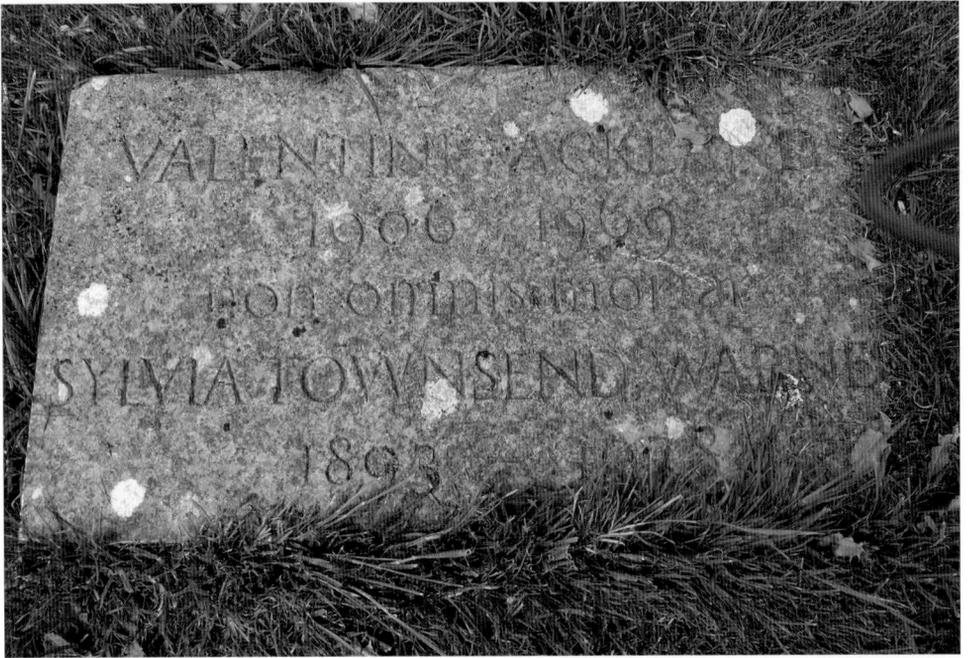

The inscribed stone over the shared grave of Sylvia Townsend Warner and Valentine Ackland. (*Author*)

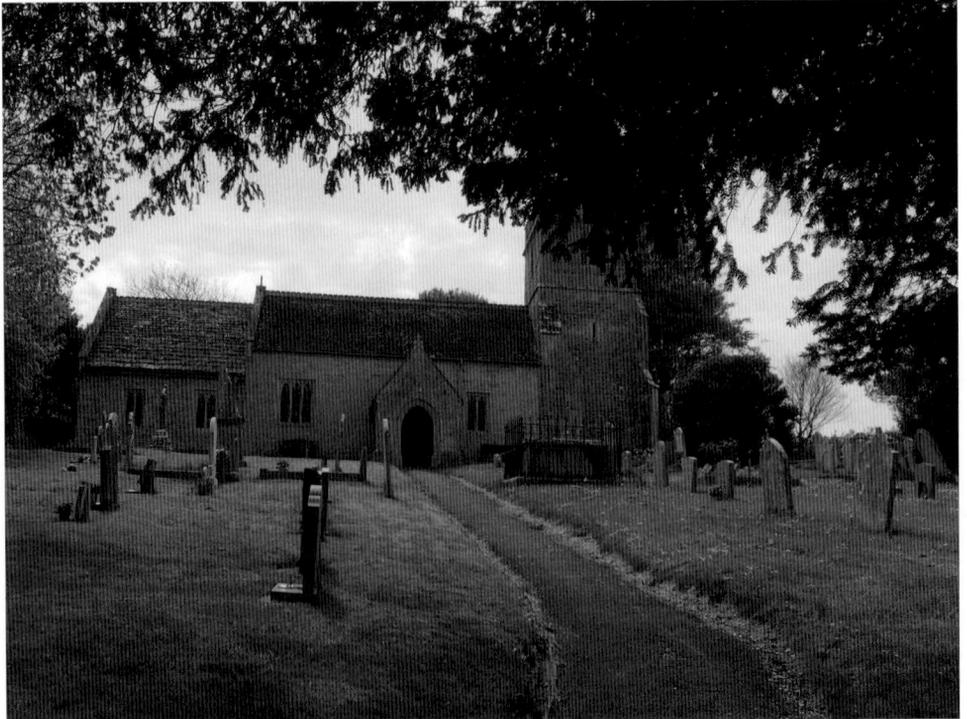

The church at Chaldon Herring, where Sylvia Townsend Warner was buried, a far cry from revolutionary Spain and MI5's campaign against communist artists and writers. (*Author*)

second series of *Postscript*. It was to be a short-lived return, a victim of 'the popular right-wing press' seemingly having the writer in their sights. Indeed the campaign began 'to look like a concerted attack led publicly by the *Mail*, the London *Evening Standard* and the *Weekly Review*, and orchestrated by the then Minister of Information, the Conservative MP, Brendan Bracken'.[12] Soon after, Priestley was taken off the air, this time for good and much to the writer's fury. Later, he held the BBC and the Ministry of Information (MOI) equally responsible, dismayed that each side blamed the other, something that hid 'the essential fact – that the order to shut me up had come from elsewhere'. He thought the whole thing 'contemptible', arguing that the British were 'democratic and free in theory' but that wasn't the case in practice. 'Men are squeezed out of public jobs,' he wrote, 'not for political reasons – oh, dear no! – but because they are discovered to be not quite the right type, not sound, old boy.' The government's methods comprised a 'stealthy hocus-pocus', he declared, incensed by what he saw as 'the British way, slimy with self-deception and cant'.[13]

The novelist Storm Jameson was another writer whose politics scarcely justified the level of attention accorded her by MI5. She had been on the 'watch-list' as far back as 1933, her involvement with the British Anti-War Council – and her £10 donation – deemed worthy of official note. Thereafter, every hint of 'leftwards looking' was recorded: her connections with the Council for Civil Liberties; the Women's Committee Against War and Fascism; the Abyssinian Relief Fund; the International PEN Club, and so on. By 18 April 1939, she was regarded as 'associated with a great variety of anti-fascist and pacifist material' and vetted by the Public Trustee Office and the MOI (who thought her 'unsuitable'). The novelist Graham Greene, then working for the MOI, tried for a second time to recruit her in August 1940: 'We are anxious', he wrote, 'to arrange a short book by Miss Storm Jameson on the women's war effort in the factories and workshops.' Greene's request was rejected in a letter of 19 August, which insisted that it would be 'more fitting if another writer of eminence whose views were not those of Miss Jameson, had been selected'.[14] Ironically, Jameson was appalled at the prospect of such a commission anyway, declaring that the work comprised writing 'a stinking little booklet', research for which would be 'most dangerous'

since she would be required to visit 'arms factories … in the middle of a Blitzkrieg!' In the event she did complete two weeks of such visits, but the book was never written.[15]

Storm Jameson's war was a turbulent one, beginning with the 'shame and guilt' she had felt at 'Britain's handing over her Czechoslovakian friends and colleagues to Hitler'.[16] These were emotions that never left her. When the much-admired Auden left for the United States early in 1939, she was shocked ('a tremendous blow')[17] – and things were to get much worse. The situation in France in the early summer of 1940 made her 'cry tears that corrode my inside'. Later, she came to regret the long hours of work for PEN, which took her away from her own writing; the fate of writers in Europe who vanished, or were consigned to prison or camps, disturbed her; the internment of enemy aliens in the UK was equally a concern. In addition, she was ill, suffering from a painful and debilitating ulcer. Home never seemed a fixed point, shifting from Berkshire to North Wales and then York ('slatternly lodgings at 55 Monkgate').[18] While visiting Poland at the end of the conflict proved deeply troubling, the result of seeing 'the ruins of Warsaw ("ossuaries of fractured stone and brick")'.[19]

All this correspondence went into her file: so too the letter she wrote to Tom Wintringham in the autumn of 1940. Much of the letter is taken up with apologies for her 'not making time to write your article' – she wrote slowly … had been ill … was working on a book. Wintringham had evidently delivered a 'preliminary blast' in his letter and it prompted Jameson to point out 'all the trouble I have taken (and not my own wish) to keep up "Right" contacts [that] I should be very glad to drop'.[20] Did the irony strike anyone at MI5: that it was watching a writer who, in turn, was prepared to sustain 'contacts' with people on the right for the communist Tom Wintringham's benefit?

'One of the More Important Communists'

If left-leaning non–communists were deemed worthy of sustained observation, it is unsurprising that confirmed members of the Party were subject to a more rigorous level of surveillance. The poet Randall Swingler had been listed for 'special observation' early in the war, with the result that MI5 took detailed and careful note of his activities, correspondence and published writing. For example, his file contains a press cutting and a file note, dated May 1941, of Swingler's piece in *Our Time*, which sharply criticised a number of poets, including Auden, Spender and Louis MacNeice. 'The rhythm of their writing has become increasingly melancholy, grey and flaccid,' he wrote, going on to declare that the war had ended 'that literary generation'. The exiled Auden came in for particular criticism, Swingler writing that 'his conspiracies, legendary plots, amazing assaults upon social life, look silly and childish now before the blatant conspiracies of real politics'.[1]

At the end of that month, one of MI5's 'watchers' reported on a conspiracy of some kind in which Swingler himself seemed to have been involved. The anonymous agent had been tailing the musician Georg Knepler, an Austrian communist who had helped set up a secret Party cell in the Workers' Music Association, before spotting Swingler emerging in the early evening from the Cranbourne Hotel where had been drinking. The poet was 'alone and then walked and ran to St. James Park where he sat on a bench until 8.40 p.m'. The agent's report bears the hallmarks of a spy movie: evening shadows; a solitary figure, head down, dozing on a park bench; oblivious lovers strolling by arm in arm; and a shifty man in a trilby and grubby raincoat leaning against a tree, dropping cigarette butts on the early summer grass. Time drifted. Eventually Swingler stirred himself, walked out of the park, clearly on his way to a rendezvous, which turned out to be the 'Sussex' public house. He emerged staggering from there just before 10 p.m., 'obviously drunk', and then meandered towards

Richard's Buffet Bar in Leicester Street. His shadow stuck doggedly to his task: 'Observation was continued here until the bar closed at 12 midnight.'[2]

Once Swingler had been called up in August, MI5's interest in him mounted: there were concerns voiced about his involvement in 'subversive propaganda and activities' and great reluctance to consider him for officer training, despite his Winchester and Oxford education. How could Swingler's 'loyalty' be trusted? Then, before Swingler could set off for Catterick, chance intervened in the shape of two traffic accidents: first, his 6-year-old daughter, Judy, was knocked down by a car in the road outside the Swinglers' cottage; then Randall himself was in a taxi that collided with a police car when he was on his way to visit his daughter in Colchester hospital. He broke several ribs and father and daughter ended up in adjacent hospital beds. A telegram wired to the army – 'PRIORITY REGRET ACCIDENT RIBS FRACTURED UNABLE REPORT THURSDAY CERTIFICATE FOLLOWS' – did not reassure MI5. The Service's Captain Mark Johnstone wrote to Major Lord George Cholmondeley OBE, MC, at Northern Command Headquarters in York early in October, hinting at unsoldierly prevarication, rather than ill luck. 'It is some little time since Swingler received his call-up notice and he has managed for one reason or another to avoid actually joining his unit.' There followed a period of confusion: was Swingler in a military hospital? Or a civilian one? Has 'this man … ever been with any unit, or whether he is in all but name still a civilian?' Such uncertainty made Johnstone's correspondent crotchety: 'Would you kindly enlighten me?' Essex's Chief Constable, Captain Peel, was asked to arrange surveillance on Swingler (5 feet 7 inches; straw-coloured hair; grey-green eyes). At the end of November, MI5's acerbic Wendy Ogilvie noted in the Swingler file that he was 'on check at his country fastness', this of a man who lived in a ramshackle cottage. She evidently had little time for the poet and his 'two-monthly little rag [*Our Time*] … designed to appeal to the highbrow … It can hardly be said to take the place of the *Daily Worker.*' The surveillance generated paper at a great rate: there were Swingler's bank statements and other financial paperwork; a cryptic letter from the writer William Golding's wife, Ann, hinting at romantic subterfuge ('It was extraordinary to see you the other day. I'd felt rather nervous about

it, that I might have been cherishing a sort of romantic memory ...'); articles written by Swingler for various magazines, and so on.

Essex Police kept watch diligently and with some disdain: on 2 December 1941, for example, one officer noted the Swinglers' 'large size cottage', its 'remote' location and the attitude of the locals: 'among the country folk, they are looked upon as strange people'. Randall had, days before Russia joined the war, 'given vent to his political views when in the local public house with his friends from London', an outburst that made him 'very much disliked'. His wife, Geraldine, was referred to as 'a musician in a London dance band', a judgement that some unknown MI5 philistine judged worthy of a solitary ridiculing exclamation mark.

Eventually, Swingler was instructed to report to Catterick Camp on 30 December 1941. His 'manifestly patrician manner of speech' was enough to set him apart from his fellow recruits, but eventually it was judged to be a sound enough reason for the army to urge him to apply for a commission. This he passionately resisted, preferring instead to remain plain 'Signalman Swingler'. Catterick, he told Geraldine, 'is a desolate place', its grimness made worse by the endless queuing, the sergeants and senior NCOs ('officers' arse-lickers, smart guys and pretty nasty'); and the mindless activities ('the sergeants just hate to see anyone sitting down, reading and writing'). His fellow soldiers, though, proved a big consolation and eventually he got used to the regime, with its echoes of boarding school. Moreover, he was readily accepted by 'other ranks' who called him 'Charlie' initially, before switching to 'Shakespeare' (a blokeish nod towards poetry); and then 'Joe' (after 'Uncle Joe' Stalin, once Randall's communism became manifestly apparent).

In the middle of 1942, Swingler was cleared for overseas service, a prospect that sent anxious ripples through MI5: 'As Swingler is one of the more important communists we should know where he is and what he is doing.' MI5 were aware – from reading an internal CPGB letter – that his time at Catterick had seen him do 'very good work in his unit for the Communist Party'. In August 1942, Swingler and a contingent from the Royal Corps of Signals sailed from Liverpool, the troopship convoy bound for an unknown destination. He was at sea for many weeks before eventually docking in Bombay. From there, he travelled by smaller ship, troop carrier and cattle train to Baghdad, where 'the population

demonstrated their loyalty to the British by pelting them with rotten fruit, decayed vegetables and dried camel dung'. Eventually, after ten weeks of travelling, they reached Kirkuk in northern Iraq, where they pitched tents in heavy rain and 'a desert of dense, sticky mud'.[3] It felt that they had arrived at the world's end.

11

Clive in India

'I lay on my back on the deck looking up
At a star which swayed from side to side
In a sea of perpetual space ...'[1]

After many weeks at sea, some of it spent gazing at the stars and wondering what lay ahead, Clive Branson found himself looking once again at the coastline of India. His troopship docked in Bombay in May 1942, a few months before Randall Swingler landed at the same port. Clive was shocked by the poverty he saw – 'a howling disgrace', he told Noreen in a letter home.[2] At the same time, he was exhilarated by Bombay's teeming humanity – 'What a people this is for painting!' – and immediately set to, sketching and scribbling notes, determined to remember it all 'when this bloody business is over'. Typically, he was keen to learn Hindustani and scoured the city's bookstalls for a suitable textbook, but was unable to buy one ('I had no Indian money').[3] It was the rainy season in Bombay and the weather was cooler than it might otherwise have been, but that would soon change. The regiment left Bombay by train at the end of the month and by 31 May was established at Gulunche Camp, near Poona ('Gad Sir – when I was in Poona in '42', Clive wrote to Noreen.) The men were billeted under canvas but there was some temporary comfort in the slackening of the heavy rainstorms. However, it was very hot, so much so that the men took to swimming in a nearby canal until a widespread outbreak of stomach trouble made that unwise. The rains returned, blocking roads, 'tracks become mires, and the earth goes a deep purple with very green vegetation. Lizards, scorpions and ants are driven into the open.'[4] Branson was longing to spend time sketching, 'providing, of course, that I get the CO's permission', conscious that India and its sharp, unflinching light had given him a new, heightened sense of colour. He started to contemplate a series of large wall paintings.

There were days when he found memories of home particularly painful and he was also aware that he was dreaming a lot, and not just at night. 'The sky today', he wrote on 11 June 1942, 'is that of a fine English summer day, but one misses the great elms with their leaves piled up like banks of cloud.' Physically, he felt fit enough, although he was very conscious of being the old man of the squad – he was, after all, in his mid-thirties when most of the men were perhaps ten or more years younger. His letters home often made brave attempts at optimism, looking forward to a shared future, or encouraging Noreen to treat the situation positively: 'Whatever happens,' his letter continued, 'keep your chin up and make the best of life.' At other times, he couldn't resist voicing a longing for a different life from the one he had been dealt. 'God,' he wrote, 'how I would love to hear some great music with you and be able to paint.' When eventually he got back to England he was determined to 'paint lots and lots of really exciting pictures like Rubens'.[5]

But the reality was that army life was of a kind to foster pessimism. There was the 'daily piffling aggravating bullshit'; the niggling sense that his letters home would never arrive, or be censored down to nothing; and the army's way of elevating the pointless. 'Tobruk has fallen,' he wrote on 11 June 1942, 'and we have been ordered to polish all brasses on our equipment.' A week or so later, after parade, the troops were asked who amongst them had seen active service. Clive volunteered that he had, but his hopes of some meaningful activity were dispelled when it emerged that what was being planned was a 'bullshit parade' for the visiting Duke of Gloucester. It meant days of polishing boots and brass and a group of Indian tailors frenziedly working to produce 'clothes for the white sahibs to wear like bloody waxworks'. It was far removed from fighting and resisting fascism. 'Sebastopol is falling,' he wrote, 'and our CO is disappointed at the lack of polish on the topee chin straps.' For Branson, the duke's parade merely produced bitter memories of the 'senseless' war in Spain, and an outbreak of septic blisters. He was aching to draw – 'How long is it to be before I get the chance to paint pictures again?' – and he fumed at both the army's tedious rituals and the wasted inventiveness the Other Ranks deployed to kill time – the fly trap, for example, made from a bottle and baited with army tea. Clive was intensely angered by the contrast between this indolent drudgery and the savage fighting on the

Eastern Front: 'Now don't you think our Russian Allies would be proud to know of how I spent this afternoon?'

Later that summer, Branson received an unexpected airgraph from home: Noreen was pregnant, a prospect Clive thought 'wonderful'. It was nearly ten years since their daughter had been born. Elated, he suggested possible names (with predictably communist or suffragette origins) and urged her to take the greatest care of herself, Rosa and the unborn baby. For his own part, he was thinner, he told Noreen, and struggling with the army food, reduced to buying 'a packet of Kellogg's Corn Flakes in order to put into my poor tummy some clean food'. Impending fatherhood buoyed his spirits though; so too the dream of returning to a life of painting, reading and lecturing – 'living', in fact.

At the end of July he received sad news: a telegram from Noreen informed him that she had lost the baby. He wrote straight back, deeply saddened by their loss, but trying hard to offer some kind of consolation: 'Anyway, no moping,' he wrote, 'we have dear little Rosa and we have all that the working class has taught us.' Typically, he turned away from the pain of her news and reported at length on other, less emotive matters: his recent weekend in Poona; a planned route march; the presence of fascists in the British Army; the lack of a second front; and the heroism of the Russians. The sadness provoked by Noreen's news was inescapable, however – ('I hope to goodness you are all right'). A troubling period of silence from home then followed, while military life continued its demoralising way – 'We are like prisoners out here, like lepers.' Letters from home started to come out of sequence, and then, for a time between July and September, there were none at all: 'It is nearly two months since what happened and no news. I am ever so worried.'

Clive was sustained through that grim summer of 1942 by planning the kind of future he and Noreen might enjoy when the war was finally over: they would visit China together and come back to peacetime India 'as civilian friends', the days of anti-British hostility having finally ended. There were also occasional spells of leave that helped alleviate the drab routine: he went to Bombay, where he enjoyed views of the Indian Ocean from his hotel balcony, watching waves breaking on the nearby rocks; took long walks; and met left-wing friends (the president of Bombay's TUC for one, freshly released from prison). He took pleasure in the city's

huge bookshops, but was astonished to see stacks of Hitler's *Mein Kampf* piled high. Despite that, the leave had been uplifting: 'I shall never forget Bombay,' he wrote.

Leave ended with a midnight third class train journey in headache-inducing heat back to Gulunche camp and its unchanging rituals. Once again he became consumed by anger at the reluctance of the British and the Americans to support their Russian allies: 'Churchill is a bastard for not opening the Second Front and for his speech on India!' And then, as well as anger, there was the uncertain prospect of what the future might hold: 'We English fellows came out here to fight the Japs,' he wrote, 'and face the possibility of finding a grave in India.'

No Peace for MI5

The defeat of Germany in 1945 signalled a decline in MI5 numbers, their staff being reduced from a total of '897 in July 1945 (down from a wartime peak of 1,271 early in May 1943) to 570 in 1947'.[1] Nonetheless, it was soon clear that, with the 'Iron Curtain' descending over Europe, the peace was precarious and fickle. By 1948, the Berlin Air Lift, when the West supplied Berlin with essential supplies to thwart a Russian blockade, demonstrated that the Cold War was a disturbing reality, its threat fuelled by the shadow of the atomic bomb. MI5's focus on the communist enemy could not be relaxed, this despite the Labour government's wariness of the Service's apparently right-wing agenda. Despite that caution, the Prime Minister, Clement Attlee, established a Committee on Subversive Activities in the spring of 1947. The need to keep Britain's communists under surveillance was, it seems, undiminished.

MI5's methods, and those of Special Branch, were little changed: they ferreted around in people's post, bugged their phones and had no qualms about breaking and entering buildings in order to obtain information. That included burgling the CPGB's HQ in King Street: for example, a Special Branch Officer noted that he had surreptitiously copied valuable information from an account book in the King Street office. The 'Watchers' continued to watch, while anonymous informers regularly channelled reports to MI5 officers. For example, Randall Swingler's various activities were systematically passed on by an agent codenamed 'Conquest'.

There was, however, considerable scope for human error – or even stupidity – in the complex web of the organisation's observations, cross-referencing and annotation. The paperwork, and the conclusions drawn from it, could be inaccurate or unreliable: opportunities were missed, mistakes made and unsupported judgements left unchallenged. On a

very basic level, there were crass errors of spelling: the novelist Doris Lessing was variously described as 'Dorothy Lessing' and 'Doris Lacey', while Paul Hogarth's name was logged as 'Van Goff' in a transcribed phone conversation. The communist historian Eric Hobsbawm's name was rendered as 'Hogsdawn', 'Hobsthorn' and 'Hobsbone' at various times by hard-pressed listeners numbed by long stints struggling to hear whispered conversations on crackling telephone lines.

There were other, more serious mistakes, perhaps where an initial judgement had unintended, significant consequences, or where failures of the various agencies to liaise and share information proved problematic. At other times, effective action or communication was unaccountably delayed. The publisher James MacGibbon figured in one such case. As early as 1938 – two years before the painstaking search of his house and belongings in rural Berkshire – it was noted on a 'Complete Information Card' that his car (registration FPE 198) had been parked outside a Communist Party meeting in Barnes, West London.[2] A year later, his work for the *Daily Worker* was logged. After the house search conducted in 1940 it was recorded that 'both Mr and Mrs MacGibbon have been connected with extreme Socialism'. Predictably, MI5's Sir Vernon Kell was kept informed of developments by Berkshire's Chief Constable, but it was only after some four weeks had passed that any serious notice was taken – MI5 officer Alan Johnstone observing that 'this has only just come to hand from Registry'. Even then, Johnstone's response was relaxed and low-key. Not everyone was so willing to accept such a dilatory approach. A note on 3 August complained that it had taken 'over seven weeks to look up former papers (which, unfortunately, are not helpful)'. There were – eventually – questions asked about Second Lieutenant MacGibbon's suitability as an Army Intelligence Officer, or indeed whether he should even hold a commission, given his political views and recent past. But despite the doubts expressed by MI5's Lieutenant Colonel Norman, MacGibbon continued his military career unhindered. 'For the rest of the war,' his son Hamish later recalled him saying, 'no secrets were withheld from me,' this despite the fact that as far back as the spring of 1941, he was working in the important War Office department that would in due course assume responsibility for Invasion Planning. It would be 1947 before any serious interest by the Intelligence Services was instigated,

despite the steady flow of secrets passed by MacGibbon to Soviet Russia, and two more years passed before 'James was assumed to have been a spy, or at least a talent spotter for Russian Intelligence'.[3]

* * *

By the end of the war, the British were exhausted, the country grey and anaemic. Its writers and artists were no different, irrespective of their involvement in the conflict. For some, the post-war world was profoundly unsettling. Sylvia Townsend Warner and Valentine Ackland, for example, shared an alienation from the changed state of things, sensing that 'the system of values in which they had grown up and flourished was being rapidly eroded'.[4] Valentine herself noted that both of them were now 'peculiarly tired', battered by fatigue and affected by an 'impacted rage'. Sylvia had already begun to resent how those who had fought fascism years before the war broke out were now suspect, even ostracised. 'Have you observed', she wrote, 'that those who stirred as much as a finger for Spain are left for the kites and crows to deal with?'[5]

The end of Randall Swingler's war happened when he was in Gradisca, north-east Italy, near the border with Yugoslavia. After Iraq, he had been posted to both North Africa and Italy, which he told his wife, Geraldine, was 'a horrible country to fight in' – it was 'messy and dirty and very unpleasant'. He too was exhausted, shaken by an emotional mix of pent-up longing and anger. He was disturbed by the treatment meted out to those whose land was being occupied, believing that they should be regarded as allies, not a defeated enemy. 'But no, that would never do,' he wrote to Geraldine on 22 May 1945, 'they haven't got whitened equipment and polished brasses and you can't bring their officers into "the mess" because they are indistinguishable from the men. In fact, they are communists and therefore less to be trusted than the Germans.'[6] At one point he read Clive Branson's *British Soldier in India* with considerable interest since he had known Branson before the war.[7] Swingler was finally released from the army in March 1946, like many others, to a precarious and unfathomable future. He was deeply depressed, 'spiritually shattered and very, very tired', losing his hair, unable to sleep, and when he did, he 'woke screaming from nightmares where he was buried alive'.[8]

As well as working for the Ministry of Information, Storm Jameson had been able to complete three novels between 1941 and 1943. Throughout that period, she was 'furiously active' supporting 'foreign writers in this country, free French, Czechs, Poles, Norwegians, Belgians, Catalans, Germans and Austrians'.[9] Her concerns about what she saw as a drift towards communism of both PEN and the country as a whole was noted by MI5, which also took cognisance of her delight at learning that she 'had been sentenced by the Soviet "peace fighters", with much more vehemence than in the Nazi Black Book of (I think) 1940'. Once the war was over, she longed to get away from England, but when she finally did, it was only to find a Europe that was broken-backed and oppressed by the atomic threat. Despite her evident distance from communist politics, there remained enough doubt about her for MI5 to keep her file open.[10]

Stephen Spender was another writer keen to leave the country as soon as hostilities ended; indeed, he became 'obsessed' with the idea of getting into Germany, according to his son Matthew. The younger Spender was 'a babe in arms' in 1945, but remembered the mood in Britain in the early 1950s and could understand 'how deep the craving was to get out of recently besieged Britain as soon as the fighting ended'.[11] Stephen flew from Croydon Airport on 6 July 1945 in an RAF Transport plane, charged with a mission to the Rhineland to 'investigate, and report back on the intellectual climate of German universities to the British authorities'.[12] A few months later he returned, this time to inspect German libraries on behalf of the Allied 'Control Commission', and subsequently worked for UNESCO travelling to the United States, a visit that initially provoked difficulties over his visa. The Americans had wanted to know if he had ever been a member of the Communist Party and the poet gave a truthful reply – that he had been, but only for 'about a fortnight'. That query apart, Spender remained on the periphery of MI5's vision in the early years of the Cold War. That would change once he became enmeshed in the brouhaha following the defection of the Soviet spies Donald Maclean and Guy Burgess in May 1951.

Like Spender, J.B. Priestley remained subject to continued monitoring by MI5. His involvement in 1942 with the establishment of the Common Wealth Party had generated further security interest in him. As a result, his public appearances were routinely watched and reported on, one

watcher observing that Priestley had 'made a speech in which he said nothing at all but put over his personality and got a lot of laughs'.[13] Despite being party to telephone conversations that clearly showed links between Priestley and the CPGB's Harry Pollitt, MI5 had raised no objection to the writer lecturing at the Army School of Education, Harlech, in 1944. Indeed, his links with both Pollitt and Soviet Russia continued after the war had ended: Priestley visited Russia in May 1945, while, in August of the following year, he told Harry Pollitt that he hoped 'when we settle in London again you will come to our flat in Albany and we can have a chat'. His file remained open despite his evident disdain for communism: MI5 were well aware that he had resigned from the Society for Cultural Relations with Russia, for example, Priestley insisting that they 'remove his name from their notepaper'. He had come to think that such organisations were 'merely disguised Communist platforms'; there were, after all, no such corresponding societies in Soviet Russia that promoted 'English culture'. In 1952, he also resigned from the General Council of Unity Theatre, a parting of the ways that the *Daily Worker* of 24 January that year reported as the writer being 'disowned' by the actors' group. Remarkably, the MI5 file on Unity Theatre remains closed to this day and is not judged fit to be seen by the public until January 2027.

Like Spender, W.H. Auden and George Orwell were both in liberated Europe when the war came to an end. Auden had flown to Europe in late April 1945, wearing the uniform of a major in the US Army. He was in the German city of Darmstadt on VE Day, working for the US Strategic Bombing Survey (abbreviated in a kind of Disney-speak to 'Uzzbuzz') and living in a house that had been hurriedly vacated by a Nazi couple. When they eventually returned, it fell to Major Auden to tell them that their parents had committed suicide, and before they had done so, they had killed their children.

George Orwell had been working as a war correspondent for *The Observer* since February 1945, both in Paris and, later, in Germany. He had left the BBC, becoming literary editor of *Tribune* two months later. He too remained subject to surveillance. On 18 October 1943, a formal 'Request for Look-up' on 'Eric Blair' had been asked for when *The Observer* wanted to despatch him to Allied Forces Headquarters in

North Africa. The response was relaxed, as if Orwell was unlikely to do any damage so far away from Europe: 'The Secret Service have records for this man,' was the response, 'but raise no objection.' Allied Forces HQ also raised no objection, although it did seek 'a brief résumé' of what was known to various government agencies. In the twelve months prior to the end of the war, Orwell suffered a series of blows: the refusal by Gollancz to publish *Animal Farm*; further rejections from other publishers, including Faber and Jonathan Cape; and, most tragically, the death of his wife Eileen in what was expected to be a straightforward hospital operation.

* * *

It did not need a past tarnished by a brief flirtation with communism to set the MI5 dogs barking. The novelist Olivia Manning, for example, was no left-wing firebrand. Her first love affair, with a fiercely right-wing Catholic, had blinded her to the left-wing passions of the 1930s. She was largely unmoved by the king's abdication; the looming threat of Hitler's Germany passed her by; while she showed no interest in Nancy Cunard's 'Authors Take Sides on the Spanish Civil War'. Had she been back in England for the 1945 election, she would most 'probably [have voted] Conservative given the Tory sympathies inherited from her father'.[14] The sudden death of her lover, Hamish Miles, of a brain tumour in 1938, reinforced her disregard for politics – 'she never entirely overcame the searing shock'.[15] Nonetheless, MI5 was unconvinced, despite the evidence to the contrary, by her seemingly apathetic attitude to the great matters of the day. Manning was married to Reggie Smith and that was quite enough for them.

When she married Reggie at Marylebone Registry Office in August 1939, she had only known him for three weeks. Smith's best man was Louis MacNeice, a longstanding friend of Reggie's, while the poet Stevie Smith was also at the ceremony. Drinking mint juleps in the bar of the Ritz that day, they were all 'on top of the world'.[16] Olivia might be apolitical, but her new husband was a flamboyant communist, and a 'cheery optimist' to balance her 'sardonic pessimism'. Moreover, she could see that he was 'unreliable, unfaithful, unpunctual, slovenly, hopeless about money', but

he was also 'dashing, classless, full of kindness and with an ability to inspire others'.[17] Within a matter of days, the newly married couple had set out for Bucharest, where Smith was working for the British Council.

Olivia and Reggie spent the war years abroad, initially in Romania, and then in Cairo and Jerusalem, before returning to the UK in 1945. Thanks to MacNeice, Reggie landed a post with the BBC, initially as a producer, then in the Drama Department, while Olivia continued to write, an occupation that someone at MI5 thought worth a grudging recognition: 'Mrs Smith is an authoress of some distinction.' It was also recorded that 'she probably has left-wing views in politics, but is not body and soul with the Communist Party like her husband'.[18] Reggie was the one that MI5 pursued energetically, not least because it was clear that he was established at the centre of a spider's web of contacts, Party members and fellow travellers.

On 12 May 1947, a letter was sent to the BBC's Personnel Department inquiring whether a 'Reginald Donald Smith' was employed by the broadcaster since 'a reliable and delicate source' had denounced him as a communist. By that October, a warrant had been issued to record all the telephone calls made on Grosvenor 2714, Reggie and Olivia's number. The couple now merited a joint MI5 file and the transcripts of telephone conversations were assiduously placed therein. Listening in to Smith's telephone conversations produced a long list of the suspect and dubious, their names invariably capitalised to ensure efficient cross-referencing and continuing observation. Over a period of a few months, there were many suspects whose files grew fatter as a result, including those of Peggy McIVER, Gordon CROOKSHANK, Terry GOMPERTZ, Alex McCRINDLE, Margaret BECK, Harry POLLITT and Margot HEINEMANN. Many of the calls were lengthy – on one occasion, the transcript was abruptly cut short because, as the listener noted, the 'machine's full'. Reggie's calls were usually focused on work and Party business, while Olivia's were more wide-ranging – what one secret listener described as 'social chatter'. On 23 October 1947, for example, she called a friend, Pam Geary: 'They discuss Reggie and his tours etc.,' the transcript reads, 'which Olivia hates.' A trip to Ireland had been proposed, but Olivia was dubious: 'I doubt whether he would come, he does not like countries where there is not a good, strong Communist

Party.' According to the eavesdropper, both women 'think [it] is a bit of [a] joke'. Reggie might have laughed too, particularly if he was describing the plodding diligence of the listeners inescapably glued to the women's chatter to those other listeners of his in the George pub in London's Great Portland Street, where the regular drinkers included MacNeice, Dylan Thomas, Augustus John, Randall Swingler and Paul Hogarth.

13

Doris Lessing Reads Clive Branson

Olivia Manning could be critical of other women writers – Edna O'Brien, Iris Murdoch and Rosamond Lehmann, for example, were all subject to her disapproval at various times – often prompted by issues of relative literary standing, as well as money. Another writer whose work she had little time for, and who was also the subject of MI5 surveillance, was Doris Lessing. Olivia thought her writing 'humourless and heavy going' and resented the diatribes 'from [Lessing's] left-wing admirers who have, about four times, used me as an example of how much better she is'.[1] Where the politics of the thirties in Europe had largely passed Manning by, Doris Lessing was deeply conscious of the decade's political tumult. She was just 16 when the Spanish Civil War began, and living thousands of miles away in Rhodesia, but the struggle between left and right was so momentous that she thought intensely and often about events in Spain. 'It was as if I were there,' she wrote later. 'Why wasn't I there?'[2]

Lessing had been brought up in a house 'two miles from the nearest neighbour'. More than fifty years later, Lessing would remember the reverberation of African drums in the compound while her mother was mournfully playing Chopin.[3] Her parents were ill-suited; the marriage unhappy: Doris believed that her 'early childhood made me one of the walking wounded for years'.[4] School in Rhodesia's capital Salisbury provided a different kind of ordeal, the nuns who ran it cultivating a regime of scolding, punishment and threats. They also opened letters and read them, just as the British Government's spies did several decades later.

As a young woman in the early 1940s, Lessing fell in love with the 'ravishing dance music of that time' and 'danced every night for four years'. There was, in addition to the left-wing activist, a romantic side to the young writer. She adored jazz (she chose *I've Got You Under My*

Skin as one of her Desert Island discs.) She loved clothes too, while recognising that 'the class struggle and clothes don't really go together'. In time she 'became extremely severe and very political', developing sympathies for 'the local Reds' whom others regarded as 'seditious, dangerous and above all kaffir-loving'.[5] Her communism stemmed from 'the spirit of the times', what she termed 'the *Zeitgeist*', as well as the fact that the local Reds 'were the only people I had ever met who fought the colour bar'.[6] By March 1943, she had acquired enough notoriety to alert the Intelligence Services, which opened yet another file, recording, for example, her activities in the Salisbury Left Club and the 'control' of that organisation by the two Lessings (Doris Wisdom, as she was, had married an exiled German, Gottfried Lessing). The Air Ministry in London was disturbed by reports of the presence at meetings of 'persons with foreign accents', together with RAF personnel, while the agenda regularly consisted of 'anti-British, anti-capitalist and anti-imperialist vapourings'.[7] Inevitably the unease reached MI5, resulting in a letter from the Director General, Brigadier Sir David Petrie to the Chief Superintendent of Bulawayo's CID, Major H.W. Clemow, posted on 21 October 1944. It did not reveal MI5 in its best light, however, since Petrie confused his 'Mrs Lessings', suggesting that the 'controller' of the Salisbury Left Club was a Gwendoline Margaret Lessing, 'formerly a dancer at the Casino in Lorenzo Marques', not the solicitors' typist and would-be novelist in Salisbury, Rhodesia.

By the time the war ended, Doris Lessing was having doubts about the Party. In a letter written on VJ Day, 15 August 1945, she revealed her newfound uncertainty, provoked, she wrote, by reading Arthur Koestler's *The Yogi and the Commissar*.[8] She intended to remain in the Party and work for it but 'without illusions'. Soviet Russia no longer seemed to promise a Utopia: there was, for example, the 'mush' that surrounded their talk about art; the 'medals and decorations and flag-waving, Goering being given the Order of Lenin'; and the overzealous nationalism. Above all there was the Terror and the murder – in vast numbers – of Stalin's enemies. She longed to see the Party divorce itself from Moscow and act independently. Nonetheless, she felt that Russia was in many ways superior to other countries. Later, Doris would reflect that joining the Party had been 'probably the most neurotic act of my life'; that she

might not possess a fitting temperament for life as an active communist; that the discipline and ruthlessness required was beyond her.[9] To make things more problematic, her husband Gottfried had threatened her with divorce if she left the Party.

Beyond her wavering commitment to the Party, there were two deeper passions. She longed to find more time for writing and she could not wait to effect an escape from Rhodesia, a country she found exhausting to the point where it threatened emotional collapse. 'I know', she wrote on 30 August 1945, 'I will never recover from spending all my life consciously rebelling.'[10] She was torn between a longing for serenity, and a natural rebelliousness that she could not discard. As well as Arthur Koestler, she had discovered Clive Branson, reading his book describing his Indian experiences and published by the Party in 1944. Lessing empathised with Branson's anger and intensity, as well as his willingness to rebel: 'We all of us acquire harsh shrill voices,' she wrote, 'like the author of *Letters from a British Soldier in India.*' Clive Branson's collection of letters home to his wife, published with a foreword by Harry Pollitt, Doris sent to her friend Coll Macdonald, along with Koestler's book and the poems of Gerard Manley Hopkins.

If Doris Lessing thought Clive Branson's letters from India were 'harsh' and 'shrill', for Clive's wife, Noreen, they were a lifeline in a bleak world: 'Oh, darling,' she wrote on 7 November 1943, 'life is really grey without you.'

14

'Afterwards I'll Paint All Right'

'**M**y eyes and ears are not dead,' Clive Branson wrote, despite the continuing lack of military action and the monotony of army life. That was the difference, he told Noreen, from his present state of mind and that of James Boswell's, from whom he had just heard. It was September 1942; Boswell had just arrived in the Iraqi desert, while Clive was still becalmed at Gulunche Camp in India. He had begun sentry duty a short while ago, after relieving the previous guard from their twelve-hour shift. It was 'the last change before daybreak, so twelve hours have gone – twelve hours nearer to being with you when this bloody war is won and over'. As well as his eyes and ears, his mind was emphatically alive, angry at his very presence in India in his role 'as a soldier and a conqueror', a situation that made him what he called 'the prisoner of my conquest'. That wasn't all that stoked his fury: there was the lonely, unaided battle the Russians continued to face on the Eastern Front; the timidity of the Western Allies in not mounting a second front; and the heartless treatment of India's population.

There was also anger at the bloody British Army, its dubious certainties, its foibles and rites, and the bullying, vindictive behaviour of some of the men who held positions of power within it. Clive's company sergeant major was one such: 'It is really hell', Clive wrote, 'being so completely at the mercy of a man like this.' More widely, there was the ingrained attitude of superiority the British had towards the Indians, the way its people and its troops were looked down on. Clive was disgusted at the way 'the old sweats' reacted to a new order requiring that Indian officers should be saluted. He welcomed the requirement, but many others reacted with a torrent of indignant remarks. Branson's disaffection extended to the censorship of letters, a process that had recently been tightened up to the extent that it now had a Nazi quality whereby 'one's personal thoughts become the property of one's immediate superiors'.

Underlying all that fury was the way that 'the iron will of the Army' killed time, its troops sitting listlessly in the canteen obliged to do nothing. It left Clive reflecting on whether it was all a devious ploy to get the men so 'browned off' that military action when it came was met with a huge, collective sigh of relief.

At the end of September 1942, a necessary, if dismal, practicality underlined the difference between Clive's view of the world and the way that many of his compatriots regarded things. He wrote to Noreen on the 29th telling her that he had signed the 'Power of Attorney' document – there was no comment on when such a legality might be invoked – and it had been duly witnessed. One of the witnesses, Major Johnson, asked with a smile whether 'it meant that his wife could spend his money' – to which Branson's reply was short, sharp and unamused: 'No sir, she can now spend her own.'[1]

In the middle of October 1942, Branson moved camp, to Dhond, near Poona. The town itself was 'derelict, filthy and poverty-stricken', but the camp had a cinema, a YMCA and, occasionally, the dubious advantage of 'a brothel under official patronage'. For a frustrated artist, none of these facilities had much attraction: he was, by this time, utterly certain about the life he wanted when the war was over. It would mean returning to the existence he had enjoyed when Noreen and he had first met – being a full-time artist. There was at least one major difference: 'This time,' he wrote, on 12 October, 'you and Rosa and I will work together.' There was a conviction about the kind of work he would do too. He planned to change the very way he painted, making use of vivid colour in large still lifes. In their size such paintings would foreshadow the work Rosa would produce many years later. Army life, he decided, was not what he wished to paint, despite the fact that he had been asked to do so, with the cost of materials met by the regiment. Putting on to canvas the very things that had become anathema to him was something he could not bring himself to do. Having once toyed with the idea of becoming a war artist, he now harboured a resentment at the way other artists had seemingly negotiated an easier path than his through the war. Some of them, perhaps, were 'getting away with cushy jobs', while Branson was trapped in a situation that threatened to end badly.

Clive wrote home regularly, passionately and at length, keeping tight-lipped about the military position and fulminating against what he saw as the fraudulence of the Beveridge Report since 'the workers will have to pay for the privilege of being ruled badly by scoundrels'. He made a point of reassuring Noreen about his mental and physical health – he was keeping himself in good shape, working hard and, overall, was broadly content. He exhorted her to keep fit and 'see good plays, hear good music and read good books'. Life was too short simply to say 'when the war is over we'll begin again'. The two of them, he wrote, had had 'such a grand beginning together' but there was much more that lay ahead.

Such optimism was sometimes not easy to sustain: for someone facing the prospect of bitter fighting, the memories of the war in Spain were still raw and vivid. He knew as a result of that experience that he was not by temperament a 'fighting man'; rather he was invariably desperate to 'get into the battle quickly' and get it over with. This protracted Indian campaign was a kind of slow torture, the pain of it compounded by the news of Noreen's miscarriage. Some while after that sadness, Noreen admitted that she was losing weight, provoking Clive into an anxious instruction – 'You are to get no thinner!' Each time he wrote he concluded with a brave stab at the uplifting flourish: 'All my love, sweet comrade', perhaps, or a scribbled drawing of a revolutionary's clenched fist followed by '¡*Salud!* Clive'. Pen set down and envelope sealed, he would then sink back into the army's false domesticity with its darning and washing of socks and soulless, clockwork routines. He dreamt of home and his family, longing for Noreen's consoling warmth. And always there was the shimmering prospect of painting again, a need that required a stoical patience until the moment arrived. In the meantime, he would 'observe everything, live and afterwards I'll paint all right'.

15

The Travels of Comrade Hogarth

While Noreen Branson anxiously waited for news from India and her husband yearned to return to the world of art, fellow communist Paul Hogarth was working for Carlton Studios, 'the biggest design studio in London'.[1] He had married in 1942, the year that Branson had been posted abroad, and, for a time, Hogarth lived at 11 Upper Park Road, Hampstead, just a five-minute walk away from Noreen's Haverstock Hill flat. They lived under the same bombs, watching London grow ever more down at heel and weary as the war stuttered towards an ending.

Peacetime signalled profound change in many people's lives. Like many others, Hogarth found the immediate post-war years difficult: it was a time of harsh winters, shortages and rationing, the country so poor that 'we have not a hope of escaping what might be considered, without exaggeration, a financial Dunkirk'.[2] These were inevitably lean times for artists: paper was rationed and opportunities for illustrators were limited, with publications restricted in size and photographs rather than artwork the preferred option for illustration. War artists were obliged to return 'to their studios with almost as much need to rehabilitate themselves as did ex-combatants'.[3] Hogarth had been working on artwork for the MOI, illustrating posters 'telling people what to save and what to cook'. Suddenly, the brave new world of 1945 promised him nothing more than 'impossible deadlines to produce illustrations for women's magazines', precisely the kind of commercial art that he could not stomach.[4] It was James Boswell who came to his rescue, an artist whose political commitment and art Hogarth had admired when he was at art school. After his demobilisation, Boswell had become art director at Shell International, 'when he wasn't observing the low life of Camden Town', and he hired Hogarth to work as his assistant for three days a week. The staffing profile at Shell was of a kind that led to Special Branch holding

an inquiry into it, and a report of August 1950 focusing on the number of communists employed at Shell's offices in London's Strand noted that Paul Hogarth 'was very active in propaganda and literary work for the Communist Party'. His past was not forgotten either: 'his name was on a list of suspected recruits for the Civil War in Spain'.[5]

The invitations Paul received to travel abroad in those early post-war years appealed to his nomadic spirit, but also provoked MI5's interest. Predictably, the organisation was suspicious of what Hogarth described as his 'working trips, on behalf of various Communist-sponsored friendship organisations, to record the rebuilding of war-torn eastern Europe'. Early in 1947, Hogarth was asked to nominate a group of artists to draw the construction of a railway line between Šamac and Sarajevo in communist Yugoslavia. The group, comprising Hogarth himself, the artists Ronald Searle, Laurence Scarfe and Percy Horton, as well as the Marxist art historian Francis Klingender, left from Victoria Station in mid-August. They arrived in Ljubljana in sweltering summer heat and set to, drawing 'brawny, sun-bronzed students, wizened peasants and smooth-talking officials' as sweating figures grappled with metal rails and wooden sleepers and the track of the 'Youth Railway' slowly edged its way into a shimmering distance.[6]

Working with other artists, Hogarth learned a great deal, things that his art school experience had omitted. He learned most from Ronald Searle, notably the importance of 'getting to grips with the reality in front of you'. Moreover, Searle was seemingly indefatigable, sketching every day without fail – 'never a day without a line'. The two of them sketched together companionably, sometimes in villages deep in the mountains to the south where the culture was 'strongly Muslim'. Back in England, questions were being asked in the House of Commons – a Major Lloyd inquiring of the Secretary of State for Foreign Affairs 'whether he is satisfied that the appeal for young volunteers from this country to assist in the Yugoslav Youth Railway Project is not connected with efforts to persuade such persons subsequently to join any military international brigade'.[7]

The following year, Hogarth travelled to Poland, again with Ronald Searle and accompanied this time by the art historian Millicent Rose. They left in August 1948, intending 'to draw the rebuilding of Warsaw',

travelling via Paris, Venice and Cracow.[8] At one point, Ronald Searle was amused when Hogarth was approached 'by a fiery-looking woman who flopped about like a puppet, reeked of whisky and shouted "Tovarich"' (Comrade).[9] More sombrely, the desolation of Europe shocked them both: in Nuremburg the landscape was a brick-strewn chaos of 'rubble and hollow shells with unnecessary windows framing the sky', while in Warsaw itself, the great heart of the Old Town had been ripped out, its palaces and churches reduced to dust. Gdansk was 'almost obliterated', a ghostly shadow of the thriving port it had once been, its burned and pockmarked brickwork bearing the scars of both Nazi slogan writers and Russian shells. The harbour was choked by the rusting hulk of a sunken battleship.

Through the war artist Felix Topolski, Hogarth and Searle secured an invitation to the International Congress of Intellectuals for Peace, held in Wrocław in late August. Soviet sponsored, it was attended by some 600 delegates from forty-six countries who were destined to sit through 'interminable speeches' from a series of left-wing worthies. Drawing 'literary luminaries' made a pleasant change from sketching Silesian miners so far as Hogarth was concerned: suddenly he was mingling with delegates who included Picasso, Aldous Huxley, Berthold Brecht and an extensive 'Who's Who' of other 'Communists or fellow travellers'.[10] It came as a revelation to Paul that 'these people who were communists (had) so much vanity, the same amount of vanity and egotism as anybody else'. Much later, he would be scathing about those delegates 'making fools of themselves by siding with the Soviets against the Americans'.[11]

The Artists' Dilemmas

In 1947, James Boswell published his personal credo. Entitled *The Artist's Dilemma*, it was thin (just sixty-four pages), printed on paper that smacked of wartime shortage, and addressed the issue of how art and artists can survive in a much-changed modern world. It considered the tension arising from an artist being both politically active and trying at the same time to produce art of the highest quality. Did the commitment of the former destroy the hope of achieving the latter? Towards the end of the book, he insisted on the artist's 'right to paint for the community', balancing that with the community's responsibility to create a context where artists could paint, enabled 'to carve those dreams and visions which enrich the present and predict the future'.[1] Two years after the book came out, however, Paul Hogarth's dilemma was more to do with whether he should abandon art altogether.

Paul Hogarth: 'You Need to Travel'

In 1949, Hogarth travelled to Spain, over a decade since he had been there during the Civil War. The country was still haunted by that conflict – indeed, 'From 1939 until Franco's death, Spain was governed as if it were a country occupied by a victorious foreign army.'[2] Observing its landscape and its people, Hogarth was sharply reminded of the scorched devastation he had seen in Poland: 'the country looked as one imagined it would have done in the aftermath of the Thirty Years War.'[3] He was travelling in his capacity as art editor of *Volunteer for Liberty*, the journal of the International Brigade Association, driving a clapped-out Hillman convertible. Even before crossing the Spanish border, the omens were bad, with large forest fires burning to the north of Bordeaux. After passing through the border town of Irun, he motored along the winding coast road towards Guernica, by then largely restored after its obliteration by

the Luftwaffe in 1937. He drove on through Asturias, before swinging south and east, towards Catalonia. At every point, 'the roads were still pitted with half-filled shell and bomb craters'.[4] Spain seemed locked into its civil war misery, kept in chains by Franco's 'world of darkness', its buildings in ruins; armed police poised for trouble on the streets; political graffiti at every turn; and morose, hungry peasants brooding in the fields. To cap it all, the extent of the misery and the scale of the destruction was so overwhelming that Hogarth felt it was all beyond his capacity to draw: 'My powers as a draughtsman', he wrote, 'left so much to be desired.' It was dispiriting, so much so that he contemplated giving up altogether.[5]

Given that he believed art was the most important thing in his life, it was highly unlikely that he could contemplate life without it. But he knew that something must change. In time, he realised that travel 'would ultimately bring out the artist in me'. He was encouraged by the advice of James Boswell. Released from the army on 25 February 1946, Boswell had returned to Shell, but couldn't settle. He resigned the following year and became art editor of *Lilliput* magazine, whose editor, Richard Bennett, had recruited him to the Army Bureau of Current Affairs towards the end of the war. Boswell's time at *Lilliput* coincided with 'four very crazy drunken years in Fleet Street'. He commissioned artwork from Hogarth and offered him insight and wisdom. 'Yours is a restless spirit,' Boswell told him, as they sat drinking red wine in the York Minster pub in Soho. 'You <u>need</u> to travel, to experience. You should do nothing but draw each and every day. Nothing else should matter.'[6] Hogarth came to regard James as 'the father I should have had'; at the same time, Paul took the place of the son that Boswell never fathered.[7]

James Boswell: 'Keep away from King Street'

Towards the end of the war, Boswell had confronted a different dilemma – whether he should remain in the Party. Being in the army had given him 'plenty of time to think' and eventually he decided the time was right to break 'with the bureaucrats of King Street'. He was not the first to decide that Russian-style communism was not the answer. But the decision to walk away did not mean abandoning his friends within the Party. They included the man who was to become Hogarth's second 'father figure',

the poet Randall Swingler, who remained as committed to the communist cause as ever. Boswell introduced Hogarth to Swingler during the winter of 1948. The poet seemed to be an 'almost legendary figure to Hogarth, battle-scarred and chastened by the war' despite him looking 'more like a West Country bishop than a poet'.[8] Boswell and Swingler had 'been through the war together' and they seemed so much more vivid than the grey of post-war London. Swingler's wisdom, sophistication and intense humour were all factors in his charm and the 31-year-old artist and the 39-year-old poet became close. Paul described him much later as 'his protégé' while at the same time, 'protecting him – or so I thought – and doing what I could to advance his literary career'.[9] For a salary of £6 a week, Hogarth worked for Swingler on *Our Time*, which was based in 'shabby offices opposite the Garrick Club'. Moreover, Hogarth was content to remain both a working artist and a communist.

Our Time, however, did not survive, a victim of the Party's continual interference. Prior to the publication of each edition, it insisted that 'proofs had to be checked and double-checked'. Sometimes Swingler would be summoned to King Street by Emile Burns. The magazine finally folded in October 1949, to the huge disappointment of its leading figures. It confirmed Boswell's view of the CPGB and his decision to leave. His disillusion informed his heartfelt, stark advice to Hogarth: 'Steer clear of King Street,' he said, 'travel and draw.'[10]

Clive Branson: Longing to Paint

Clive Branson's dilemma was of a different order – not about the place of art, or indeed communism, in society. His uncertainty was essentially concerned with whether he would ever be in a position to paint again; indeed, would he even manage to survive the war? At all events, the months of inaction dragged on. Just after Christmas 1942, Clive went on leave to Bombay, staying at 'a posh hotel', chosen for its 'good food, good bed, hot baths and quiet'; he wanted to keep clear of more 'drunken revelry'. He visited the Communist Party HQ and was very touched, he told Noreen, by a gift from an 'Indian rank and file comrade' who gave him a photograph of 'Uncle Joe' Stalin, with 'Red Greetings' written on the back. Smiling, Clive promised to keep the picture in his tank when

he and his crew finally went into action. He browsed the bookshops, wandered the streets, ate at a Chinese restaurant, drank iced coffee at the Coffee Club, all the time horrified at the famine and poverty he saw. Even walking back to Bombay's Victoria Station to catch the train back to camp, the 'hundreds of people sleeping on the pavement' brought home the cruel injustice of it all. The thought haunted him as the Poona train left the city and rocked its way through the darkness heading south-east.

Back in London as 1942 came to a close, Noreen fought her aching loneliness by trying to keep busy. Despite – or perhaps because of – the war, in the Bransons' part of London, Christmas that year and the subsequent New Year were marked by a succession of parties, fevered occasions designed to combat war-weariness. Harry Pollitt turned up at one, arriving an hour before midnight and staying for over three hours 'telling stories about funerals', Noreen wrote, 'so we all felt extremely honoured'. New Year's Eve she spent in a pub that was loud with off-duty, well-oiled bus drivers and conductors. The bar was a haze of cigarette smoke, the windows were misted up and the dance music turned conversation into something of a guessing game. At one point, she told Clive, a bus conductress lurched towards her, evidently 'very tight' and unsteady, but determined to grab hold of Noreen's arm, insisting that she was doing so on the grounds that she was a 'celebrity'. Her eyes stared intensely and she clung on fiercely, desperate to tell the celebrated Mrs Branson that she had a boyfriend in India and it was only after he had left for the east that she had felt able to join the Party. Such caution was nothing new: 'I know quite a lot of girls', Noreen wrote to Clive on 9 January 1943, 'who daren't write and tell their husbands.' She took comfort from the fact that the relationship she enjoyed with Clive was of a different kind.

There was comfort too in the plans she and Clive had made to try for another baby once they were together again. As 1943 passed, they continued to write, the subtext of each letter inevitably emphasising how starkly different their lives had become. Noreen's days comprised 'rush jobs' at the Labour Research Department; fire-watching during air raids; bouts of flu; walks on Hampstead Heath; going to the pictures. Clive on the other hand was engulfed in the unchanging soldierly routine, or being driven in convoys of lorries that lurched and swayed over unmade

tracks to point A or B and back again, the reason unclear. Change remained a rarity, at least for now: he was always desperate to paint the beauty of India; spent hours contemplating the country's insect life, its golden crops and far horizons; stayed true to his communist principles; and wrote with unerring regularity to his wife, letters of reassurance – 'feeling grand – pretty fit, sleeping out'. Both knew, however, that this limbo would end at some point and Noreen was all too aware that, when Clive referred to being 'on the move', it meant that his situation had become more dangerous. That suspicion increased when Clive's letters became vaguer, unwilling to give any hint of military information – ('I wish I could tell you something of my present activities – but I mustn't'). Then, in February 1943, he travelled south, driving through the night, surrounded by 'real, primary jungle'. Sleep had been impossible, but there was some compensation for the discomfort of the lorry drive: they arrived in dawn light at Karwar where he was able to swim from a golden beach in a 'gentle sea', looking one way towards an empty, distant horizon and the other way to a green phalanx of palm trees beyond the sand. Karwar was 'one of the loveliest places I have ever seen'. It demanded the attentions of a committed artist with time on his hands, and a sketchbook.

Then suddenly, on 1 March 1943, his circumstances changed: he was posted to a gunnery wing, where he would achieve an ambition he had long cherished: to be confirmed as 'a sergeant-instructor in a technical branch'. As if that wasn't enough, there was the shock of where he was to be posted: of all the cities in India it could have been, the army had despatched him to Ahmednagar – the place where he had been born. Clive still felt himself to be a kind of 'prisoner of war', though of a different sort than those grim days he had endured in Franco's jails in Spain. In both cases, though, he had been far from home, having no control of where he went or what he did, and without any idea of how it would end. His new rank, and the return to somewhere that held a special significance for him, did not remove the underlying fear of some anonymous, soon-to-be-faced battlefield.

A Communist Cell at the BBC?

I n August 1949, Soviet Russia exploded its first atomic weapon, significantly changing the temperature of the Cold War and taking what Doris Lessing called its 'snarling, hating atmosphere' to an even more icy state.[1] The world feared the worst with even greater conviction: George Orwell, for example, had written in the previous October that 'atomic war is now a certainty within not very many years'.[2] Now it seemed that nuclear midnight had ticked that bit closer. The Intelligence Services in the West were entirely clear about who the enemy were. An 'assessment of the Soviet threat' had been drawn up during the summer of 1948 by the Joint Intelligence Committee in which it had reported that 'the fundamental aim of the Soviet leaders is to hasten the elimination of capitalism from all parts of the world and to replace it with their own form of Communism'.[3]

Britain's homegrown communists felt the backlash of this heightened fear. For example, the eminent scientist and Party member Professor J.B.S. Haldane, in protesting about the increased level of surveillance, was reminded of the fact that the Gestapo's main purpose in Nazi Germany had been to 'deal with German communism'. Now, he wrote, 'MI5 seems to be largely preoccupied with British Communists and sympathisers in positions where they have access to secret documents.'[4] Certainly there was even greater scrutiny of those in sensitive positions. In March 1948, Prime Minister Attlee introduced a 'Purge Procedure' whereby both communists and fascists would be excluded from work 'vital to the Security of the State'.[5] MI5 had reported that 'around two hundred people in the civil service were estimated to be Communist Party members, with twenty at the policy-making level'.[6] Attlee knew full well that British fascists were now, in his words, 'feeble', their time having gone with the demise of Nazism. The 'procedure' was designed to target British communists and the consequences could be severe, even

at a relatively mundane level. 'One Scottish teacher', for example, 'was refused a job because she had a communist husband.'[7]

Inevitably in such a febrile climate, there was great interest in any active 'Reds' tucked under the BBC's bedclothes, although such suspicion was nothing new: as far back as January 1939, for example, the Lancashire Chief Constable, in updating MI5 on the surveillance of the theatre director Joan Littlewood, reported that an officer of his had 'recently been informed that the left point of view is well represented in the personnel of the BBC both locally and nationally'.[8] (Arguably this could have been written any time in the subsequent eighty years.) During the war, a BBC employee, Marjorie Redman, recorded in her diary that a confidential memorandum had been circulated to the corporation's producers warning that 'fascists, communists, conscientious objectors, and pacifists' must not be allowed anywhere near a microphone.[9]

Olivia Manning's husband, Reggie Smith, was one of the victims of this determination to purge the BBC and other influential organisations in the country, his name gleaned from 'secret sources' – some anonymous 'snout' – and then corroborated through a tele-check on the phone of the communist writer and activist, James Klugmann, when Smith's name had cropped up. That got the wheels turning and it wasn't long before Mr and Mrs Smith's telephone was being regularly tapped, something of which the couple were well aware – indeed, they 'regularly joked about it when on the phone with friends'.[10] Reggie was only one of the three 'BBC officials' being monitored in this way at that time – in 2017, it was still judged necessary to redact the other two names in Olivia and Reggie's file – and the bugging was extended for a further period. MI5 was determined to ascertain 'the extent of communist activity in the BBC' and whether a 'communist cell had been organised' at its headquarters.

Over many years, the BBC 'secretly vetted a large number of its employees', its stance apparently justified by 'its potential role as the wartime broadcasting station' and the 'sensitive information' to which some staff had access. Indeed, the Corporation went further, vetting 'all their journalists, even directors on drama and arts programmes'.[11] The journalist Alaric Jacob – who at one time had shared a house with Paul Hogarth – took up a post at the BBC Monitoring Service in Caversham, near Reading, in the summer of 1948. Three years later it emerged that

he would not be eligible for establishment rights and would therefore not receive a pension. He went to complain to the Director of Overseas Services – who happened to be his second cousin, General Sir Ian Jacob – at Broadcasting House in London. Asked if he was a member of the Communist Party, he firmly denied it. 'What about your wife?' was the follow-up question. Alaric's answer was emphatic: 'You have no business to put that question. The BBC knows full well that I hope to become a Labour MP.' He was not, he said, prepared to answer questions about the politics of his wife. Iris Morley, whom Jacob had married in 1934, was a writer and journalist – and a communist. (By this time, the couple had separated.) 'The discrimination against Jacob was only resolved in 1953 when his wife died of cancer.'[12] Ian Jacob had become Director General of the BBC in the previous year.

The concern about Reggie Smith felt by MI5 was increased when it emerged that he was intending to travel to Romania early in 1948. Party officials were exercised by the news too. On 8 December 1947, Harry Pollitt rang Margot Heinemann from CPGB headquarters to inquire after Reggie's background: 'Look Margot, you know that pal of yours who worked with you on that coal production business? He is going to Romania. Is he all right?'[13] Heinemann played for time ('my mind at the moment is a blank'), but Pollitt persisted – 'I think he is called Smith is he? Is he all right?' The answer was a non-committal 'Hmm' and Pollitt draws his own conclusion … 'Right.'[14] Margot's doubts about Reggie centred on his indiscretion: he was a flamboyant and voluble communist who had made no secret of his political beliefs. This worried Olivia, who feared he might, as a consequence, lose his job at the BBC. His manner troubled the Party too, since it might prejudice future appointment boards against communist applicants and thereby reduce the number of opportunities for Party members to broadcast. He had been given instructions, it seems, by Professor George Thompson on 15 February 1948, to curb his work for the Party and was now 'apparently behaving himself'. There was, however, no guarantee that Reggie would keep up his recently acquired Party discipline.[15] Margot Heinemann, for one, certainly felt that Smith lacked 'proper stability and professional competence'.

The prospect of Reggie Smith running amok in Romania was enough to stir MI5 into action: on 30 December 1947, a letter was sent to the

British embassy in Bucharest drawing its attention to Smith's communist background. The initial plan had been for Olivia to travel with her husband, but problems over her visa meant that, in the end, Reggie travelled alone, leaving London on 9 January 1948. Very soon after his arrival in Bucharest, a city he knew well, he began to cause diplomatic unease, prompting the wiring of anxious reports back to London: he was 'running true to form' and peppering his talk with 'peculiar utterances', was the message, Smith insisting, for example, that British food aid was nothing else but a cover for espionage. There was, it seemed, no stemming his passionate, eloquent ire and, eventually, an official at the British Legation wrote a blistering report about Reggie's visit, highlighting the BBC man's determination to turn the blindest of eyes to the Romanian Communist Party's 'ruthlessness and cynical indifference to the well-being of the people'. Smith could not stop from peddling 'anti-British propaganda', and – damn it! – he had the gall to claim that the Legation was 'staffed with reactionary fascists who represent nothing and are out of touch with all Romanians who count'. His behaviour was nothing less than 'treacherous and disloyal'; it threatened his country's safety; and it was quite unacceptable – shocking – that the BBC could be 'penetrated by this kind of agent'. Finally, Smith's loyalty to the Crown was questioned, his allegiance to a different regime asserted: 'His only loyalty is to International Communism.' At some point he must be put in a position where he has to choose between his country and his political masters. 'A man can either serve his country, or be a Communist,' the report concluded, 'but unless he be Russian he cannot do both.' There was, the furious official wrote, 'no doubt in whose service is Reggie Smith'.

Understandably, Olivia was becoming increasingly anxious about Reggie's job security, an anxiety made worse by the continuing bugging of the Smiths' home telephone, surveillance of which the couple were aware. MI5 officers were concerned too, but only because it was clear that their listening in to telephone conversations was becoming widely known: 'too many of our suspects are aware of the possibility for our comfort'. There were 'a lot of people, particularly in Communist circles, [who] are conscious that monitoring telephones is an MI5 technique'.[16] The presence of listeners was all too easy to spot: on 13 February 1948,

for example, a caller to Olivia's number had questioned what the problem was with the line, since 'it keeps rattling at me'. 'It's the boys tapping it,' Olivia had replied. Unsurprisingly, the combination of MI5's silent listeners and her husband's tenuous hold on his BBC career put pressure on the couple's relationship, and on 22 January, for example, she was overheard insisting to a friend that 'she was not going to be sacrificed to the Party' since she didn't believe in it. In fact, 'she was thinking of separating from him'.

The sensitivity of the BBC about the communists it employed was also evidenced by the experience of Randall Swingler, someone who was, like Clive Branson, all too aware of how MI5's interest could shut off the route to opportunity. Interestingly, Swingler and Smith reminded Paul Hogarth of each other – they both 'had a pub for every time of the day and every day of the week'.[17] Swingler ran headlong into the BBC's 'communist cell problem': in 1948, he had submitted an application for a BBC staff job and, initially, was recommended for appointment, his 'personal integrity', honesty and qualifications all impressing the Appointments Board. But, once MI5's Major Badham had alerted the Corporation to Swingler's Party membership and his activity as 'a propagandist in the Communist cause',[18] Swingler did not get the job. At times he submitted work under an assumed name, but 'the witch-hunters at the BBC were not fooled'.[19] There was no escaping the fact that, as a freelance scriptwriter, he had no future.

Listed by Orwell

George Orwell was the first to coin the phrase 'Cold War': it appeared in a book review written some time before the old war had even ended. Coincidentally, it was a cold, bleak period for Orwell himself, struggling with illness (his tubercular, fading lungs); recently bereaved (but contemplating a second wife); and struggling with his 'dystopian' novel *Nineteen Eighty-Four*. The Ministry of Information had earlier discouraged publication of the preceding novel, *Animal Farm*, 'an important official' at the MOI taking exception to the book. The official turned out to be Peter Smollett, later unmasked as yet another Soviet spy. *Animal Farm* was eventually published in August 1945 and in the United States the following year. It was an immediate success, its publisher reporting: 'We printed as many copies as we had paper for, that is 5,000 copies, and they were sold within a month or two.' That success was a rare bright spot in a grim time for the writer. Soon after *Animal Farm* came out, Orwell bought himself a gun, telling the friend who sold it to him that 'he feared a communist attempt to kill him'.[1]

Suspicion and distrust; the fear of the lengths implacable enemies would go; the smoke and mirrors of deception – such was the nature of the Cold War period. The editor and painter Sir Richard Rees – 'his rich, aristocratic and ever obliging friend'[2] – caught the mood of the time when he described the imaginary game he habitually played with George Orwell whereby the two of them would discuss who, of the people they knew, might be a paid agent of which organisation and to what level of treachery each one of them would be prepared to go.

The weather in the winter of 1946–47 mirrored the political ice field. Orwell himself 'was fighting a one-man battle against the forces of post-war darkness'[3] and in May 1946, he left London for a retreat on the Scottish island of Jura in the Inner Hebrides, only returning to the capital late in the year. There he endured a winter so cold that – in the

absence of coal – he was obliged to burn the furniture. The next two years were characterised by a grim decline, struggling to complete *Nineteen Eighty-Four*, exhausting journeys to and from Jura and London – just the journey from Glasgow to the island involved a train to Gourock, a boat, a bus ride, and then 'a seventeen-mile taxi trip', which could end, depending on the weather and the roads, in a walk.[4] Eventually, however, Orwell's illness became inescapably evident. TB was diagnosed and it was clear that 'he was entering the final phase of his life: a world of hospital beds, enforced idleness and long hours of brooding'.[5] By January 1949, he had been admitted to a remote and spartan TB sanatorium in Cranham, Gloucestershire.

Twelve months later, in January 1950, *The God That Failed* was published, with its reflections by Spender, Koestler and others rationalising the collective collapse of faith in communism. For his part, Orwell had long since despaired of 'the true nature of Soviet Communism' and its 'poisonous array of naïve and sentimental admirers of the Soviet system'.[6] Indeed, the year before, he had gone a stage further than Spender and the rest, passing notes on Party members and fellow travellers to a 'secretly funded Foreign Office section'. In 'Orwell's List' he identified thirty-eight communists as well as others tainted by association with the Party.[7] The List came about as a result of a visit to Orwell's sanatorium by Celia Kirwan, who worked for the government's Information Research Department (IRD). The ostensible purpose was to identify people whom Orwell thought should be avoided when it came to commissioning anti-communist propaganda, an essential part of IRD's role. Coincidentally she was Arthur Koestler's sister-in-law and someone whom the dying Orwell regarded as a potential spouse. The List drew on a notebook that Orwell had kept since the mid-1940s, in which he had listed the names of communist sympathisers, Stalinist apologists, fellow travellers and the rest. There were some 135 men and women blacklisted by the writer. On 2 May 1949, Orwell wrote to Celia Kirwan: 'I enclose a list of … names. It isn't very sensational and I don't suppose it will tell your friends anything they don't know.'[8]

One of Orwell's motives was to ensure that 'people like Peter Smollett' would be denied the chance to slip unnoticed into key posts. The 'very slimy' Smollett 'gives a strong impression of being some kind of Russian

agent', Orwell thought, as well as showing every sign of being potentially dangerous. Orwell exhorted Kirwan to return the list 'without fail' since it was 'very libellous, or slanderous, or whatever the term is'. The names comprised people whose activities had placed them in the public eye. They included Members of Parliament (the Labour politicians Tom Driberg and Richard Crossman, for example); journalists (Kingsley Martin and Alaric Jacob);[9] actors (Charlie Chaplin and Michael Redgrave); and writers (Arthur Calder-Marshall and Naomi Mitchison).[10] Orwell wasted no words in his comments – the reporter John Anderson was 'stupid'; Calder-Marshall was 'insincere'; Cedric Dover was 'venal'; Mitchison was 'silly'; Paul Robeson was 'very anti-white'; and Kingsley Martin 'dishonest'.

Inevitably the names that Orwell cited omitted some that MI5, for example, might have anticipated. There was no mention of Sylvia Townsend Warner, Storm Jameson or Olivia Manning – indeed, most of the people named are men. Stephen Spender is included in the notebook ('Sentimental sympathiser … tending towards homosexuality'); Randall Swingler's name appears too (and his brother Stephen, who was a Labour MP); as well as J.B. Priestley, whose name 'has against it a red asterisk, which is crossed out with black cross-hatching and then encircled in blue with an added question mark'. Others included: Alaric Jacob's wife, Iris Morley, the Labour politician Michael Foot, Nancy Cunard, Cecil Day Lewis, George Bernard Shaw, John Steinbeck and Orson Welles. Having seen the List, Celia Kirwan let Orwell know that 'my department were very interested to see' the names and was keen to access his wider list of 'fellow travellers and crypto-journalists'. Such information, she assured him, would be treated 'with the utmost discretion'.[11]

* * *

Within a year, Orwell was dead, an artery having burst in a lung during the night. It was Saturday, 21 January, and he was alone, thin and emaciated, in a hospital bed. In his last days he had been visited by a number of friends, including Stephen Spender, one morning ten days before the end. He told Spender that he had lost 2½ stone in weight and the poet thought he 'looked very thin and sick', but, despite that,

Orwell was still capable of forceful opinions – 'There are certain people like communists and vegetarians whom one cannot answer,' he declared. 'You just have to keep on saying your say without regard to them, and then the extraordinary thing is they may start listening.'[12] Spender, later that day, recorded Orwell's remarks in his journal, no doubt with the ghost of his own two-week Party membership more than a decade before lurking in the back of his mind.

19

Austerity and Restriction

Randall Swingler and Reggie Smith, in their different ways, increasingly troubled the BBC and MI5 through the early Cold War period. Other left-wing writers, while not being judged sufficiently unimportant to be disregarded, their files closed, managed to avoid the relentless hounding that Swingler, for example, had to endure. Sylvia Townsend Warner remained a loyal communist and a Party member, but was largely ignored, presumably because of her relative inactivity. She had other things on her mind. 'My mood is centrifugal,' she wrote to Nancy Cunard in 1949 about a Peace Congress in Paris. 'I can't at this moment in history warm to the thought of a congress about anything.' Life, with its narrative of love and death, had rudely intruded. Her mother had died, while Valentine was caught up in a dalliance with the American writer Elizabeth Wade White, a relationship sufficiently serious for Sylvia to move out of the house she shared with Valentine in Frome Vauchurch. 'What hell it is to be away from you,' she wrote to Valentine in early December 1947. Like most of the country, Sylvia was exhausted by six years of war: 'tinned foods, cigarettes, paper, and paperclips all ran short and everyone was fed up with austerity.'[1] The future looked equally gloomy. None of this was reason to prod MI5 into redoubled surveillance: the occasional low-key inquiry was enough. For example, in 1948, Dorset's Chief Constable, Major Peel Yates, reported that 'the lady in question' was 'not known to be actively engaged in the Communist Party in this area'.

* * *

Doris Lessing was not mentioned by Orwell in his list because she spent the war years in Southern Rhodesia, her literary reputation not yet under way. She was more preoccupied with her doubts about her dubious status

as 'a good communist', aware that she was unsuited by 'temperament, though remaining one by conviction'. It was the 'dogmatism and tight theorising of communism' that she could not stand.[2] Shaky communist she may have been, but she was already of interest to the Intelligence Services, indeed, had been since 1943, when her involvement with the Salisbury Left Club had been first noted. By 1947, she was judged a 'Person of Suspected Communist Tendencies' by the British South African Police, while her marriage to the German refugee Gottfried Lessing resulted in her being listed as an 'enemy alien'.[3] The surveillance was sufficiently unsubtle for her to register that she was being watched: 'We were all paranoid – pleasurable on the whole: it gives one importance to think the Secret Services are preoccupied with your doings.'[4]

For someone with Doris Lessing's ambition and view of the world, life in Rhodesia was limited and constricting: 'If I don't leave this country soon from sheer exhaustion, I will collapse and become a good Rhodesian.'[5] Eventually, in the spring of 1949, she left for England, her departure judged sufficiently noteworthy for a Security Liaison Officer (SLO) in Central Africa to warn the Security Service (MI5) in London. The alert, written on 21 April, made a point of drawing attention to her recent acquired status as a double divorcée, this at a time when 'divorce for most [was] an unthinkable social disgrace'.[6] Special Branch began monitoring both Doris and her ex-husband, logging their newly acquired London addresses and, in the case of the former, the fact that 'she has no regular employment and is frequently away'. Arriving in England 'full of confidence and hope' in April, Lessing was greatly disconcerted by the capital's Dickensian, smoke-filled atmosphere. 'It was unpainted, buildings were stained and cracked and dull and grey; it was war-damaged, some areas all ruins, and under them holes full of dirty water, once cellars, and it was subject to sudden dark fogs.'[7] She lived in a down-at-heel Bayswater garret with her young son, Peter, at 20 Denbigh Road.[8] It was so small, she wrote later, that she was unable to even 'unpack a typewriter', but despite that she was writing. In time she would face fierce criticism from Party members who questioned her determined focus on her own work and the time it took. The expectation was that she should be handing out leaflets or selling the *Daily Worker*. Writing, painting, making music were all seen as 'bourgeois indulgences'.

Doris would later have 'Comrade John' in *The Golden Notebook* remark, when told that the main character was about to join the Party, 'You're mad. They hate and despise writers who join the Party. They only respect those who don't.'[9] Doris Lessing was not alone in being confronted with the Party's suspicion of 'intellectuals', particularly those who put their art first. Whenever Stephen Spender met Harry Pollitt, for example, the poet had always been asked, 'Why don't you write songs for the workers, as Byron, Shelley and Wordsworth did?'[10]

* * *

Actors, journalists, poets – Orwell, when he had noted down the names of those who might be classified as fellow travellers, communists or crypto-communists, paid little or no attention to the ranks of left-wing artists. After all, the IRD's purpose was to identify left-wingers whose writing could not be relied on to follow the Establishment line. Predictably, perhaps, the official view was that those who worked in oils or watercolours would not have the same value as propagandists. So it was that artists like James Boswell, Hugh Slater, Paul Hogarth and Clive Branson were ignored.

The Watched One

'I will show you
Almost hidden in the shadow
Of an Indian night
Pavements strewn with human bodies.'

Three decades after he had left Ahmednagar ('Nugger') as a child, Clive Branson was back, an artist, communist and soldier now in 'the pompous monument of the Imperial Army'. The fort at Ahmednagar was a monument in its own right, 'a fifteenth-century circular fort with thick black walls of hewn stone, with twenty-four bastions and one gate. An immense curtain wall stretched upwards for 80 feet.'[1] The camp would be his posting from March through to October of 1943, a time when the war in India remained emphatically static, although there was compensation for Branson in the country's magical qualities and the 'proud durability' of its people. Through the summer, Clive tried hard to keep a positive frame of mind, determined, for example, to learn more about the art of watercolour. It was a comfort that, as time passed, he felt closer to the real India. By now he had been promoted to a fully made-up sergeant and was enthusiastically working on 'large diagram-drawings for the gunnery wing'. Nevertheless, politics and the ways of the military invariably intruded: when four Indian communists were executed on 29 March for organising a demonstration, Branson was incensed, laying the blame on 'the white sahib' and his 'society of jackals'.

By dint of age, beliefs and artistic temperament, Branson was an unusual representative of the 'Imperial Army'. When the army chose to reveal a more humane face, it was both a surprise and a cause for celebration. Towards the end of March, the 'new Major' announced to all that the 'ill-treatment of the Indians has got to stop'. Failure to comply would mean loss of rank and severe punishment. 'It was good to hear,' Clive wrote

home. Then, a month or so later, the Major took him to one side: 'Would you be willing to be recommended for a Commission?' Branson agreed and anticipated 'an interview with the Brig shortly'.² Nonetheless, he doubted that anything would change in the near future, thanks to his past record: 'Members of the IB [International Brigade] have sometimes been promoted only to gain the position of splendid isolation.'³ It could take 'another three years at least', he told Noreen, which would give him the time to 'study the language', the ability to recast 'What the bloody hell's that?' into the more urbane 'I say, old boy, can you put me in the picture, what?' The true meaning of which would be something like 'I don't really want to know, you know, what?' When it came to it, the interview with the Brigadier, on 16 May, was predictably unsatisfactory. Early in the session, Branson was asked whether he had a private income. Clive, incandescent with rage, 'answered NO, quite emphatically', a response that inevitably shortened the interview. Before he left the room, Clive 'explained that among the rank and file there was much ill-feeling against the officers because of this business of money, school tie etc.' He was not willing to become an officer except on merit; 'every time anything to do with money or class came into it, I would turn it down flat.'

On leave in Bombay, the dark side of the city troubled him, its threatening shadows and unmistakeable signs of desperate poverty. But overall there was much to like in the city – there were bookshops to get lost in; he bumped into a former International Brigader; and he spent time drawing in the house of an Indian artist, sketching the artist's young niece, working in indelible pencil and ink. 'You have no idea how lovely it was to draw again.'⁴ There was another reminder of his time in Spain when, having succumbed to a bout of fever, Branson was in hospital and met a nurse who had been there during the Civil War. They talked at length, travelling back to relive the heat and dust of a different war.

But by June in India, the monsoon season was drawing closer, the rain either threatening or already falling. It was dispiriting, despite Branson taking some satisfaction from successfully training his first squad of men. Otherwise, things were at a low ebb: the one decent bookshop in Poona had been declared out of bounds to British soldiers; Clive was longing to see a good film, instead of 'the muck dished up to us'; and the rain kept pouring. Instead of dust, there was mud, and sudden bursts of greenery,

'Absolute Typical Stephen'

On 5 July 1951, a fourteen-day 'Return of Correspondence' was requested on 15 Loudoun Road, the North London home of Stephen Spender and his wife, Natasha. While Stephen had long been a person of interest to MI5, this new inquiry was the result of 'the missing spies imbroglio' in which two British diplomats, Guy Burgess and Donald Maclean, had disappeared on 25 May. They had been recruited by the Russians back in the 1930s and had long been established in important posts within government, Maclean for example being a key civil servant within the Foreign Office. Despite evidence of leaks over a significant period of time, the background of the two was thought to be such that they were beyond suspicion. 'The assumption was that anyone who had served ably in the foreign service was a pillar of moral rectitude.'[1] Suspicion fell on those lower down the chain of command.

In mid-April, Guy Burgess was urgently summoned back to London from the United States, where he had been second secretary at the Washington embassy. He arrived back in Southampton on 7 May having 'spent most of the five-day Atlantic crossing drunk'; he was met by Anthony Blunt.[2] That same day, an internal memorandum was circulating in MI5 – a 'Note of Further Action to be Taken' – which noted that the lists of Burgess and Maclean's friends and acquaintances were less than complete and needed to be updated to include full details of both men's significant contacts. Gleaning such information might involve interrogation of some of those contacts, who included John Lehmann, W.H. Auden and Stephen Spender.[3] Of those, Spender was thought to be in Italy, but it was judged essential to question him on his return. Meanwhile, Burgess was being shadowed by officers from the Intelligence Services – the 'Watchers from A4 Section' – and was uncomfortably aware of the fact. Over lunch at the RAC Club, Maclean had told him that he was 'in frightful trouble. I'm being followed by the dicks' – and certainly there was no mistaking the

two watching policemen about whom Maclean was scathing. 'They're so clumsy', he said, 'that their car even bumped into the back of my taxi the other day.'[4]

On 7 June, the Foreign Office announced that the two spies had defected to Russia, and, in the weeks following, a series of interviews began, accompanied by a series of crisis-driven telegrams and memoranda emanating from London or Washington. One key issue was whether Guy Burgess had telephoned Auden just before his escape. Certainly, 'traces held by MI5 show Auden to be left-wing and to have been in Burgess's set in the USA.'[5] Inquiries revealed that Auden had been staying with the Spenders in London and Natasha Spender had taken a phone call from Burgess, who was keen to speak to Auden. He was out and when Stephen got round to telling him about Burgess's call, Auden was reluctant to ring back. 'Do I have to?' Auden drawled. 'He's always drunk.'[6] MI5's initial interviews did not necessarily clarify matters, with Auden and Spender providing conflicting testimony: one or other was forever 'prevaricating'. As a result, the Head of the Special Branch in Italy was 'carrying out investigations at Auden's and Spender's homes', and an officer – the name in the file redacted – was despatched to re-interview Auden.

The need to gather more information from 'significant contacts' meant a considerably increased workload for MI5's team of interrogators. On 11 June, the memoirist Gerald Hamilton – known as the 'wickedest man in Europe' – was questioned by William 'Jim' Skardon, MI5's principal interrogator. Maxwell Knight had interviewed Hamilton in Brixton Prison back in August 1941, at one point archly inquiring about Hamilton's habit of ending his letters to Christopher Isherwood with the words 'all my love'.[7] Hamilton's questioner ten years later was a former Metropolitan Police officer. A dapper man, Skardon was 'often wreathed in pipe smoke like Sherlock Holmes', somewhat dishevelled and with a 'nice, unpretentious and even cosy' manner.[8] Part of Skardon's effectiveness lay in his low-key style, the fact that he epitomised 'the world of sensible English middle-class values – tea in the afternoon and lace curtains' – a stratagem that tended to throw the interviewee off balance.[9] Under Skardon's unflappable, almost friendly questioning, Hamilton blithely named names: Auden, Spender, Christopher Isherwood and the Labour MP, Tom Driberg. Hamilton prattled on, happy enough to talk

about 'ancient history' and to tarnish the names he had mentioned: 'he must have done infinite harm', he said of Stephen Spender's changing political opinions. Tom Driberg? Well, he was 'certainly a homosexual' and Hamilton insisted that he had seen Driberg's Communist Party membership card.[10] Burgess? Well, he was 'one of the most dirty and untidy people' he had ever met, with 'deplorable table manners' and an 'unorganised' mind.

A week after Hamilton's interview, Jim Skardon turned his attentions to John Lehmann, interviewing him at 31 Egerton Crescent, SW3. Lehmann was a poet, publisher and fellow traveller, while his novelist sister Rosamond had been a friend of Guy Burgess since before the war. John Lehmann's interview with Skardon involved some 'initial fencing' during which Lehmann made clear that he had no wish to talk about his pre-war association with Burgess. That reluctance did not extend to those with Burgess connections and he went on to name a string of people from the world of the arts, including Isherwood, Auden, Harold Nicholson, Anthony Blunt and Goronwy Rees. Blunt and Rees, in particular, were especially reprehensible, for holding 'official positions', Hamilton argued, and for 'failing to inform the authorities of the politics of Burgess and Maclean'. At much the same time, Rosamond Lehmann, having asked Harold Nicholson to put her in touch with MI5, was interviewed in 'a safe house in Mayfair' by two officers who advised her to keep the meeting confidential. Rosamond couldn't resist telling her brother, who, in turn, relished the prospect of snubbing Spender, 'who had been "jabbering away" that Burgess could never have been a spy'.[11] John Lehmann wrote to Spender with the news and he duly passed the letter to the *Daily Express*. Its front-page headline on 11 June was: 'MYSTERY WOMAN PHONES MI5'.

The *Express* reporter had assured Spender that the letter would be treated as confidential, but the fact that the poet had been duped cut little ice with others in his circle in London. The level of irritation was evident to the listeners on bugged telephone lines, including a conversation between Robert Kee, his fellow publisher James MacGibbon and his wife Jean. MacGibbon had been routinely tailed by Special Branch for several years: ('When I followed MacGibbon on 30 January 1948 he left home at 8.45 a.m., took the tube from St John's Wood to Oxford Circus

and a bus to New Oxford Street before proceeding on foot.') On another
occasion, James had been formally questioned by Jim Skardon. Jean tried
to downplay the interest in her husband: 'I mean James is a Communist. I
suppose he must expect this kind of attention – the same as in America.'[12]
At all events, the surveillance on the MacGibbons' telephone revealed
what the collective view of Spender's indiscretion was:

JAMES: What on earth Spender thought he wanted to take [the
 letter] away for if he wasn't going to …
ROBERT: Absolute typical Stephen.
JEAN: He's never quite grown up.[13]

<p style="text-align:center">* * *</p>

The naming of names fostered a kind of feverish contagion. Auden's
wife, Erika Mann, for example, having told her interviewer that she
'never recalled seeing [Burgess] in a sober state', then proceeded to
implicate Isherwood and Spender, as well as the poets Brian Howard
and Louis MacNeice, and the writer and journalist Cyril Connolly.
Christopher Isherwood was interviewed on 15 June in Santa Monica,
California, and added two more fresh 'contacts', E.M. Forster and the
Literary Editor of *The Listener*, J.R. Ackerley, the man responsible for
discovering and promoting Philip Larkin, as well as Isherwood, Spender
and Auden. The web of connections continued to grow as the round
of interviews multiplied. Jack Hewit, Burgess's 'on-and-off lover and
general manservant' for the previous fifteen years, submitted to Skardon's
questioning on 21 June, the interrogator finding him a 'loathsome creature'
and was only too glad when the interview could be terminated.[14] Hewit
named the usual suspects, and then added Tom Wylie, a clerk in the War
Office. 'These men', it was noted, 'used to foregather at Chester Square
for long, earnest discussions on political affairs.' Another of Burgess's
lovers, Peter Pollack, claimed that Guy's 'greatest friend' was the art
historian Anthony Blunt. 'The common attraction between them was
art.' More names? Pollack obliged: the art critic Ellis Waterhouse, Victor
Rothschild, and Isaiah Berlin (who had actually worked for MI5 during
the war). When Blunt was questioned, on 14 July, his 'list' included

Goronwy Rees, Rosamond Lehmann, Isherwood and Otto Katz, a spy who would be hanged the following year. At that point, Blunt hesitated – he 'appeared to be uncomfortable' – before muttering a further name, David Footman, another writer as well as being an officer in MI6.

Almost without fail, Spender and Auden's names emerged in the varied testimonies of interviewees. For example, a Special Branch report, dated 22 June, noted that 'cocktail parties' at 7 Cathcart Road, Kensington, were usually attended by the two poets, the officer observing that there was 'little doubt' that the parties 'were attended by individuals with homosexual tendencies'. The weight of evidence was such that surveillance was inevitable, but warily undertaken, since it was often important to keep information and, particularly its source, secret. 'We cannot repeat not use your para. A,' MI5's James Robertson cabled on 15 June, anxious to ensure that any subsequent 'police enquiry' did not reveal to Auden 'that his line was tapped'. Auden's involvement brought with it the added complication that he was an American citizen, a potential embarrassment that did not stop his house being 'watched night and day by plain clothes men'. Auden watched them in return: the whole affair had, he told Spender in a letter of 14 June, 'turned this place into a madhouse'.[15]

For much of the summer of 1951, Spender and his family were in Torri del Benaco, 'a small fishing village halfway up the eastern shore of Lake Garda' in northern Italy.[16] However, he was briefly in Oxford in mid-summer for the opening of his play *To the Island* at the Playhouse Theatre on 9 July. Keen to interview Spender, Jim Skardon travelled up to Oxford, but it was to prove a fruitless journey. The City Police had told Skardon that the poet was staying at the Randolph Hotel but, 'after attending to other matters', Skardon got to the hotel soon after 7 p.m. to find that Spender had already left. A check with the management of the Playhouse Theatre also drew a blank. So did the 'Return of Correspondence' on 15 Loudon Road that took place between 7 and 23 July – unsurprisingly, since Stephen was back in Italy by then, his London house occupied temporarily by an American whose background was inevitably probed by the authorities as a result, and the house watched. A Chief Inspector Daws reported in September that 'at the moment some foreign people, believed to be Communists' were in residence.[17]

A year passed before an anonymous MI5 officer took the decision that Spender was sufficiently innocent to be ignored; after all, his enthusiasm for communism had died as long ago as 1943. 'We have no grounds for thinking that his political views or activities today are of security interest.' Jim Skardon noted in the file that 'there is certainly nothing to show that he did any "serious damage" while a communist'. So far as Burgess and Maclean (and Blunt) were concerned, Spender would look back on them with the hindsight of thirty years, as possessing 'the arrogance of manipulators' who had always 'treated me with near contempt when I met them'. He was unsure whether that contempt stemmed from his rejection of communism, or his being 'a Liberal, or an innocent'.[18] There was no avoiding the fact, however, that the tenuous connection with the Soviet spies had pulled the poet deeper into the murky world of the Listeners and the Watchers.

Paul Hogarth's Defiant People

I5 did not like losing track of a suspect: after all, who knew what damage he or she might cause? So when Paul Hogarth could not be traced in the summer of 1952, the telephones started ringing urgently. On 25 July, MI5 left a message 'asking that urgent discreet enquiries be made to ascertain whether or not Arthur Paul HOGARTH is at present out of the United Kingdom'. It emerged from such enquiries that he was in Italy and would be back in the UK by the end of August.[1] The tip-off proved wrong, however, or at least out of date, since the artist was in fact in Greece, having gone there with the intention of changing the way he worked, determined now to become what he called an 'artist-reporter'. The concept of artist-reporter – 'this buried art of our century, and of past centuries' – essentially involves a powerful connection between the artist's work and the events of the time.[2] Hogarth was seeking to fuse his art and his politics in order to say something about the world in which he lived, to give 'a unique [commentary] on the social life' of those he saw and heard.[3] To that end, he was living in Athens that summer, 'under cover to avoid surveillance'.[4]

The starting point had been an approach from a Welsh former teacher, Betty Ambatielos, whose husband, Tony, was about to stand trial in his native Greece. The couple had met in 1940 in Cardiff, the 'craggy looking' Tony eventually marrying Betty Bartlett, 'a woman with a determined jaw, but a sudden sunrise of a smile'.[5] Tony was then General Secretary of the Greek Seamen's Union; a communist who had been in exile in Britain during the war, and latterly a resistance fighter against the Nazis. When the war ended the couple moved to Greece, only for Tony to find himself sentenced to death by the Greek government under its right-wing leader, Marshal Papagos. Ambatielos was arrested, along with nine others, in 1947, an act that provoked protests around the world. The outcry had led to a stay of execution, but nonetheless, Tony was now to appear before a military court. Paul Hogarth was invited by Mrs Ambatielos to attend the trial and sketch its proceedings.

Paul arrived in stifling August heat and found a country on its knees, after five years of civil war; it was, in a sense, Greece that was the 'first victim of the Cold War'.[6] Hogarth lived cheaply in a succession of safe houses and seedy hotels, wandering through the streets to observe the ebb and flow of Athenian life. It proved illuminating and Hogarth felt that each day he was becoming better able to assume the role of the 'compassionate observer', the way in which he now wished to work. He began to 'acquire the resourcefulness of a pictorial reporter', recognising the newsworthy and capturing that on the page. His sketchbook filled with images of a deeply troubled nation, drawn in simple, confident lines and angry shading: a Greek woman in a dark headscarf, sitting on the pavement selling matches; a baby asleep across her lap, her own feet bare; the starved, pinched face of another woman, the wife of an unemployed factory worker; back streets and market places crowded with the hungry and destitute; people scrambling for rotten fruit lying in the gutters; war veterans on crutches; and everywhere an overwhelming sense of despair. It was truly shocking, but at the same time, he was grateful to the citizens of Athens for 'risking their own safety [showing] me the real Greece'. Hogarth also drew landscapes – mountain peaks, for example, and the city's buildings set against the encircling hills. He drew Tony Ambatielos's trial too: the hollowed-out faces of his relatives in the public gallery; the bemedalled soldiers trying the case, sitting stone-faced behind a long, cloth-draped table; and Marshal Papagos himself, his face a hawk-like mask that showed not a hint of compassion. One of Hogarth's drawings was of the Averoff Prison, brick-built, with narrow windows, loops and coils of wire fence, the guards forever patrolling, while inside 600 anti-fascist prisoners waited in vain for justice. Paul also sketched Tony Ambatielos's mother, an old woman who still retained a revolutionary's defiance. 'I mean to live', she said, 'until I can kiss my son again.'

Defiance was not enough. Ambatielos's sentence was confirmed by the military court, although subsequently commuted to life imprisonment. In fact, he would serve another twelve years before he was released – only to be jailed again by the Greek Colonels in 1967. As for the drawings that Hogarth produced to testify to what he had seen, they were eventually shown at the Galerie Apollinaire in London's Litchfield Street – but only after many galleries had turned down the chance to exhibit them. They were judged to be too subversive.

The Failing God?

In the post-war world, Stephen Spender made no secret of his antipathy towards communism: his contribution to *The God That Failed*, which was published in 1949, was evidence enough of that and two years later – the year of the Burgess and Maclean defection – he chaired a meeting of the British Society for Cultural Freedom, an organisation whose 'very purpose was to try to counter the influence of Communism'.[1] It took more than that, however, for MI5 to deem someone no longer worthy of suspicion, this despite evidence that the Party's influence was declining. It had won just 0.3 per cent of the vote in the General Election of 1950, for example, losing both its MPs. Nonetheless, evidence of the success of anti-communist strategies was not enough for files on former suspects to be closed. Special Branch made a point, for example, of recording Spender's links with Spanish anarchists (in June 1954), as well as with Russia. It also recorded the testimony of Lya Klinge, an Estonian who had worked as a servant in the Spender household, and who, in November 1953, reported that he was still a member of the Party. MI5 logged the information, while being sceptical about it, noting Spender's recent, overt denunciations of communism. As if to draw a line under the poet's case, a 'loose minute' on 1 February 1955 by C.A. Herbert, from MI5's Section F1A, drew attention to a piece in the *Manchester Guardian* under the headline 'AUSTRALIA REBUFFS MR SPENDER'. He had been heckled in Melbourne, 'attacked and denounced by a small clique of Australian communists' who believed him to be a 'deserter' from the communist cause.[2] His quip that 'having been a member of the Communist Party is rather like having a vaccination', which the informer thought 'perhaps over-subtle for Australia', did not go down well. No doubt the hostile reception greeting Spender will have pleased C.A. Herbert and other MI5 officers.

Christopher Isherwood was similarly monitored after Guy Burgess's flight to Russia. His travels were logged (such as Southampton to New

York, on 28 February 1952, and Berlin to Northolt twelve days before); and his temporary addresses when in the UK were similarly recorded – he stayed with the Spenders in January 1956, for example. Of more significance was a letter Isherwood received from Guy Burgess, which was discovered at the Courtauld Institute – a body presided over by the as yet unmasked Soviet agent Anthony Blunt – in November 1951. Much of the content of the letter was unexceptional, but the penultimate paragraph tied Burgess closely to both Isherwood and Auden. 'I have seen', Burgess wrote, 'a certain amount of Wystan [Auden] and I must say became devoted at once.' Under interrogation, Isherwood sought to defend himself, insisting that he was fully aware of 'the evil of Soviet Communism' and 'would do anything in his power to combat it'.[3] He had come a long way in his political views since he had been 'recorded as associating with suspected Comintern agents'.[4]

Cecil Day Lewis had also drifted away from the Party, having terminated his membership as long ago as 1938, after just three years – or so he claimed.[5] Decades later, he was asked by an embassy official why he had resigned and he replied that it had been necessary 'to choose between political work and my writing'. MI5, however, believed he was a Party member until 1943, when a 'difference about communist policy', notably over Finland, caused him to quit. For all that, his Personal file remained open: 'As Cecil Day Lewis has progressed rather since he was an assistant master at Cheltenham, I have no doubt that you will want to bring the file up to date.' This file note was written in September 1952. Lewis himself reflected sardonically on his flirtation with the Party: 'We had a kind of officer class mentality that we are privileged people and we should feel some responsibility for the under-privileged.' It was a view, he recognised, that was 'woolly-minded but respectable'.[6]

Storm Jameson's involvement with the International PEN club was reason enough to keep MI5 adding information to her file from time to time – a cutting from the letters page of the *Daily Telegraph* for 17 October 1955, for example. In the letter's margin an unknown hand had written alongside the reference to PEN that it was a 'League formed by Communists and sympathisers'. The letter – one of whose co-signatories was Stephen Spender – was merely a declaration of support for 'authors who seek freedom of artistic expression outside their own countries'.[7] No

matter; Jameson's file remained open and it was necessary to take note of her activities. Another file entry implicated the novelist C.P. Snow: Jameson had written to him about the possibility of donating books to a library behind the Iron Curtain. That correspondence was filed, together with a note on Jameson's left-wing pacifism and 'her possibly communist sympathies'.

Sylvia Townsend Warner remained a Party member in the early 1950s, but not an active one, while Valentine Ackland resigned in 1953. On 6 March that year, Ackland wrote to Harry Pollitt from Winterton in Norfolk, initially recalling Pollitt's kindness to her when she first joined the Party back in the mid-1930s and indicating that that was the reason for writing to him personally. She had 'ceased being a member of the CP some years ago' – 1944, she thought – but had never formally confirmed her resignation, something that she now wished to do. She gave no reason other than saying that her views were very much in line with those of the writer Mervyn Jones, whose piece in the *New Statesman* of 20 December 1952 criticised the Party's unswerving allegiance to Stalin and its bitter anti-Americanism.

That same month, there was a fresh flurry of MI5 and police activity around Sylvia and her partner. A Detective Sergeant Parsons tendered a report on the two women to Superintendent Blakeman, a document that was duly forwarded to MI5. Sylvia and Valentine lived 'in a rather isolated position', keeping themselves to themselves and, it seemed, making no contact with Party members. Parsons, however, remained wary. After all, 'both persons were great readers' who 'possessed some literature appertaining to Socialism', facts that 'may or not be significant' – but which Parsons, it seems, thought decidedly unhealthy. A telephone check on Party HQ revealed, however, that the hierarchy there regarded her as inconsequential: she may remain a member, but 'she never does anything'. Moreover, it was a cause célèbre within the Party that when funds had fallen low in Dorset, someone had been despatched down from London to elicit a donation from the writer. The train journey was slow and tedious and relatively expensive; indeed, 'the comrade concerned [had] spent 30 shillings in fares to get down to Dorset, and then received a donation of half-a-crown.'[8] In October 1955, some new information about Sylvia Townsend Warner was logged, evidently derived from

someone who was operating deep within the administration of the Communist Party of Great Britain. Anonymously provided, and deemed 'reliable', the informant had gained it 'in very delicate circumstances'; it concerned Sylvia's membership of the Party's Writers' Group, as well as listing the names of other members. MI5's 'Consumer Section' found the tip-off 'extremely valuable'.

The security of undercover informers was something over which MI5 invariably took pains: 'Warning,' a file note might begin, 'Refer to Appropriate Officer before using.'[9] That was an essential element in protecting its sources. At the same time, the organisation was typically 'bureaucratic and inconclusive', its files drifting on, added to 'over the years in fits and starts', an insidious, diligent exercise in paper proliferation. The files, however, 'rarely climaxed with an explosive arrest', or provided a definitive summation of what had gone before and what all that paper and typescript, watching and listening actually amounted to.[10]

The Party is Not Yet Over

While there were some former communists and fellow travellers from the world of the arts whose political commitment or philosophy had changed over the war years, or in the immediate post-war period, there were others whose loyalty was staunch and undiminished. For them, MI5's surveillance remained very much in place, constant or intensified. Randall Swingler – 'the Communist Party's best-known poet'[1] from the mid-1930s to the mid-1950s – was one writer whose career fell victim to Leconfield House's agents, his travels monitored and his activities reported and logged.[2] MI5 also tracked his slow decline into poverty and depression, ultimately to the point where he was both 'unpublished and broke', as well as drinking heavily.[3] The decoration for bravery he was awarded for his role in the Italian campaign counted for nothing; instead, he was, for example, traduced in an essay by George Orwell in the magazine *Polemic*. When Swingler took issue, arguing that Orwell's essay was 'intellectual swashbucklery', over-reliant on 'persuasive generalisation and unsupported assertion', he was taken to task by Orwell, who thereafter refused to shake the poet's hand and tried to avoid drinking in the same pub as Swingler.[4] The communist poet was also one of those named by Orwell in the information he passed to the IRD in 1949. He was denied the opportunity to work for the BBC and was pilloried by Stephen Spender, who thought his work both dogmatic and inferior, the kind of voice that had encouraged Spender to turn away from communism.

By 1952, Swingler was 'very hard up' and 'getting very little work',[5] according to the telephone conversations between Party officials that MI5 listeners heard. Then, on 27 June, Swingler wrote to Harry Pollitt asking for help to 'ease the rather anxious position I am in at the moment'. It was a forlorn request, both pessimistic and apologetic, the poet all too aware that he was overburdening Pollitt, who had many other difficulties to consider; Randall hoped that Pollitt was 'keeping fit and not overtaxed'.[6]

Unsurprisingly, with the State weighed against him, Swingler's professional life got no better. In the coronation summer of 1953, another telephone tap of the CPGB picked up a further reference to Swingler's struggle: he was 'doing some English poems from the Hungarian', but had stopped doing lectures, since 'he couldn't afford it anymore', and was largely inactive, as well as being 'rather down in the mouth'. By August he had been obliged to take work as a casual labourer at a War Office motorcycle depot in Essex. The work at 52B Vehicle Depot, Halstead, involved little more than dealing with flat tyres, oil changes and faulty carburettors, but MI5 was taking no chances and contacted the War Office ('We think you should know...') in case he was involved in any 'secret work'.

Swingler resigned from his labouring job in Halstead in October 1953 and, a few weeks later, Special Branch was reporting that he had left London on a flight to Amsterdam, accompanied by Paul Hogarth. Questioned by uniformed officers, they said that their ultimate destination was Prague, a trip 'just to look around'. Hogarth and Swingler were near-neighbours, living 4 miles apart, seeing each other virtually every day, and drinking at the Cock public house in Great Maplestead, Essex. Essex police had the pub under close review: it 'has become a meeting place for many Party intellectuals who all have their country houses in this district', reported Essex's Chief Constable to MI5's D.G. White. It was also reported that the BBC proposed to broadcast from the Cock Inn on 21 February 1954, which the police attributed to the dubious influence of 'intellectuals' with 'connections in Broadcasting House'. Those 'communist intellectuals' who had settled in Essex – and the Swinglers in particular – were of great interest to the local police as well as those concerned with national security. On 9 September 1954, for example, it was noted that 'a member of this Directorate' believed that Mrs Swingler – the pianist Geraldine Peppin – was 'either a communist or a sympathiser', the evidence including the various pictures of Stalin on the Swinglers' cottage walls and that fact that she read the *Daily Worker*, the judgement being reached despite the house being 'very well furnished', and money was clearly 'plentiful'.

* * *

It is safe to assume that Olivia Manning had no pictures of Stalin on the walls of the Smiths' comfortable home in London's St John's Wood, although Special Branch might well have expected such a display of Party loyalty, since it believed that Olivia condoned her husband's political creed. At all events, Reggie and Olivia were kept under close observation throughout the mid-1950s and the shared file MI5 kept on them grew ever fatter. A letter was sent to the BBC in April 1951, citing 'various sources', accusing Smith of easing the path for other communists who were anxious to infiltrate the BBC, either to get on the air or to gain some kind of employment. Randall Swingler was also named as being 'in close touch' with Smith. At much the same time, managers at the BBC and MI5 were in correspondence about those actors and screenwriters who had been contracted to work for the Corporation through the interventions of Reggie and other communist employees. A Party official was overheard, courtesy of a telephone check on King Street HQ in January 1951, commenting on what seemed to be the Corporation's strategy for dealing with the problem: 'The BBC was of course quite clever. When they see any of our bright bastards with political ideas they removed them from the programme side and offered them better jobs in administration.'[7]

Despite the 'bear-like' Reggie's undoubted charm, sociability and generosity of spirit, the combination of his expansive ebullience and his overt communism was enough to unsettle officials and the Establishment more generally. When he returned from a European trip in the summer of 1952, for example, a letter soon arrived on the desk of MI5's Lieutenant Colonel John Baskervyle-Glegg expressing the concern of 'a proven source' about Smith, described as an 'outside broadcasts commentator' with the BBC. Reggie had been covering the signing of the European Defence Community treaty in Paris, where his 'pronounced Communistic views' had been 'causing flutters amongst diplomatic dovecotes'. He was equally loud in his preaching of communist doctrine at the BBC, according to another source ('a new agent but trained to be accurate'), but there were also those who were 'uncertain whether he is more of an exhibitionist rather than a true sympathiser with communism'.[8]

With the apparent unwillingness of Reggie to curb his enthusiasm for the Party, it is unsurprising that MI5 maintained its surveillance of both

him and Olivia, adding to the shared file over the following years.[9] For example, a routine telephone check on James MacGibbon's line picked up some gossip between Jean MacGibbon and Olivia, who, it was noted, 'moaned about everything she did and saw' – coincidentally, she was referred to by her friend and writer Francis King as 'Olivia Moaning'.[10] No doubt her husband's larger-than-life persona exacerbated her dissatisfaction with the world and, after listening to Olivia's litany of complaints, the eavesdroppers to the conversation heard a sympathetic Jean remark that she wondered 'why Olivia did not leave him what with all his Communism and cricket'. A month later, Olivia and Jean spoke again, with MI5 listening in, this time with the news that Olivia was pregnant, a major problem since Reggie did not want her to have the baby: 'it meant too much responsibility and the Party meant more than anything else to him.'[11]

* * *

The same year as Reggie was rattling 'diplomatic dovecotes' in Europe, Doris Lessing was invited to visit Russia as part of a British delegation to the Authors' World Peace Appeal. By then she had been living in England for three years, most recently in a flat in Church Street in Kensington. Her landlady was Joan Rodker, a communist sympathiser who worked for the Polish Cultural Institute and who was very well connected with people in the Party, including Randall Swingler. Lessing had yet to join the CPGB, but was very much caught up in the world of international political ideas and argument, of communists and communism – she 'spoke the language'.[12] Inevitably, therefore, she was someone to be kept under close observation. When a tip-off arrived in Leconfield House from the SLO Salisbury informing MI5 that Mrs Lessing would soon be travelling to East Germany, the information was filed; so too when an apparently innocuous advertisement appeared in the press – 'Cheap room offered to woman with child by woman with boy of nine who needs companionship in return for child-sitting etc. Write Mrs Lessing' – that too was filed. At one point, an informer told the police that her flat saw frequent visits by 'Americans, Indians, Chinese and Negroes'. Moreover, 'some of the visits are made by apparently unmarried couples' and there

was a suspicion that the flat was being 'used for immoral practices'.[13] Both MI5 and MI6, it seems, were 'watching the house from across the road', contending that Doris 'kept an international Communist brothel'.[14]

The writers involved in the peace mission to Russia were a mixed bunch with very varied political views. Some of them were also 'of interest' to MI5, but once they were in Soviet Russia they were all subject to intense KGB surveillance, every word monitored, every action pre-determined. Such scrutiny led to jokes amongst the group at the prospect of the KGB 'tapping our telephones and the concierges examining our belongings'. After all, they 'were from the West and did not go in for that sort of thing', showing a naïve trust in the UK's own spying techniques. Lessing was energised by the whole experience, 'so torn, astonished, disappointed, alert … <u>alive</u>'.[15] It was a very eventful few weeks, a round of relentless banquets, earnest speeches, visits to hand-picked, approved locations, the wandering hands of a doddery fellow delegate and sweet-smelling bread shops. On the other hand, there was the marked absence of clothes shops; the gunshot damage on the walls of Leningrad; the stark reminders of a decimated male population; the library in a children's holiday camp, its shelves stocked with countless Russian, French and English classics ('Our children read only the best'); and the Russian writers who argued that 'Communist writers develop an inner censor – which tells them what to write'.[16]

MI5 compiled a report on each of the 'six British authors' who had travelled to Russia between 29 June and 13 July 1952. In Lessing's case, it was damning: 'Her communist sympathies have been fanned almost to the point of fanaticism,' while her Rhodesian upbringing had evidently provoked in her a loathing of the 'colour bar' to the point where she thought 'everything black is wonderful and that all men and all things white are vicious'.[17] The British press was scarcely less forgiving, the delegates faced with 'journalists who hated us so much they could scarcely be polite'.[18] Anti-Red witch-hunts in the United States; the ongoing Korean War; spy fever and associated defections – all conspired to create an anti-communist mood in the West whereby to be a communist was an act of treachery. It was no surprise that, when Picasso came to London, there were loud and angry voices insisting that 'we don't want communists here'.

Hogarth and Branson (2)

T hose with the loud, angry voices fulminating against the communist threat were glad enough of the Party's existence in 1943. Clive Branson was typical of those back then who never for a moment doubted their belief in Soviet Russia. However, as the tide turned against the Germans on the Eastern Front, he was bemused by the shifting attitude of the officers around him. 'But now see what <u>they're</u> saying about the Soviet Union,' he wrote to Noreen, quoting an officer's enthusiasm for the Red Army's 'marvellous show' and the merits of the Russian leader: 'There must be something in this man Stalin.'[1]

Branson's mood might have been lifted by Russian fighting spirit, but he was knocked back by the reality of his own unsatisfactory army life in India and the sudden and unwanted return to his unit in the autumn of 1943. Noreen was 'very sad and indignant' on his behalf, when she wrote on 7 November, telling him how much she loved him and how she wished 'so very badly that this business were over and you were home again'. Clive was not the only one aggrieved about his sudden recall, some NCOs thought the 'whole affair stank', while officers were less demonstrative, settling for shrugged shoulders and blaming those more senior than them. An officer who had been obliged to censor Clive's letters sidled up at one point, declaring that he had 'hated' reading them, while another 'invited me round for a drink and a chat before leaving'.[2] More comforting perhaps was the evident warmth of his Indian 'artist friend' whose whole family were reduced to tears by Clive's abrupt departure and whose wife baked some cakes for his journey. As Clive ate them on the train, he looked out of the carriage windows at the grim lines of starving people shambling through the dust. What he saw was beyond mere hunger; these thin and desperate people were evidence of a widespread famine.

Although he told Noreen that his return to his unit found him 'in the pink', it was clear that the move had ratcheted up the danger he faced.

The priority now, he told her, was to make sure that his tank and its crew was in the best possible fighting condition. As if to reinforce the end of the irksome regime of waiting and the approach of battle, there was a sudden increase in the level of censorship, with any information regarded as highly sensitive. That included the unit's location, so that his address became 'ABPO 10', with the detail redacted. 'Only the chai-wallahs', Branson wrote, 'know who we are, why we are etc.' In addition, no reference to soldiering could be made. 'All I can say about it is that it is going to be tough,' he wrote. Moreover, there was surveillance even here – 'the Police Commissioner has now informed the FSU that in future "Special Branch" men must be present at all lectures.'

Clive was not someone who could be content with a brief, bland letter, so, instead of telling Noreen what he could see and what he did, he now covered pages with intense reasoned argument outlining the need for a second front and predicting a Russian victory in the east. Noreen was alert to the change in her husband's letters. 'I am very worried about your being moved,' she wrote, adding that she could 'guess the reasons, though you don't say'. She didn't say either, but the implication was that Clive's political convictions had proved too obvious and too explosive for the army's peace of mind. There was more troubling her: she could sense the onset of military action. It was all so uncertain, although she took solace from the fact that 'nothing can spoil the life we have had together'. Knowing it would please Clive, she insisted that she would keep herself busy 'because it keeps me from thinking too much about you and feeling too lonely'.

Branson's unit was now in close proximity to the Japanese forces, and necessarily living in much more primitive conditions than in previous encampments. It was essentially a 'jungle hideout' close to what passed for a front in the jungle, tanks rumbling through tree-choked paths or artillery fire rolling round the hills. There were few compensations of the location, although an exception was the gentle stream of clear water that ran close by. It was apparent that the prospect of action was drawing ever nearer, and was now perhaps just days away. To reinforce that likelihood, a VIP – unnamed by Clive in his letter – had arrived to give the men a pep talk; they stood in rows, politely listening to the exhortations, but really more focused on whether they would survive the next few days.

Letters from home still arrived: Noreen suggesting that they might have another baby when the war was over; she was thinking of him, keeping busy still and reassuring him that 'the Party backs you up'. Clive was equally determined to keep writing home, but the letters had a different tone, reflective – philosophical even. 'Life glides by like a falling leaf,' he wrote, and he described the wealth of ideas he had had about what he might paint when the time came. He was fired by 'natural observation', he said, 'a dead-still glade', the sudden quivering of plants in the jungle, or the way the sudden whistling of a bird broke the jungle's oppressive silence.

'It is nearing zero-hour,' Clive wrote, and all thoughts of sketching now or in some future time were forgotten. Instead, there were the mundane preparations for combat: getting kit clean and ready, 'darning, buttons, vests, socks and pants'. Noreen would have sensed his unease, the uncertainty all too plain. He sent her a poem too. It began:

> Today we got our orders for tomorrow,
> A few brief sentences as a title page
> Preludes a book …

It felt valedictory, made more so by his fervent exhortations to 'remember that one is given by fate only one lifetime in which to work and live for humanity'. Whatever lay ahead, he wrote, 'you must go on <u>living</u> – there are so many years of grand work ahead.' Then, in a brave flirtation with optimism, he told her that once the war was over, they would return to India 'as civilian friends'.

<center>* * *</center>

Clive Branson had always wanted to travel, very aware when he was younger of how blinkered living in England could be ('hopelessly divorced from the rest of humanity'). His wartime experiences only served to reinforce that longing. He wanted to 'learn more, much, much more' about the world. It was that which lay behind his wish to return to India when circumstance allowed – and China too, when the time was right …

It was not to be. Clive Branson was destined never to see China, although, in the decade after the war ended, the fledgling Communist Republic

was regularly visited by artists and writers who had been ferried east to see and praise the benefits of revolution. Paul Hogarth, when he went there in the summer of 1954, described it as 'a formidable pilgrimage', recognising the double burden of the trip, the several days' journey time, as well as the expectation that the visitor would worship the communist miracle once he or she was there. Paul had been commissioned by the World Peace Council to 'depict the life and landscape of the New China'.[3] The Council was an organisation that had grown out of the Soviet-sponsored Wrocław Peace Conference – which Hogarth had attended – and was regarded as a front for communist activity. Over the early post-war years, Hogarth's involvement in such initiatives had ensured that he remained under close observation by MI5 and Special Branch. They were well aware that he was, in 1950, a member of the Party's Hampstead Branch as well as being employed in Shell's advertising and publishing department, a known lair for active communists. As Hogarth travelled more widely, so the surveillance on him grew. The telephone bugging at King Street (there were <u>four</u> microphones inside the building) picked up a substantial number of references to him – his character, whereabouts, activities – and they were not always entirely complimentary.[4] Two Party officials, Hymie Fagan and Betty Reid, were overheard talking about him, having 'checked on' him through the Hampstead Branch, and were told that he was 'not very active' but 'quite well known'. His work in Spain was judged valuable, they said, but he could not be considered 'a top artist', merely 'quite good', this of an artist and illustrator who would later be judged as 'the majestic Hogarth'.[5]

Hogarth's travels, particularly those behind the Iron Curtain, were monitored closely. His attendance at the Second World Peace Congress 'as an artist-correspondent for the *Manchester Guardian*' was noted; so too his flight back into London Airport (at 12.50 a.m. on 2 May 1952), and the fact that his passport included 'a number of Iron Curtain country visas'. His baggage was searched with monotonous regularity; he was 'discreetly ascertained' to be in Italy; he lived in a small, top-floor flat in a house whose other occupants were the journalist (and 'Orwell's List' name) Alaric Jacob and his wife; he travelled to Poland in 1953 and had been seen earlier in Copenhagen in the company of a 'well-known, ruthless communist'.

There had been plans to visit Russia with Alaric Jacob in 1953, but, in the event, Hogarth travelled to Poland that year. It proved an 'eye-opening experience', partly as a result of the inescapable presence of Soviet Russia at every turn, pictures of Lenin and Marx looming high over the repressed city's streets, and also stemming from an unhealthy xenophobia. Poland? It might as well have been Nazi Germany. He spent a more cheering week in the Tatra Mountains with the artist Jerzy Zaruba, its 'unspoilt alpine community' a warming contrast to the threat evident in Poland's northern cities. But doubts had begun to surface: Hogarth found it unsettlingly hard to dismiss the incredulity that Zaruba and others felt that 'an Englishman, a Westerner, could possibly believe in the edicts Socialism imposed on artists and writers to portray a perfect world'.[6]

That same year, Hogarth went to Czechoslovakia intending to collaborate on a book about the country: he would do the illustrations, while a writer would need to be commissioned to write the text. 'I could think of no better person to handle this challenging task', Hogarth wrote, 'than Randall Swingler.' Since being introduced by James Boswell soon after the end of the war, they had become staunch friends, influential enough for Hogarth to observe much later that, 'If one can think of the Party as my university, then Randall was my Professor of Life and Literature!'[7] He also greatly admired Swingler's 'irreverent wit and poetic wisdom' and the proposed collaboration seemed to have every chance of success. The two men, duly commissioned, left for Prague in the early summer of 1953, both in receipt of £200 from the Czechoslovak Embassy.

It did not start well, the raffish Swingler soon offending the official minder. The poet was impoverished, cultivated a 'beat' appearance and dressed in 'rumpled, ink-stained Oxford bags and dingy tweed jacket'. His luggage comprised only an ancient rucksack. The minder, by contrast, was the prim, earnest Olga Klusakova who, four years earlier, had driven Dylan Thomas to threaten drastic reprisal: he would dive off the Charles Bridge into the river 'unless she was banished from my sight'.[8] Klusakova was not someone who could forgive or forget the Welsh poet's intemperance – he was 'not a very nice man', she said – and relations declined as the Hogarth/Swingler tour progressed. Paul

grew increasingly frustrated that he was prevented from drawing the 'arcaded squares' and the cobbled streets in the succession of quaint towns and villages through which they passed. No! You are here to see our steelworks, factories and State farms! Stone-faced Olga talked of economic miracles, churned out unlikely statistics and kept the tightest of grips on where they might go. Some places were completely off limits – 'not recommended' or 'centres of anti-party activity'. When eventually they were taken to a 'forbidden zone' close to the border with Austria, they were woken by armed guards who insisted that they must be taken in for questioning. Predictably, Swingler saw the funny side of it all, remarking with a grin, 'Orwell <u>was</u> right, after all!'[9]

Swingler, Hogarth and the disapproving Olga travelled the length and breadth of the country, the two Englishmen starved of pleasure. Then, at an ancient castle near Brno there was a moment of hedonism, with Swingler proving 'a true son of Bacchus' to the huge delight of the castle's cellar men. Klusakova was horrified and threatened to put a phone call through to her bosses in Prague, which would have led to an immediate abandonment of the whole tour. The mood stayed morose and the final days of the tour proved suitably wretched. Back in England, it soon become clear that the project's problems were not over: Swingler found writing the book an 'agonising struggle', unable as he was to meet the expectations of the Czech patrons given his own growing scepticism. Eventually, he managed 35,000 words to go with Hogarth's sixty drawings, but the text was couched throughout in Swingler's jaundiced views. It was 'a triumph of finely judged criticism, studied omission and disingenuous special pleading'[10] – and was never published.

There was some compensation in what at first seemed like months of wasted time criss-crossing Czechoslovakia since Hogarth emerged from the experience more assured about his art. An exhibition of his work arising from his visits to Poland and Czechoslovakia, *Buildings and People*, was held at the Architectural Association in London's Bedford Square. He was now much clearer on what he was aiming to do, seeking a 'robust and dignified realism', while at the same time scorning abstract art since it was 'beyond the comprehension and respect of our working people'. He knew too what he disliked: the world of oils and 'gilt-framed canvases' with their inherent 'snob value'; instead, he was inspired by the work of

artists such as Cotman, Constable and Turner. He was committed now to producing art that would 'fight injustice', expose what he hated about the world and 'extol what I feel to be noble'.

While Paul Hogarth had become certain about the kind of art he valued and wished to produce, the Party had its doubts about him. A telephone tap on the King Street office picked up a conversation in which Sam Aaronovitch, a full-time organiser for the Party, was told that Hogarth 'had come forward a lot', but nevertheless still 'made bad contributions'. His pessimism had not completely gone, it seemed, partly because of the negative attitude of some working-class Party members towards 'intellectuals', a stance that Hogarth found dispiriting. He remained under the watchful eye of both the police and MI5. In December 1953, the Essex police reported that Paul's wife, Phyllis, while she was 'hardly ever seen in the village', was however 'associating with a Mrs Fisher of Pebmarsh'.[11] There was much more detail that the police wished to draw to the attention of MI5: the house where the Hogarths lived in Little Maplestead was not only provocatively called 'Red House', but was 'fairly large'; moreover, at night, 'the blinds are seldom drawn'. The make and number of the Hogarths' car were noted (an Austin, with the registration PJ 731) and Hogarth could often be seen driving towards Halstead at about 7.15 in the morning. Oh yes, and the locals described the group of artists living in their midst as 'proper communists'.

Lines from the Burma Front

It is Christmas Day 1943, and Clive Branson is 'making the best of it' in this alien jungle outpost far from home. There is rum-drenched tea to drink; the sergeants have followed tradition and served the Other Ranks what passes for Christmas lunch; and now the men are all circled around the camp fire, their sweating faces glistening in the firelight. Close by, in the secret shadows, are the Japanese, bemused by the beery, bawdy singing that is the British Army's Christmas. 'C'mon sarge, do us a turn!' someone cries and so Branson recites Wordsworth's 'Westminster Bridge'. 'Speech! Speech!' follows on from Wordsworth and Clive willingly obliges: 'We'll do all right', he says, 'if this spirit of Christmas is taken into the hard days to come.' The contrast between Wordsworth's 'Earth has not anything to show more fair' and this harsh prospective battlefield will not have eluded him.

A few days after Christmas, Clive wrote home, dispensing reassurance again, this time for his wife and describing the contentment he felt with his comrades. He might 'never have been happier' than he was among the lads, but there were problems beyond that select circle. His immediate superior was an officer who was irascible and could never admit it when he was in the wrong. He was frequently and 'consistently rude' and thought nothing of calling Branson 'a liar'. Clive attributed some of his evil temper to the fact that the officer was enduring 'a soldier's most difficult duty, waiting'. By contrast, Branson himself preferred to manage the anxiety of waiting, and the apprehension about the battle to come, by taking an obsessive interest in his kit, particularly to the complex task of transforming his blanket into a three-sheet-lined sleeping bag for the chilly nights. This was the kind of detail the censor would accept, but as for anything about the location, or information about what might lie ahead, or the strength of the British units, Noreen 'must wait for a lot of it till we meet'. There was something of a clue, however, in his assertion

that 1944 was going to be 'busy'. As if to prove the point, the next day the unit set out on an excursion to look for the hidden Japanese, only – rather disconcertingly – to be beset with technical problems, the tanks grinding to a halt. The men sunbathed and swam instead, while Branson became absorbed in the 'staggering' show put on by nature – the fish-like lizards, the startling camouflage, and the exotic butterflies, including a yellow-gold one poised on a green leaf and turning yellow when its wings were touched by the sun.

During the first week of January 1944, the rain fell unceasingly for three days, soaking everything and adding to the strain on the men's nerves. The major invited the sergeants in for a drink, during which Clive drank three rapid gins with lime before leaving early. As a result, he missed the drama that took place much later on when, as if the threat from the Japanese wasn't enough, one of the NCOs attempted to shoot one of the others. Throughout these fraught days, Branson thought of little else but his painting and his return both to that and his home. 'When I get back,' he wrote, 'I want a proper studio.' The comfort of routine had taken over, the darning of the mosquito net under an inspection lamp, the filling of water cans, mosquito parade, small arms firing practice, and map reading. Then, the moment for the unit to move out finally happened – 'We leave at night' – something that provoked Branson into writing a sonnet, lines from the Burma front that he would not be allowed to send home, since 'it might contain military information'.

He wrote a brief note on 16 January, asking Noreen to make sure she kept his letters in order so that he could write about the events afterwards; he also anticipated being able to make notes on scraps of paper during the fighting, something that would constitute a diary of the campaign. Although they were close to the enemy, perhaps just a few miles from the front line, there was little sign of the Japanese, other than bursts of occasional gunfire and enemy aircraft racing across the sky, flirting with anti-aircraft fire. He felt frightened and worried about how he might behave in combat. Would he be able to 'command my tank as a Communist ought?' His absorption in making notes while the men waited for action helped to keep his nerves under control. They were scrawled with a stubby pencil and comprised both his thoughts on the progress of the war, and his descriptions of what he could see around him

– all the signs of the two belligerent armies removed. Instead, he wrote about the 'bird that makes a noise like water drops', the hillside alive with red ants, women winnowing rice, a farmhouse directly in the line of fire when it came, and the paddy fields that surrounded it.

The days passed, with little to separate them, one from another. Each one invariably began with a bitterly cold dawn, followed by a token wash in a convenient pool of water, then a confusion of 'order, counter-order, disorder', before returning to the default position of merely waiting for something to happen, the activity that had dominated all their lives for many weeks – waiting. The men's anxious killing of time was in sharp contrast to the intense activity of the gangs of peasant children who had been tasked with improving the surface of the road, watering it and then packing it down with more earth. Branson's tank crew kept busy, plotting positions on the map, washing the tank, and being lectured on first aid. As darkness fell at the end of each day, Clive sat inside the tank and read. On 17 January, there were unmistakable signs that the men's nerves were close to breaking: one man shot himself with a tommy gun, another deserted, while two other NCOs were detained. 'All feeling browned off', Branson wrote, 'as we don't move until the 22nd and even then the RAF may have done the job.' It meant at least five more days of struggling to overcome frayed nerves and to calculate the prospects of survival.

Hogarth in China

Ten years later, in the autumn of 1954, Paul Hogarth was amongst a party leaving London Airport for the Far East. Although there were a number of different groups travelling east, under the overall broad umbrella of the 'British-China Friendship Association', Hogarth's was a solo commission. Too politically controversial to be a VIP perhaps, he ended up in the dubious company of a boozy 'delegation of trades union shop stewards, none of whom had ever been out of the country before'. It was very much a 'third class' ticket, comparing unfavourably with two other, more feted groups. One of those was 'a top cultural', but 'motley', group led by the geologist Herbert Hawkes (pike-like and with a cigarette forever on the go). He was accompanied by the philosopher A.J. (Freddie) Ayer (diminutive, dapper and distinctly amorous), the architect Hugh Casson (duffel-coated and straggly-haired), the painter Stanley Spencer (just over 5 foot tall and in a white panama hat), and the writer Rex Warner (tall, 'in suede shoes and with unusually smart luggage').[1] Stanley Spencer was a particularly uncertain traveller, trembling with nerves at London Airport as he looked at the waiting aircraft; he made the journey 'wearing pyjamas as underclothes beneath his suit'.[2] It was rumoured subsequently that he had been invited in error, somehow confused with Stephen Spender. Hogarth dismissed the calumny – if such it was – but recognised that the artist was indeed 'the odd man out'. Certainly he was at odds with Freddie Ayer, the two of them 'baffled and exasperated' by each other.

In addition, there was a group of backbench Labour MPs and senior trades union officials. It fell to Hogarth, with his status as a seasoned traveller, to act as a kind of chaperone to the 'very unpleasant, rather third-rate Labour delegation' whose principal interest appeared to be getting 'pissed every night at the Chinese government's expense', rather than diplomacy or culture.[3] The long flight out and the subsequent excursions

through China with the Labour dinosaurs, as he saw them, with their 'ignorance and prejudice', proved both arduous and dispiriting. Hogarth felt he 'was flying with the defeated aspirations of British socialism slouched in the seats all around him'.

The artist and his rowdy charges stopped over in Moscow, Hogarth struck by the incongruous décor of the city's airport with its deep piled carpets, the porcelain bowls on blue chenille tablecloths, the limp aspidistras – and the billboards of Stalin and Molotov towering over everything. The British visitors were driven into the city along a boulevard that cut through a sprawl of suburbs, then a regiment of skyscrapers, past the Moscow Art Theatre and through a chaotic rush hour, before sweeping up to the doors of the Savoy Hotel, whose fin-de-siècle magnificence housed a decidedly non-Tsarist clientele. The hotel lifts were old, brassy and creaking, and in the care of porters straight out of Tolstoy. Hogarth spent a morning sketching the Kremlin churches from a spot on the Moscow River under the inquisitive gaze of children and building workers. The next day, before the sun had risen, the delegation was airborne once more, and by 10 a.m. had landed at Sverdlovsk on an airstrip in the middle of a tan-coloured prairie, the surrounding dense green forest stretching into a lonely distance. They took off soon afterwards, heading further east, over the stark emptiness of Siberia, bound for Omsk and beyond.

At Novosibirsk, there was a change of aircraft and, more exotically, a champagne lunch served by 'short-skirted waitresses with Betty Grable hair-styles and wedge heels'. Suitably wined and dined, the party was conducted back through thickly shrubbed gardens, the deep green of the plants punctuated by ghostly statues of Stalin and Lenin. On the path in front of them was a group of leather-coated men, which Hogarth assumed to be an 'ominous bodyguard' but proved to be just a cheery mob of trade officials from Poland and Czechoslovakia. Flying again, the land beneath was on an epic scale, huge forests and interminable steppes, followed eventually by the foothills of Mongolia, the Gobi Desert and, as the aircraft slowly descended towards Beijing Airport, a first glimpse of China's Great Wall, its crenellated geometry rising and falling over a confusion of green hills; finally, terraced fields, 'a pagoda, a factory, a new housing estate and then – Peking'.

The Chinese capital had a 'medieval' quality, or so 'Freddie' Ayer thought.[4] Certainly it was dusty and its traffic largely consisted of bicycles. Overall, after some initial doubts, Ayer thought it 'the most attractive city' he had ever visited. As for Paul Hogarth, he was mesmerised by his first morning there, the azure sky turning pink and the figures in blue denim exercising metronomically to the tinny music of the revolution. 'Everywhere there was a sort of medieval pageantry,' he thought, 'a sort of visual spectacle straight out of Breughel.'[5] It was noisy, the hubbub reaching a crescendo by midday. He spent days padding round the streets, sketching 'string makers, potters and scribes', often trailed by hundreds of curious children. He met a group of Chinese artists, including the Secretary General of the Artists' Union, Hua Chun-wu, who reassured Hogarth that it was perfectly acceptable to draw 'everything but military secrets'. So Paul drew people and places: the Summer Palace, for example ('too Chinese to be real'), a wedding cake of a building, all pillars and curved roofs; and the 'tiny [and] dignified' Miss Wang-Yang who had, in a different life not so long ago, 'organised underground workshops to supply Mao's partisans'.

On 1 October, 'the fifth anniversary of the Liberation', there was a parade through Tiananmen Square watched by 'forty-seven delegations visiting from twenty-six countries'. Ayer, Rex Warner, Hogarth and others were there, stunned by the grand spectacle. It was loud and inordinately long, beginning at ten in the morning and still going five hours later; unsettling too, with seemingly endless waves of marching troops and noisy lines of armoured vehicles.[6] Hogarth sketched a view across Tiananmen with balloons drifting over a fine mesh of inked lines, studiously avoiding both human and military activity, the overall effect of such careful avoidance of the forbidden being a chaotic bustle of urban confusion.

From Beijing, Hogarth travelled north, taking the night express towards industrial Manchuria. The sleeping car reminded him of 'an early Dreiser novel' and, as the train rumbled and rocked through the darkness, 'snores alternated with the clacking of the wheels'. Once there, he sketched the physical signs of China's resurgence – a machine tool factory, rolling mills, blast furnaces – as well as the work-worn operatives who manned them. He was engaged in a marathon, travelling for three

more months and visiting nearly every corner of China. He completed some eighty drawings, before finally arriving back in the capital, in a state of physical and mental exhaustion. By then autumn had arrived, the leaves were falling and there was more than a hint of snow in the air. Indeed, it was cold enough for him to kit himself out with 'a blue padded suit, a heavy leather jacket and a bushy fur hat'. When he finally flew out of the city, looking out of a frost-scarred aircraft window at the swirling snow and the faint outline of the sprawling metropolis, Paul reflected on how the trip had changed him, particularly the newfound ability he had acquired to 'see subjects for their own sakes, rather than for their value as social comment'. Perhaps, after all, art <u>was</u> the thing that mattered most? Maybe he should focus on painting landscapes? At all events, he had learned that China was a country where it was as well to remember that the selection of subject matter was critical: 'it is good to paint shrimp. It is better to paint the Long March. It is best to paint Chairman Mao. But if I paint a sick shrimp, I am politically unreliable. If I paint two sick shrimps, I am an aggressive imperialist reactionary.'[7]

Being a Red is Tough

y the time Paul Hogarth and his motley missionaries travelled to
China in 1954, British communism was already in decline. Stalin
had died the year before and it wasn't long before uncomfortable
truths about his Terror began to emerge. A four-hour speech by the Soviet
Union's First Secretary, Nikita Khrushchev, in February 1956 at the 20th
Congress of the Party, 'delivered the final blow for many Communists'
when he revealed details of Stalin's 'monstrous acts of mass terror', the
murder of thousands and 'the filling of the concentration camps of the
Gulag'.[1] Until Khrushchev's exposé, it had been possible to reject such
rumours of a murderous regime in Moscow and so, when the British
cultural missions toured China two years before, the leftist-sympathising
visitors were all too willing to be hoodwinked, some of them softened
up by the 'outrageously lavish hospitality' they received. In their hearts,
however, most recognised that they were witnessing a sanitised version
of the country, while convincing themselves that China was embarked
on the path from revolutionary terror to something akin to democratic
socialism.

There was another factor at work in the decline of British communism:
1956 was twenty years after the outbreak of the Spanish Civil War and
many of the young communist activists in Britain who had rallied to the
Republic's cause at that time were now approaching the more conciliatory
conventions of middle age. Some, like Felicia Browne and George
Orwell, were dead, while others had softened their tone, or simply
changed their minds.[2] The world meanwhile had become infinitely more
dangerous. The communist historian Eric Hobsbawm, himself a subject
of MI5 surveillance, described the pervasive fear and the 'kind of nervous
hysteria' that existed in the country 'because we lived under that black
shadow of the mushroom clouds' – the permanent threat of the hydrogen
bomb.[3] Moreover, the events of 1956 inevitably brought the prospect of

nuclear war closer: the summer saw British and French airstrikes and troop movements against Egypt's nationalisation of the Suez Canal, while in the autumn, Russian tanks were thundering through the streets of Budapest intent on crushing a serious uprising in Hungary.

Some 7,000 CPGB members resigned in the wake of Russia's action in Hungary, but for others, leaving the Party was a slow process of disillusion, rather than a sudden rejection. Valentine Ackland, for example, had turned to Catholicism instead, cancelling the *Daily Worker* and replacing it with the *Daily Mail*, and then the *Telegraph*. As far back as December 1937, Sylvia had remarked of her partner that the 'Communist Party is at once too tight a pot for her and too draughty for her roots to settle in'.[4] By the 1950s, Valentine had lost her belief that Soviet communism was something to emulate; instead, she believed it evil and it was in that frame of mind that she wrote to Harry Pollitt formally tendering her resignation from the Party. Occasionally she would tease Sylvia over the latest Red atrocity, without ever eliciting any weakening in Sylvia's support for the Party – when Stalin's crimes were denounced, she clung on to memories of his broadcasts back in 1943 and 'those broad, serviceable shoulders that they were all content should shoulder the burden'. It left her feeling 'a deep distaste – a Tory distaste, I daresay, for my eminent comrades'.[5]

* * *

Doris Lessing finally joined the CPGB after returning from Moscow in the summer of 1952, albeit with some reluctance. She 'hated joining anything' and disliked intensely having a membership card – the acquisition of which had been delayed until the Russian excursion was over. She was interviewed prior to joining by the CPGB's Sam Aaronovitch, whom she described as a 'cultural commissar'. He was young, slender and 'military in style, with the grim, sardonic humour of the times'.[6] It troubled her greatly that the party had 'chosen a young man who had read nothing of modern literature, and was not interested in the arts, to represent culture'. It was an overhasty judgement, since, by the time she and Aaronovitch faced each other across the dark King Street office, Sam 'had [already] read Goethe, Schiller, Dickens, Tolstoy, Cervantes, Balzac and Shelley', as well as teaching himself German and some Russian.[7]

When she was still in Rhodesia during the war, Lessing had belonged to a 'pure' communist group – so pure, she claimed, that Lenin would have approved. The problem was that it existed in a vacuum, very far removed from the European brand of communism. With the benefit of hindsight, Doris could see that the group's members had yet to realise that 'the beautiful purity of the ideas we were trying to operate couldn't have worked'.[8] Both in Africa and England she was an instinctive protester, a defender of liberties and a 'Red' – but one with a deep distrust of the Party line and the obligation to follow it blindly. She knew too that loyalty to the Party brought with it the potential for trouble and danger. 'Being a Red is tough,' she said. 'My personal experience isn't bad, but friends of mine have been destroyed.'[9] The McCarthy witch-hunt against communists in the USA had horrified her: 'No British Communist was ever treated with the harshness the American government used towards Paul Robeson and some other American communists.'[10] Some 134 writers in the US were routinely under surveillance, and the FBI's methods could show a Stalinist quality: 'At the heart of the Cold War FBI agents even tried to persuade librarians to inform on the reading habits of library users. Such was the paranoia of the times.'[11]

The parochial nature of British communism troubled her too. Early in the 1950s, Doris would go to London's Little Venice, then down at heel and grubby, where in a canalside garden there would be regular ceilidhs where the communist singer and poet – and MI5 target – Ewan McColl would sing. Milling around in the garden in the evening sun would be a cross-section of cultural London, its common thread an allegiance to the Party, 'people from the worlds of radio, music and nascent television'. The house belonged to the actor Alex McCrindle, who – ironically – was then starring in the radio soap opera *Dick Barton – Special Agent*. Even then, early in the decade, Doris was dispirited by such worthy occasions, 'all those people doing Scottish folk dances, often in cold drizzle'. For her, politics was infinitely more passionate and visceral: rather than sad dancing in the London rain, she was determined to challenge the status quo, to expose, for example, the 'colonialism and apartheid' in the Rhodesia where she had been brought up. It was that which was in her mind when she met Paul Hogarth at an exhibition of his China paintings in December 1955.

Hogarth and Lessing go to Africa

The plan was to collaborate on a book about Africa – Doris Lessing's writing coupled with Hogarth's drawings. In later years, they would disagree about who had initiated the arrangement: Hogarth claimed that the instigator was John Berger, while Lessing claimed that it had been Paul who had made the first approach, or perhaps the Party had asked her 'if the artist Paul Hogarth could go with me'. The idea did not appeal to her, but she felt it incumbent on her to accept: 'I did not particularly want this, but why not.'[1] A further issue was the financing of the trip, a problem only resolved when Lessing approached the Soviet News Agency, TASS, after which a cheque soon arrived from the Narodny Bank, providing enough money to pay for the air fares and some of the other expenses.[2]

Money was just one of the things to worry the two travellers. Doris, with her experience of Africa, wrote to Hogarth warning of the hazards ahead: yellow fever (injections were necessary); procedures for entering Southern Rhodesia and South Africa (complex); and passport endorsements (obligatory). Moreover, Southern Rhodesia, Doris advised Paul, was 'very sticky indeed' if visitors arrived without enough funds for their stay, although there was some reassurance in the fact that they would be met by 'wealthy and respectable friends'. They flew BOAC from London to Salisbury (£243 return for each of them) and within hours of flight SA 211 leaving, a telegram had been sent to the Security Liaison Officer (SLO), Central Africa, alerting him to Lessing's presence on the aircraft. Agent 'LAND' confirmed that the reason for the trip was to do with her writing career, but that 'she is likely to make contacts for future Party use'. Both she and Hogarth ('freelance artist and longstanding member BCP') had their bags searched before leaving London, although nothing untoward was discovered. It was an auspicious arrival in Africa, the dawn skies over Ethiopia revealing dark mountains and 'the sun, like

a luminous spider's egg or a white pearl', its surface turning red as it broke the line of the horizon.[3]

More mundanely, there was a tiring five-hour wait in Lusaka Airport before the onward flight to Salisbury took off. Once in the Rhodesian capital though, there was the compensation of the city's dry heat, so life-giving after the dank fogs and blanketing cloud of London. At a stroke, Lessing felt the intervening years had fallen away and she had never left, so familiar were the air, the landscape and the sun's intensity. She felt somehow that it all belonged to her.[4] Rhodesian government officials, however, were distinctly uneasy, irritated by London's failure to supply sufficient and timely advice on Doris Lessing's companion. The writer had already been designated as a 'prohibited immigrant',[5] albeit with a temporary one-month permit to stay. But who was this Hogarth chap? 'Please cable all available information on Hogarth and advise as to whether local authorities should deem him prohibited immigrant.' There was disquiet in London too: would Hogarth 'take over subversive contacts' in the event of Lessing suddenly leaving? There was some reassuring news, however – for SLO Central Africa, if not for the unsuspecting Lessing and Hogarth: MI5 could confirm that the 'source' who had provided the information on the couple to the authorities was still able to operate, under cover, undetected and safe.

The South African police were similarly briefed by both London and Salisbury. They knew in advance, for example, about the flight Lessing and Hogarth took to Johannesburg on 4 April 1956. Once in South Africa, they were due to meet up with Bram Fischer, a communist lawyer, and other likeminded people, as well as showing Hogarth locations that 'most visitors never suspected were there'.[6] On the flight Hogarth and Lessing had been amused at the idea that Lessing might be denied entry to the country and unceremoniously sent back on the very same plane. After the shared laughter, Doris had suggested a little more seriously that should she indeed be arrested, then Hogarth must pretend that they had never met before. The posse of Special Branch officers waiting in the airport finally killed what was a limp joke at best: the two visitors from England, subjects of two extensive MI5 files, clearly merited a heavy-handed security presence.

Doris remained outwardly calm and didn't resist, even when it became clear that she was to be bundled back on the next Salisbury-bound flight.

But behind the insouciant face, she was hugely unnerved by the ominous atmosphere of the Jan Smuts Airport: not least because everyone she saw there seemed to be a Special Branch agent or informer 'down to the girl selling cigarettes'. Paul Hogarth's reaction to her arrest was less than helpful too, since instead of pretending that Lessing was a total stranger and ignoring the arrest, he waved his arms and shouted, demanding to be told where she was being taken. Two officers propelled her on to the plane, with other Special Branch men – all Afrikaners – chivvying her on board 'like a pack of dogs herding one sheep'.[7] She sat on her own, uncomfortably aware that people would be contemplating all sorts of reasons for her arrest. Lessing found the whole episode deeply upsetting, a feeling that would have been even worse had she known that 'the usual very delicate source' had kept London fully informed of events. Which of her close friends and associates was the guilty party? Anxious and angry, she flew back to Salisbury all too aware that there were just three weeks left on her temporary visa.

Nevertheless, Lessing made good use of that restricted time, travelling widely – to Umtali on the Mozambique border; to an African township; some copper mines; and to the Kariba Dam, then under construction. On their return from the dam, she and Hogarth stopped at a roadside kiosk to allow Paul to sketch; he was struck by the way a sign advertising Coca Cola captured the stark contrast between this land of grass huts and flame trees and the brash art and sugary confection that passed for Western 'civilisation'. Hogarth sat on a stool in the dusty heat, drawing, and surrounded by noisy African children, while Doris sat in the car, drinking what else but a Coke. Suddenly the peace was broken when a car screeched to a halt outside the kiosk. A man stepped out and stood, staring initially at their car's number plate, and then observing the artist at work. He was a stranger, but Doris recognised the type: a face with no emotions bar suspicion and a 'disgusted and irritated hate'. He paced to and fro for some thirty minutes. He had to be an undercover policeman, judging by that look he shared with others of his kind, that baleful stare, 'as if he would like to wring both our necks if only there was a law to permit it'. Paul finished his drawing, showed it to the admiring African children and carefully packed his drawing things away before he and Lessing pulled back into the road. They drove slowly at first, deliberately

allowing the policeman to tail them, but he had disappeared as rapidly as he had arrived, 'back to whatever post he operated from'.[8]

Despite such official attention, Doris was able to interview Garfield Todd, the country's prime minister, who proved 'a tall, handsome man striding about like Abraham Lincoln'. He gave the impression of a man who would much rather be out in the open air. The Prime Minister's office had been kept informed by the SLO, Bob de Quehen, of the surveillance exercise on Hogarth and Lessing, who had evidently proved adroit at evading the watchers to the extent that 'at the time of writing [30 April 1956], CID have lost track of them'. De Quehen used the failure to keep tabs on the suspects as an excuse for pressing for more resources, arguing for a 'properly equipped Special Branch'. Without it, there could be no guarantee that it would be possible to keep abreast of 'what mischief they are up to'. Unsurprisingly, the three-hour meeting between Todd and Lessing was less than successful, the Prime Minister making quite clear that Doris's stay in Rhodesia was approved only on the assumption that she 'would write nice articles' about what she saw. The meeting ended without any meaningful rapprochement and, from that time on, Lessing always travelled with the Prime Minister's 'publicity people' in attendance, as well as a squad of policemen.

Paul Hogarth had remained in South Africa for a while after Lessing had been returned to Salisbury, telling officials that his reason for visiting was to see relations. With him was the anti-apartheid activist and communist Ruth First, who was then married to Joe Slovo, the leader of the African National Congress (ANC).[9] Hogarth visited a gold mine, sketching more than a mile below the surface, 'sprawled against the wet, sloping walls of the mine, [his] lamp feebly illuminating the pages of my sketchbook'. The African townships disturbed him greatly – the 'conditions made me think of medieval Europe' – and despite the presence of an ANC 'minder', he felt uneasy at the baleful suspicion in the faces of the people he saw on the streets.[10] Once he began to draw, though, resentment turned to inquisitive interest, a kind of 'wonderment'. Like Doris, Hogarth travelled widely, across the 'dun-coloured desert of the Karoo', over lands where the shadows of the Boer War still lingered, and on through a veritable 'Garden of Eden' to Cape Town, a city 'flanked by the Atlantic on one side and the Indian Ocean on the other' and where the contrast between the rich and the desperately poor was unmistakable.

Rhodesia was equally troubling: Lessing's 'old comrades' were now struggling to cope with their evident isolation from the main stream of communist thinking. 'I found my old friends had become paranoid,' she wrote, 'had taken to drink, or had turned into their own opposites.'[11] She herself was regularly confronted by racism amongst some parts of the white population. All that was bad enough, but there was also the inescapable fact of the watchers and listeners continually dogging Hogarth and Lessing's time in Africa. There were, for example, the 'delicate' sources who reported that Lessing had contacted the *Daily Herald* to describe her abrupt exit from South Africa, and the fact that she had been making contacts 'for future Party use'. There was also a growing conviction that the writer was interfering in African education on the orders of the Party at a time when Garfield Todd was already concerned about the number of communists and fellow travellers to be found in the Native Education Department.

Special Branch interest in Lessing inevitably spread to her friends and associates, including the people she wrote to in London, those who travelled with her, individuals who had offered accommodation, as well as others who had stayed in the same house, local communists, black Africans, and those who already had some kind of 'security background'. The growing list of suspects included teachers, school inspectors, foreigners (especially those with Eastern European connections), civil engineers, civil servants, government health inspectors, researchers, an officer from the Department of Justice (he had recently resigned), and Mission staff. The number of people named in an 'interim report' on dubious contacts of the writer exceeded twenty, and more would be added over time. Part of MI5's methodology was to regard association, friendship or correspondence as inevitably risking contagion and so it regularly conducted investigations 'with a view to establishing the identity of contacts', a process that was true of the 'the cultural field generally', and involved obtaining 'the names of intellectuals sympathetic to the Party who may not already be known to us'.[12]

Lessing and Hogarth returned to London on a mid-May afternoon, arriving on flight BA 120 from Livingstone. MI5's Commander Johnstone had been alerted in good time and the two had been observed closely throughout their flight, the watchers' suspicions further aroused by the two passengers under scrutiny being absorbed in writing for much of the

time, as well as covering up 'the pages when anyone passed by'. There was some thought given to the idea that it would be worth taking a thorough look at Doris Lessing's large, black notebook – as well as the set of what appeared to be interesting photographs – but in the end was dismissed, reluctantly but recognising that 'Mrs Lessing's suspicions' could well be aroused. This was a woman, after all, who seemed to attract trouble. She had, for example, recently written a piece for the *New Statesman* accusing MI5 of alerting the South African government to her intended visit to that country. Security officers were very aware that she was 'an extremely irritated woman' and someone whose anger could provoke trouble – a file note observed that 'the least we can expect is a question in the House'. So it was that, while Doris and Paul were watched scrupulously on the Livingstone flight, no attempt was made to disturb them on the aircraft. Once they got to London Airport, their luggage was subject to a 'discreet' search, but 'nothing of interest to Special Branch' was found.[13] There was interest, however, in the fact that Paul Hogarth was met by a woman in a red mackintosh, 'age about 25–30, 5 foot 2 inches, medium build, light brown straight bobbed hair'. They were seen driving away together in a maroon convertible, with Hogarth in the passenger seat, the Special Branch man sufficiently flustered to catch only part of the vehicle's registration number – was it LHK or UHK 432?

Previously Lessing had regarded with impatience those members of the Party who were convinced that their phones were tapped and their post routinely read; she thought them 'romantic and paranoid souls'.[14] Now she discovered that she too was a victim of the same scrutiny, her letters opened, for example, and then carefully resealed. More disturbing than this covert surveillance perhaps was being confronted by the harsh face of the bureaucracy itself. A few months after returning from Africa, in August 1956, Mrs Lessing was summoned to the Rhodesian High Commissioner's office in London. Anticipating problems, she went accompanied by a lawyer. It was a meeting that, in effect, denied the writer her homeland. Declared a 'Prohibited Immigrant' by the Governor General, she could no longer enter the country. Moreover, the ruling had been made with no scope for any appeal. This despite the fact that her written account of her 1956 trip to Rhodesia, illustrated with Hogarth's line drawings, had been titled *Going Home*. That home would now be denied her because of her political beliefs.

Resignation

T here was disappointment too for Paul Hogarth following the African expedition, although not on the level of Lessing's enforced inability to go back to Rhodesia. For an artist to have his regular gallery at that time – the Leicester Galleries – choose not to exhibit his African drawings was a major blow, the reason – 'because of their challenging content' – even more so.[1] *Going Home*, the book over which Paul and Doris had collaborated, was problematic too, since the publishers, having been enthusiastic at the outset about the artwork, proved less convinced when the book was finally published, Paul's contribution being limited to only a few drawings 'reproduced as chapter headings, not much bigger than postage stamps'. The collaboration, which had been fraught with difficulties from the time it left London, was still causing irritation and disagreement many years later. At one point, for example, Lessing took exception to Hogarth claiming during a television programme that he had felt 'restricted' on the African trip by Doris's presence; she pointed out that she too could make such a claim about him. They even disagreed about whether Paul had, as Doris claimed, waved and shouted when the police in Jan Smuts Airport seized the writer, prior to forcing her back on to the aircraft in which she had just arrived. She wrote a terse letter to the artist, blaming the difference of opinion on the fact that the English had never fully grasped the reality of political threat. The reason for that, she argued, was because as a nation they had never actually experienced it. In that respect, she felt, they were very lucky. Hogarth would probably have wanted to point out that he too had been very well aware of 'political threat', as well as feeling that this was a disagreement that could never be resolved. Doris concluded her letter with a proposal to have lunch together in due course. By then forty years had passed since they had been uneasy travel companions.[2]

By the 1990s, when that letter was probably written, Lessing, along with many others, was no longer a communist. Indeed, even in 1956

she no longer thought of herself as a Party member. Those who ran the CPGB in King Street needed to be saved from themselves, she thought, and 'the baleful influences of the Soviet Union' entirely extinguished. She saw herself as a Trotskyist, uncomfortably but defiantly aware that in whatever communist country she went, she 'would have been shot for saying a hundredth of what I thought'. The Party was losing members fast and the days when it had seemed de rigueur to be a communist had long since gone.

It wasn't just the Russians' crushing of the rising in Hungary or the truth about Stalin seeping out from the Soviet Union, there was also great resentment about how the Party regarded artists, its belief that somehow the luxury of sitting at a desk, or standing at an easel, was incompatible with what was required to be a Party activist. Stalin's Russia, Lessing believed, had been anti-intellectual and the communist parties of the West had dutifully taken the same line. The assumption was that 'all bourgeois writers wrote trash' and a writer's time should be devoted to political organising. By the mid-1950s, Lessing was deeply resentful of the constraints imposed by the Party on artists and writers that in effect were 'a straitjacket of what we've all been thinking and feeling for so long'.[3] Clancy Segal, an American with whom she had a long affair, recalled her 'snarling' about the way the Party patronised her – 'they hate me' she said; moreover, 'the left is just like the right: they talk culture but they hate us. We're wayward and unpredictable and that's dangerous to deal with. Better anything than danger!'[4] In a letter to the writer Edward Upward, she recalled how someone – was it Frank Pitcairn? – had left the Party out of sheer boredom, but, she went on, it was also 'because he is an artist'.[5] Lessing too had had enough. At one point, she wrote to Paul Hogarth telling him that she anticipated sending 'in my party card during the next couple of weeks'.[6] When she finally mailed it to King Street, she was determined to make it a low-key gesture avoiding publicity, since she hated the pleasure the British newspapers derived from each Party member's resignation.

Resigning was becoming fashionable. Before the shock of seeing Russian tanks in Budapest, the revelations about Stalin had already disturbed many Party members: clearly, knowing that 'Uncle Joe had murdered them all' was a compelling reason for abandoning the Party.[7]

By 1957, Doris had become actively involved with the Campaign for Nuclear Disarmament (CND), and, while still regarding herself as a socialist – a 'rackety, atheistical Red' – she was no longer a communist, convinced that there was something in the Party's nature 'that breeds lies' and unhealthily elevates the collective over the individual. A discussion she had heard in Moscow about the Party's relationship with writers had taught her that, revealing as well that in Russia, 'fear or economic pressure' can force a writer to choose silence. A provocative Westerner had gone on to accuse Russian writers of being 'bludgeoned' into what he called 'false writing'. The notion was summarily rejected – 'bludgeoning'? There is <u>no</u> bludgeoning here! Rather, the view of Russian writers was that 'our conscience is at the service of the people', that they should show a sense of responsibility towards the community. 'We develop', one said, 'an inner censor.' If you put the community first, then it followed that you knew when it was right to keep quiet for the good of everybody; it was a view to make Westerners shake their heads in dismay.

Doris also found attitudes in the CPGB were increasingly unacceptable. There was, for example, the time she addressed a branch meeting in a crumbling suburb of South London, standing at the front of a room 'full of failures and misfits', uncomfortably aware that the Party was a kind of refuge, 'a club, or a home, a family' for many, rather than an instrument of revolutionary change. So disaffected and disillusioned was she that she took comfort from the fact that when an old and dear friend died, it was 'before he could know how shameful a failure Communism turned out to be'.[8] To cap it all, there was the unmistakeable and lingering taint of doubt and suspicion – it wasn't just MI5 that had agents, the Party did too. Those American exiles in London who had fled Senator Joe McCarthy's communist witch-hunts in the United States – which ones were agents of the CIA? Was her former husband Gottfried Lessing an agent of the Russian KGB?

* * *

Stephen Spender had read Khrushchev's marathon speech of denunciation on 17 March and felt 'the kind of horrified satisfaction one gets with the end of *King Lear*, when Edmund exclaims "The wheel has

turned full circle. I am here"'.[9] Spender was staggered that '<u>anyone</u> had ever believed <u>anything</u> the old crook in the Kremlin had said'. He had, after all, quit the Party many years before, after the briefest of dalliances. In the spring of 1956, he attended a conference in Venice of Soviet and Western intellectuals organised by the European Cultural Association. Inevitably, the timing in that spring of 1956 guaranteed bitter arguments between those who clung to the Stalinist past and those disillusioned by the revelations about it. The sniping between Spender and the scientist J.D. Bernal exemplified the divergence of opinion. Bernal was a longstanding communist ('inflexible until death') and Margot Heinemann's lover. At the Venice Conference he found himself 'baited at every turn by Spender, the writer who had become an active anti-communist'.[10] At one point Bernal went so far as to admit that the Party 'seem to have made some very serious mistakes. I don't know how it happened but it is bad.' Nonetheless, he remained convinced that communism was hugely preferable to the alternative, which was characterised by its 'waste and lack of opportunity'. Spender, however, spared no one with a communist background, arguing that 'the dupes believed Stalin, the counter-dupes believe Khrushchev' and both were equally misguided.[11] Later he would write a novel, *Engaged in Writing*, in which a Spender-figure attends such an intrigue-ridden conference and is driven to distraction by the 'arcane ideological wrestling match' played out in front of the Russian delegates who, in turn, watched the proceedings 'with detachment, clothed in the mystic virtue of survival'.[12] They knew the value of silence in Soviet Russia.

Stephen Spender's flirtation with communism might have been short-lived, but he was the exception among those artists and writers who had aroused MI5's interest. Many had retained a deep-seated loyalty to the Party over two decades. Some were members of the Geneva Club, 'a drinking and dining club' that was intended to bring 'together writers and artists associated with the Communists'.[13] Founded in the mid-fifties by Randall Swingler and John Berger amongst others, its attendees included J.D. Bernal, Margot Heinemann, Paul Hogarth, Joan Rodker, Berger and – infrequently – Doris Lessing. The exposé of Stalin and events in Hungary shook many of them to the core: Randall Swingler, for example, resigned from the Party soon after the 24th Congress of the CPGB, held

in Battersea Town Hall. Swingler was one of the writers who had attended meetings in the past of the CP Writers' Group held at Doris Lessing's flat. She later claimed not to remember him ever being there, although in her autobiography she at least gave him credit for his puritan tenacity – the fact that he had bought a cottage in Pebmarsh for £5 and lived there 'without running water, light, telephone, heat or toilet'.[14] According to Paul Hogarth, Lessing 'held him in great esteem as he was supportive when she was attacked at a Women's Cultural Conference for being a bourgeois deviationist'.[15] Paul would often reflect on whether Swingler was the model for one of the characters in Lessing's *The Golden Notebook*.

Swingler had been hit very hard by the turmoil in the Party, a furore that must have seemed to him to be yet another manifestation of the harsh post-war world. There was also the persistent shadow of surveillance, the BBC's cold shoulder, his seemingly permanent state of poverty, and his loss of reputation. At one time, before the war, he had been a literary mover and shaker, editing *Left Review*, writing the *Left Song Book*, and working with Benjamin Britten, Paul Robeson and Vaughan Williams amongst others. After the war was over, Swingler's career had stalled. He was attacked by both Orwell and Spender, turned down by the BBC and the Arts Council, his adult education courses closed down, and no one published his work after 1950. 'By the early 1960s Randall Swingler was already air-brushed out of the picture, unemployed and unemployable.'[16]

After the CPGB's 24th Congress, held at Easter 1956, Swingler returned to the Castle Hedingham branch to report back on proceedings. Near to tears, he told the meeting that he intended to resign from the Party. He could not be persuaded otherwise, too disillusioned by the Party leadership and disappointed in his communist friends: 'Monty Slater shrugs and is dumb,' he wrote to Edward Thompson, adding that 'Paul Hogarth can't afford to think,' while another friend, Alan Bush, acted as if 'nothing at all had happened since the General Strike and I had resigned from the Athenaeum because the wine was corked'.[17] Swingler and the CPGB had parted company, but Paul Hogarth, Montagu Slater, the poet Edgell Rickword and others chose not to follow his example, at least not yet, preferring to put off the inevitable.

Things got worse. By June, Swingler was 'restless with anger and frustration' and, when King Street banned the *New Reasoner*, he seethed

about the 'mean-minded little squirts' responsible. The Party's leaders, he believed, could not escape 'the Moscow cast of countenance and the Stalinist cast of mind'. When Khrushchev's troops crushed the Hungarian rebellion, Swingler was incensed, comparing it to 'Cromwell's suppression of the Leveller regiments in 1649'. By now Randall was poverty-stricken, reduced to abridging novels for children, depressed and drinking heavily. On one occasion, he had to borrow the train fare to London. He attended a meeting at Doris Lessing's flat but was unable to contribute in any meaningful way, his 'head … like a hive of bees'. After another meeting of the Geneva Club, the writer Jack Beeching, who had been sitting next to Lessing, described Swingler as drinking heavily in the bar downstairs, convinced that Beeching and Jack Lindsay 'were there on the secret orders of King Street'.[18] Swingler by then was living the life of a peasant, doing casual labour for local farmers, or repairing motorbikes and feeling 'old and outdated and hating it'. Visits to London were no longer in the hope of work, but tended to be for maudlin sessions in city pubs. On one occasion, in the York Minster pub in Soho, he introduced Paul Hogarth to the playwright Brendan Behan, who would become a valuable connection for the artist. He wrote to Reggie Smith at the BBC: 'Our fortunes are at rock bottom,' before asking Reggie if he could see his way to helping him 'get back into the BBC'. Despite Smith's efforts, there was no reopening of that door; Smith was to resign as well from the Party in 1956 over Hungary. By December 1958, Swingler had given up his editorial board position on the *Reasoner*, apologising to Edward Thompson that he had become 'such a weak reed'. He was nearing 50 and 'must now start/All over again, rather late in the day …'[19]

* * *

A month or so before the Russian invasion of Hungary, Paul Hogarth wrote an angry letter to James Klugmann at Party HQ – another one that would also be read at MI5's Leconfield House offices. In it, Hogarth revealed his fury at the Party's 'expulsion' of the Marxist historian E.P. (Edward) Thompson, whose view of the current state of the CPGB was that it was 'in the impossible position of trying to follow a formula evolved for a foreign people'.[20] Hogarth thought expulsion would be 'disastrous'

and claimed that doubts about the Party leadership were widespread amongst intellectuals, that it persisted in working 'in the old Comintern way', and was both undemocratic and unintelligent. The 'radical culture' that had been created, despite all the odds was dead, he thought, and the culprits were 'the bureaucrats of King Street'.[21]

The critical turning point for Hogarth was still to come, however. In the October after his long African trip with Doris Lessing, he was invited to Bulgaria by its Committee for Friendship and Cultural Relations, to put on an exhibition of some one hundred of his drawings. He and his wife, Phyllis, flew out of the UK on 2 October, a Special Branch officer noting that 'the passports of both ... contained unused Czech and Russian visas'. It all started idyllically: Bulgaria seemed almost Mediterranean in its verve and colour, lines of poplar trees along placid river banks, although its warm-blooded people seemed uneasy. Hogarth then left Sofia by train, bound for Poland, but expecting to stopover in Budapest. He arrived at much the same time as the riots in the streets and the Russian tanks, with the result that no one was allowed to disembark from the train as it stood in Budapest station.

Eventually the Warsaw train and its sealed-off passengers slowly pulled away. When they reached the Polish capital it was to find the streets were similarly riotous and bloody. 'The scales certainly fell from my eyes in Warsaw in 1956,' Hogarth later wrote, and, after months of growing disillusion, he now felt compelled to expose the crimes against the people of which he had been a witness. As well as the violence on the streets, he had been shocked by the furore at a conference he had attended when Russian observers 'were being challenged by Polish and Hungarian delegates to produce their heroes of the Spanish Civil War'. One incensed delegate argued that there were none left since they had all been shot on Stalin's orders.[22] Hogarth made contact with Robert Harling at the *Sunday Times* – and a man who 'had links with MI6' – and then, 'feeling like Judas', he dictated an eyewitness account of what he had seen in Warsaw to one of the paper's staff. It duly appeared on the paper's front page on 28 October 1956.[23] He was fully aware that fellow members of the Party would be appalled by his action, since 'being a Communist is like being a member of an army or a religious sect'. The Russian writer Ilya Ehrenburg told Hogarth that he had 'done a great

deal of harm', in effect, 'betraying genuine art in the Soviet Union'.[24] It was a considerable comfort that his old friend, Randall Swingler, thought he had done the right thing.

Paul Hogarth flew back to the UK from Hamburg on 3 November 1956. A fortnight or so later, he was one of a number of artists and writers who signed a letter to the *Daily Worker* criticising the Party's policy on Hungary, its regular distortion of facts, the systematic shunning of the truth, and 'the underwriting of the current errors of Soviet Policy'. The signatories included John Berger, Eric Hobsbawm, Edward Thompson and Doris Lessing – MI5's listeners, tuned in to the King Street telephone, noted down the names for the files. For his part, Hogarth was coming to realise that Soviet communism was a kind of 'purgatory not paradise'. At the same time he was being ostracised by many communists who could not forgive his exposé of Russian brutality in Warsaw. For the time being, though, he remained a Party member. His attitude to his art, however, had changed: 'After 1956, I turned my pencil the other way.' From that time onwards, he 'turned to drawing people and places for what they were'.[25]

Burma 1944

Twelve years earlier, when the war was stumbling towards its ending, and the Russians were staunch, if unpredictable and exacting allies, Britain's communists viewed the world very differently and were themselves tolerated. As for Clive and Noreen Branson, their continuing correspondence showed no hint of a diminution in their political convictions. In early December 1943, Noreen told her husband that she was now 'acting branch secretary' and was 'taking a very strong line', insisting that 'the first responsibility of our members is to be in contact with the masses'. Now was not a time to question allegiance to the Party or its Soviet overlord. Her doubts were not about the political context, but focused as 1943 drew to a close on whether Clive would still be alive when her letters finally reached the front, given his evident proximity to the Japanese positions.

Inevitably, perhaps, the correspondence between them stayed much the same, on the surface at least. On 22 January 1944, Branson wrote home again, telling Noreen that he had finally been promoted to troop sergeant. It was a minor victory, but he was now convinced that he would never break free of non-commissioned status, since his communist background was simply too toxic for the army establishment to ignore. It was a prohibition derived from the same anti-communist prejudice that Paul Hogarth had met when he had been summarily removed from army training in the winter of 1939–40. That had been because of his politics too; now there was the additional twist that communist Russia had in the meantime become an ally. Clive's letters remained fond and passionately political (famine in India; fascist officers; the Second Front), while Noreen's were loving ('All my love dearest ... I have not heard from you for over a fortnight and am feeling a bit worried'), political (put Oswald Mosley back in jail!), or domestic. On day-to-day life, Noreen had the advantage, since she was free to describe it in uncensored detail.

So she told him about Rosa's performance in the nativity play, her own bouts of flu, Christmas with the in-laws, and going to bed at two in the morning, only to be roused at five o'clock by an air raid warning since she and her next-door neighbour, Margot Heinemann, 'were supposed to be fire-watching'.

By February 1944, however, Noreen had become 'horribly depressed', edgy and bad-tempered, regularly taking it out 'on Margot all the time which makes me feel a beast'. It troubled her that she had made a New Year resolution 'to be nicer', but had failed abjectly to keep it. Newspaper stories of tank action in Burma frightened her and she was troubled by thoughts of how her life – 'safe, with three meals a day and a bed to sleep in at night' – compared to her husband's growing uncertainty. Through it all she clung on desperately to the thought of their shared future when 'we can carry on where we left off'.

With the prospect of action drawing ever closer, Clive returned Noreen's letters, urging her to keep them safe 'as I am determined to write a book on my return'. It was an edgy, impatient world in which Branson now lived, censorship screwed ever tighter and with mounting uncertainty about when the fighting would actually begin. At one point, a colonel gave a lecture to the troops, replete with hunting metaphors and an insistent and probably unwelcome promise that he would get them all 'blooded' in the not too distant future. Then, on the night of 24 January, the unit moved and, by the following morning, a full-scale battle was underway, sufficiently vivid for Branson to make some rapid sketches on scraps of paper, depicting 'great Jap planes', for example, and 'our own barrage'. That night, he took a sleeping draught and went to bed at seven. He slept well and woke to hear C Squadron moving out. But his own squadron was to endure yet another day of waiting, during which there was nothing for it but to make the bed, loaf around and chat, sunbathe (though 'not so openly as before'), sleep fitfully, and look across at the enemy lines. The Japanese troops were occupying a series of low hills into whose sandy, rockless slopes they had dug, 'the way children make tunnels in sandcastles'. The hillsides were thick with bushes, as sharp as barbed wire.

Eventually, at the end of January 1944, Branson and his unit went into action, a flurry of frenzied activity, followed by an anti-climactic cleaning

of the tank, a wash and contemplation of what might happen next, the men apprehensive following the warning they had received that the 'next operation is going to be more difficult'. A VIP turned up, his presence requiring the donning of 'overalls, boots and berets', and the temporary abandonment of shorts and bare chests. He meandered through the lines of men, firing off practised questions – Been long in the Army? Same regiment? Troop Sergeant since when? – and the whole charade proved intensely irritating, since the prevailing thought was 'get on with the fucking war instead of asking useless questions'.

Through all this period of doubt, Branson was writing poetry, his output increasing as the fighting intensified. His letter of 4 February included a sonnet with an ominous last line: 'When life has gone, then where does death begin?' From that point, his letters dried up while the all-consuming Battle of the Admin Box developed; they were 'fighting for the Ngaukedauk Pass'.[1] Then, on 25 February, with the battle won, an assault on Point 315 was mooted and tanks detailed for the attack. Soon after, Branson's tank was hit by enemy fire. A Lieutenant Miles halted his own tank and his crew ran back along the track, where they found 'the other crew laying out the body of their commander'. Troop Sergeant Branson had been standing with his head out of the turret, guiding his tank's driver, only to be hit by a shell, his body falling back into the heart of the tank. 'His crew, not surprisingly, were inconsolable.'[2]

* * *

In due course, Noreen received a notification from the Officer in Charge, Cavalry and RAC Records, Hertfordshire:

> You are requested earnestly not to write immediately to this office or to the British Red Cross Society for further details but to allow time for a communication to arrive from the Theatre of War by post, bearing in mind that operations may have prevented a letter being written as soon as the casualty occurred.

Aftermath

Had Clive Branson survived that direct hit from a shell in the mountains of wartime Burma, how would he have reacted to the events of 1956? Would he, like Hogarth, Lessing and the rest, have signed the letters to the Party berating it for 'distortion of facts', the 'grave crimes and abuses' in Russia, and the Executive Committee's 'underwriting of the current errors of Soviet policy'? Or would he have clung on to the political creed that had sustained him through wars in Spain and India? He would not have been one of the first to jump ship, one suspects.

Paul Hogarth certainly was not one of the Party members who resigned as soon as Stalin's past was revealed. He kept his membership card for the time being, despite his growing disillusion, and MI5 continued to watch him. Indeed, in some ways, surveillance was stepped up. In late January 1957, the Romanian press announced an 'exhibition of the works of the British etcher, Paul Hogarth', news that prompted an enquiry from the embassy in Bucharest. Was this 'etcher' a communist or a fellow traveller? 'Any background and guidance on his standing' would be welcome. MI5's response was quick and damning: 'Hogarth has been an active member of the British Communist Party for about 20 years.'

On 28 February 1957, after a tip-off, a beige saloon car, registration MUW 5, was spotted by a police motorcyclist on the A131 between Halstead and Sudbury. It was parked outside Red House, Gestingthorpe Road, Little Maplestead. Around four in the afternoon, despite the light beginning to fade, PC893 Leonard Gore of the Essex Constabulary could just make out a man sitting in the car's front seat. He was aware that it was parked outside the house belonging to Paul Hogarth, 'a known communist'. Thirty minutes passed and the twilight faded to darkness. Then two men emerged from the house. They looked around cautiously before getting into the car, which soon drove off fast in the direction of

Braintree. PC Gore's report describing the men in MUW 5 was noted by senior officers at Essex Police HQ and one observed that 'security enquiries have been made respecting [Hogarth] on many occasions, by CID Braintree'. The artist was, he noted, 'a good friend to many other known Communists in this area – there are many of them'. Earlier that day, around noon, a police car patrol had, following instructions, stopped a beige-coloured 'Pobeda Saloon motor car', the number of which was logged as MUR 5. In the car were three officials from the Russian embassy, the chauffeur, Mikhail Novikov, as well as Vladimir Filatov, and Vasillis Bogatyrev, both 'clerks'. Their papers were checked and found to be in order. They drove off, to be spotted later by PC893.

Surveillance on Essex's 'many' communists, including Hogarth, continued into March. An officer from the Castle Hedingham police station reported on 18 March that a suspicious black Ford, SLX 71, owned by Albert Joseph Tiley, of London SW1, had been spotted in a number of significant locations – outside Randall Swingler's house in Pebmarsh, and on the forecourt of the Cock Inn, Little Maplestead. Hogarth's car had been seen in the same public house car park 'shortly after the visit of members of the Russian Embassy to Hogarth'. The Essex Chief Constable forwarded the names of those under surveillance to MI5 on 22 March. Later that month, a phone tap revealed that Hogarth had met Bogatyrev for lunch in London, though the nature of the discreet chat remained unclear.

Four weeks later, at the end of April 1957, Hogarth finally acted, tearing up his Party membership card and posting the two neat halves to John Gollan, who had by then replaced Harry Pollitt as secretary of the CPGB. Pollitt had become a diminished figure, shown all too clearly the previous year 'on the weekend that Soviet troops intervened in Hungary' by 'the angry and emotional scene in which, very much the worse for drink, he turned on the scientist J.D. Bernal'.[1] With his ripped-up card, Hogarth also enclosed a brief typed letter that explained why: the 'evasion and vindictiveness' that had been evident at the 24th Congress; the absence of a 'real and effective place for artists and writers in the movement'; the 'objectionable personalities' who had held sway for far too long. Later, he would write to Jerzy Zaruba in Poland that 'the [Party] leadership is only interested in defending indefensible Soviet actions'. He was certain, he

wrote, that 'it is essential for the artist to NOT be a member of a political party'.[2] He was not repudiating socialism, he wrote, but now saw himself as 'an unattached humanist'. True to form, MI5 knew about his decision from yet another 'delicate source', as well as opening and copying the letter. In all probability they would have read it before King Street's officials did. It now sits in Hogarth's personal file, bizarrely daubed with a red stain like dried blood, suggesting that the furious artist had splashed it with crimson paint in protest at the real blood spilt in Budapest. The truth is more mundane: since the thin river of 'blood' has spread across the envelope and the MI5 'Secret' paper to which the copied letter is pinned. The responsibility must lie with some cack-handed clerk behind an MI5 desk, swearing over a bottle of spilt red ink.

Predictably, Hogarth's resignation from the Party did not stop official interest in him. Essex's Chief Constable was informed on 9 May that 'in view of [Hogarth's] recent contacts with members of the Soviet Embassy we continue to be interested in his activities'. MI5 was not an organisation given to forgiveness, or unconsidered closure of surveillance, perhaps because of 'the question which is always asked of any Communist, or former Communist ... was the rupture sincere or a tactical ploy?'[3] Anyway, the artist was due to travel to Russia in only a matter of a few weeks' time. Russia, of all places!

Towards an Ending

I t is quixotically British that a number of these artists and writers whose political views had encouraged the Intelligence Services to pursue them for many years were eventually awarded honours by the British Government: Hogarth became an OBE; C Day Lewis received a CBE; Stephen Spender was knighted in 1983, having been made a CBE in 1962; Olivia Manning was similarly rewarded; and Doris Lessing became a Companion of Honour in 1999, having earlier turned down the title of Dame of the British Empire on the logical grounds that the Empire no longer existed. Lessing also won the Nobel Prize for Literature in 2007 at the age of 88 and just over fifty years since she and Paul Hogarth had been hounded on her 'going home' to Africa. She wrote more than fifty novels, some under a pseudonym, and died in November 2013, aged 94.

Sir Stephen Spender, as he became, was similarly feted by the literary world, this despite revelations that *Encounter* magazine, which he edited from 1953 to 1966, was 'a covert tool of American policy', funded by the CIA and with one of its editors an agent of that organisation. The episode was the subject of rumour and supposition for years, followed by bitter recriminations. Spender's reputation was tarnished by accusation and innuendo, but in career terms he was highly successful, teaching in England and the United States, Professor of English at University College, London University from 1970 to 1977, and then with emeritus status. He died of a heart attack in 1995, aged 86.

For the most part, the latter years of the Cold War and beyond saw communism lose its hold on writers and artists: Valentine Ackland's MI5 file was closed in 1957, it seems, and her latter years were marked by a struggle with alcoholism, a growing Catholicism and a series of romantic dalliances that caused considerable pain to Sylvia Townsend Warner. Valentine died of breast cancer in November 1969. She was buried with Sylvia in St Nicholas's churchyard in Chaldon Herring,

Dorset. Unlike her partner, Sylvia Townsend Warner retained a stubborn support for communism, although her earlier activism was forgotten. Her membership lapsed during the 1950s, although it seems she never formally resigned. There was a view that 'Sylvia had been kept off both radio and television for two reasons: her membership of the Communist Party and her lesbianism'. Her literary reputation suffered 'after the worm of McCarthyism' had burrowed deep into the cultural world and she became 'a literary casualty of the Cold War'. There would be no more novels from her. Her explanation for that loss was a despondent one: 'We had fought,' she said, 'we had retreated, we were betrayed and now we were misrepresented.'[1] She died in May 1978.

In some cases, political conviction became blunted or subsumed by other things, career or the blight of middle age: Auden remained largely in exile, although he was appointed Professor of Poetry at Oxford in 1956, his tenure lasting for five years. He was required to give just three lectures a year. He would winter in New York and spend each summer in Europe, latterly in Austria. He died in Vienna in 1993. C Day Lewis preceded Auden as Oxford's Professor of Poetry, holding the post from 1951 to 1956. He was appointed Poet Laureate in 1968. He was very much the disappointed communist, his feelings revealed, for example, in his detective novel – written as Nicholas Blake – *The Sad Variety*, where the communists are seedy and intent on treachery. He died of cancer in May 1972, aged 68, at the house of Kingsley Amis and Elizabeth Jane Howard, and was buried near Thomas Hardy's grave in Stinsford, Dorset. Christopher Isherwood remained in America, living in Santa Monica, writing and teaching fiction. He died in 1981, his ashes scattered at sea.

Two men who were caught up in the defence of the Spanish Republic in the later 1930s, the artist Julian Trevelyan and the writer Ralph Bates, were both increasingly focused on their work through the later post-war years: Trevelyan, who married the artist Mary Fedden in 1951, lived near the Thames in Hammersmith and was prolific – the Tate holds 105 of his works. His annual boat race parties were very popular and attended by figures from the art and literary worlds, including Dylan Thomas and Stanley Spencer. He was also in touch with Auden and Isherwood. Bates left Europe for Mexico and, in time, became Professor of Creative Writing at New York University, retiring in 1966 and moving to the Greek island

of Naxos. He was climbing mountains until he was well into his eighties. He died in Manhattan in 2000.

Reggie Smith was another former communist who became an academic. He retired early from the BBC and became Professor of Liberal and Contemporary Studies at the New University of Ulster in 1979, achieving emeritus status in due course. He married the actress Diana Robson, with whom he had been conducting a longstanding relationship, a year after the death of Olivia Manning in July 1980. He died of cirrhosis of the liver in May 1985. Manning's sought-after fame escaped her: she had died years before a BBC production of her trilogy *Fortunes of War* brought her to a very wide audience. J.B. Priestley was a founder member of the Campaign for Nuclear Disarmament (CND) in 1958; he too was accorded an academic niche as Doctor of Letters at Bradford University.

Storm Jameson became a firm anti-communist and supported the Labour Party. She wrote an indictment of communism, which formed the foreword to a paperback edition of *The Diary of Anne Frank* published in 1951. However, during the Cold War, it 'remained clear that the kind of Europe she had in mind was still fired by … anti-capitalism'. Like Spender's brush with American money and influence, she was caught up in a similar situation with CIA funds being channelled into PEN. She died in a nursing home in September 1986.

Randall Swingler was perhaps the most significant victim of the times: a major communist poet and influence before the war, he was almost a forgotten figure thereafter. For years, he and Paul Hogarth had seen each other most days unless the artist was abroad. After 1960, when Paul moved from East Anglia, they met just occasionally, 'in London at the French pub and the Colony Room where he increasingly embraced a bohemian lifestyle'. That lifestyle had been more apparent 'after his break with the Party'.[2] He died after collapsing in a Soho street in 1967. He was 58 years old.

Wogan Philipps, the artist turned Gloucestershire farmer with the aristocratic provenance, was elected to Cirencester Urban District Council as a Communist councillor in 1946 – the Cotswold town an unlikely seat of Red protest. He remained under MI5's watchful eye: the Party literature in his luggage on a return from Prague in May 1948 was noted and a tele-check recorded a phone conversation that same

year between two of the Party faithful, which revealed that 'he and Jack Dunman [were] beaten up in a Berkshire village. Wogan was hit in the eye by an egg thrown from a great height.'[3] He stood as a communist in the 1950 General Election in Cirencester and Tewkesbury, picking up just 432 votes. In 1962, on his father's death, he assumed the title of Baron Milford, entering the House of Lords as its first communist and using his inaugural speech to argue for the House's demise. He died in 1993.

The title of staunchest communist of the protagonists belongs to Margot Heinemann. She stood as a communist candidate for Vauxhall in the election of 1950 and stayed in the Party until it was dissolved in 1991. She taught English at Camden School for Girls, Goldsmith's College, and latterly was a Fellow at New Hall in Cambridge. She was fondly remembered by students: Lanetta Smith, a student at Goldsmiths towards the end of the 1960s – over fifty years ago – recalled her 'dark eyes and deep voice'. She was a deeply serious woman but with a 'wry sense of humour'. Heinemann taught Ben Jonson and Jacobean tragedy – 'appropriate subjects for her', Lanetta remarked. 'She could have been a character in them.' She kept her politics hidden away from her students. The writer Deborah Moggach, writing in *The Guardian* in January 2010, described her as 'my most inspiring teacher ... hugely intelligent with large dark eyes and a Past'. Heinemann was one of those teachers brave enough to introduce books and writers outside the set texts; and wise enough to entice students 'somehow to life itself, with all its tragedies as well as its possibilities'. She died in June 1992, twenty-one years after the death of J.D. Bernal, with whom she had lived and produced a daughter, Jane, in 1953. Her MI5 file remains sensitive. Attempts to have file MEPO 38/67 released through the Freedom of Information Act have been refused – 'under Section 17' – in other words, because of 'issues relating to national security' or the potential for compromising 'our law enforcement function'. Evidently, 'investigative techniques employed in the 1930s' threaten 'present-day policing'.[4] Phone tapping and the opening of letters continues ...

* * *

A sub-plot of this story of MI5's campaign of surveillance on those artists and writers deemed to be communists, fellow travellers or just

plain 'left wing' is the complex spider's web of connections linking them. Randall Swingler, for example, worked closely with Reggie Smith at the BBC; Wogan Philipps was married to John Lehmann's sister, Rosamond, before she left him for C. Day Lewis; Rosamond Lehmann was a friend of Jean MacGibbon; Felicia Browne was part of a 'Euston Square' Circle, which also included Auden and Coldstream; James Klugmann was a close friend of Donald Maclean at Gresham's School, as well as being John Cornford's 'closest friend'; Maclean, Auden, Tom Wintringham, Spender and Klugmann all went to Gresham's; Klugmann was tutored by Anthony Blunt; Klugmann's sister, Kitty, went to school with Felicia Browne; Kitty was also good friends with Margot Heinemann; Heinemann lived in the same block of flats as Noreen Branson when Clive was in India; Clive Branson was at the Slade with William Coldstream, who was a friend of Auden; Auden lodged with Coldstream at one point; Coldstream had an affair with Sonia, George Orwell's second wife; Sonia was a friend of the MacGibbons; James MacGibbon was a good friend of Julian Trevelyan; Louis MacNeice was a friend of Auden's and Anthony Blunt; Alaric Jacob, who shared a house with Paul Hogarth, went to the same prep school as George Orwell; Randall Swingler and James Boswell were in wartime Iraq at the same time; Humphrey (Hugh) Slater, who had been to the Slade with Branson, became a fervent anti-communist and rowed furiously with Donald Maclean; Tom Wintringham had links with Storm Jameson and Sylvia Townsend Warner; and so on.

Perhaps the most striking connection concerns Paul Hogarth's fourth wife, Diana, whom he married in 1989. She had previously been married to Reggie Smith, having been his mistress while Olivia Manning was still alive. When Reggie died in 1985, she was left on her own. Diana was in her fifties, a talented and attractive actress, sufficiently glamorous in her early days in the theatre for the poet John Masefield to want her cast in the role of Helen of Troy in his drama *The Taking of Helen*. Diana and Paul met in 1986 soon after he had finished collaborating with Graham Greene, a project that involved Hogarth visiting – and drawing – the locations of Greene's novels. It had not been an easy commission, mainly because of the depressing locations involved. When Paul and Diana married in 1989, her cousin Pat and her husband Mike declined the invitation – although she and Diana were close – because Mike 'was worried about

MI5', given his sensitive occupation, working in the aerospace industry.[5] For her part, Diana remained unaware that Paul was being watched by MI5; Reggie, however, had certainly known. 'The boys in blue are listening,' he would say.

Hogarth's work through his later life was busy and varied: he produced stamps for the GPO; illustrated the covers of paperback Shakespeare ('he got to the heart of each play'); drew a series of watercolours of National Trust properties; and illustrated books by Brendan Behan, Graham Greene, Stephen Spender, Laurence Durrell and Robert Graves amongst others. Paul had met the Irish writer through Randall Swingler, when the two of them had been propping up the bar at the York Minster pub. It was in 1958, the year that Behan's *Borstal Boy* was published. The chance meeting led to a collaboration between writer and artist, aimed at producing 'an update of Thackeray's *Irish Sketchbook*'.[6] When Hogarth duly arrived in Dublin in the summer of 1959 to embark on the project, Behan made his priorities clear: 'I don't give a damn whether or not an artist is effin' abstract or effin' realist, jes so long as they're not effin' illiterate or teetotal.' Predictably, the book proved a challenge, with the Irishman providing only a tape recording, rather than the promised text, but the book, *Brendan Behan's Island*, proved a best-seller in both the US and the UK when it appeared in 1962.

Hogarth's collaboration with Graham Greene involved the artist travelling in the footsteps of the writer to illustrate key locations from a number of Greene's novels. In October 1985, for example, Paul wrote to Greene having 'just returned from Belgium and Germany' researching *Stamboul Train*.[7] In November he wrote again, having been in Zaire on the trail of *A Burnt-Out Case*. At the end of the month, Greene replied: 'I hope you won't come out with leprosy in ten years' time. Edith Sitwell was afraid to kiss me when I came back!' In February of the following year, Hogarth wrote again after visiting Vietnam, which he had found 'deeply fascinating', Saigon having 'looked as though it had resurfaced from a flood of time'. By 1986, the odyssey was complete, with some relief felt by the much-travelled artist but with 'a deep sense of regret too' – the impact on him had been significant: 'Your novels', he wrote on 29 October 1985, 'have given me another pair of eyes.' *Graham Greene Country* was published in 1986.

At one point, in 1972, Hogarth tried to get a visa for Russia in order to draw the Canada/USSR ice hockey series for *Sports Illustrated*. 'But I returned empty-handed. I now appear to be on the blacklist.'[8] In the summer of that same year, he visited the US for some five weeks for a proposed book with Stephen Spender – his contract required him to visit a string of American cities, including Washington, Philadelphia, Natchez, Chicago, Seattle, Las Vegas and San Francisco. *America Observed* eventually was published in 1979, the delay arising because of Spender's workload: 'I am so utterly overwhelmed with promises to keep', he explained to Paul in the summer of 1972, 'that I thought I would never be able to do [it].' Hogarth found himself selling the importance and significance of the idea to the writer: the 'project reflected the current revival of pride that many thoughtful Americans are experiencing for their way of life', he wrote.

As late as 1991, it seems, Hogarth's past could unexpectedly catch up with him. In April of that year, Paul and Diana were due to fly to Sydney, travelling via Los Angeles, but after queuing at Passport Control in the US, the artist's passport provoked 'a blip on the computer and [they] were sent to Immigration'.[9] They were obliged to wait for hours 'to see if Paul was to be allowed into the USA'. He was refused entry and interrogated before he finally emerged 'sadly out of the office and said, "I'm being deported"'. Diana thought 'it was obvious that the whole episode was because he had been a member of the Communist Party'.[10] He had, after all, been refused a visa in 1962 when the response from the US Embassy indicated that it had been turned down as a result of the following ineligibility: 'Persons who are or at any time have been anarchists, communists or other political subversives.'[11]

Work was central to Paul's being and he 'needed to work every day'. He lived for the present and never talked willingly about the past, believing that art was the most important thing in his life. When her husband was in his seventy-sixth year, Diana intimated in a letter that 'Friday is a good day for Paul because he's relaxing from the working week'.[12] He was working until the day he died. It helped that Diana was 'a brilliant organiser – all he had to do was paint'.[13] They were a close couple and she travelled with him on his frequent expeditions and commissions abroad. Hogarth had a great sense of humour and, as he grew older, studiously

avoided political arguments. He 'exuded life' and took great pleasure from his conviction that he was descended from the great Hogarth. In 1974, Hugh Casson and Ruskin Spear proposed his elevation to Royal Academician.

He always regarded himself as a 'compassionate observer', seeking to accentuate the characteristics of a particular building, homing in on its quirks, and yet establishing a kind of order on what he observed. He recognised an element of caricature in what he did, but his priority was to encapsulate the particular spirit of a place. He had a certainty about his work and worked quickly. Large and bearlike in his final years, he would sketch outdoors, sitting on a campstool, wearing a shapeless hat, perhaps in white trousers and a loose top. By then he was walking with the aid of a stick.

Diana's cousin Pat always believed that it was 'the National Trust that killed Paul'. He and Diana had been living at Hidcote Manor in Gloucestershire and their rental had suddenly been terminated by the Trust. Among his projects while at Hidcote was to write his autobiography, *Drawing on Life*, but a change of editor at a critical stage had emasculated the book: 'much was edited including many anecdotes, references to drink, drugs and sex which I feel removes a great deal of any cutting edge it may have possessed.'[14] The house itself had been a kind of symbol of his success, his journey from humble beginnings, but they were obliged to vacate it just before Christmas 2001, moving to a cottage in Park Street, Cirencester. They were still in the process of unpacking when they went away to Pat and Mike Tayler's vineyard at Aust on the river Severn for the Christmas festivities. The holiday period was over and the two couples enjoyed a wonderful Christmas, but Diana was troubled by the fact that Paul seemed agitated and keen to get back to his painting. He would never paint again, a heart attack striking him down in the night of 27 December as he stumbled towards the bathroom. He is buried in Majorca.

* * *

Rosa Branson was 11 years old when her father was killed. The walls of her front room in north London are a gallery of Clive's work, landscape after landscape, many drawn in the brief tranquil gap between the war

in Spain and its global successor. She herself is an artist, her large, bold canvases stacked in the basement, vibrant with colour, confident and reflecting her classical grounding in art. Rosa became an artist because of her father and, aged 85, she is still working. We talked about her memories of Clive: he was funny and inspiring, his politics never in doubt, although Rosa suspected that his views would have changed when the truth about Soviet Russia eventually saw the light of day. Her parents 'adored each other', she said. This passionately leftist couple were 'immensely wealthy', their background one of 'stately homes' and 'a hundred servants'. Rosa showed me the relevant entry in Debrett's for Noreen's side of the family: I noted the irony of its motto – 'Follow the Right', forcibly struck by the fact that, for Noreen and Clive, 'right' was steadfastly – extremely – left wing.

Rosa's house was a kind of museum – the telephone on the stairs, which had been tapped for decades after Clive had died; the canvases, paint and the rooms devoted to art; the suitcase of Clive's belongings, which Rosa watched me work through (school cap, International Brigader's beret, photographs and letters …). I left and walked back to Highgate tube station, accompanied for a while by the shadow of Branson's past.

A visit to the Tate, by contrast, was a disappointment. The gallery holds five Clive Branson's, but after a fruitless search I discovered that they were all held in store. What art galleries show to the public is just the tip of an iceberg. I made an appointment to visit the store. I was early, having overestimated the journey time from the Kentish suburbs. The store is located in Mandela Way, just off the Old Kent Road, and looks like a distribution centre for a large supermarket chain, although the security is much more overt. There is a high metal fence and a double high gate for those on foot. Once again, I was dealing with a world of surveillance and hidden cameras. I pressed a button under an opaque window and a disembodied voice responded, cold, charmless and wary. I explained why I was there and understood very little of what emerged from the speaker. Eventually a tall female guard emerged with a clipboard. 'Who is your contact?' she said. I didn't know. I showed her the email confirming my appointment and she disappeared back into her lair. I waited for perhaps five minutes, during which a member of staff arriving for work offered to let me in, a kind offer that I declined. Finally, the guard reappeared and the double gate was opened.

Eventually I was taken through to the store by way of some locked double doors. I was told incidentally that 90 per cent of the Tate's collection is in store, either here or in a disused nuclear shelter near Salisbury. The room I was in was large and rectangular with numbered vertical shelves along both walls. The first picture was out ready for me. 'Why did the aircraft have two motifs on it?' I was asked, and it was true: the looming bomber had a swastika and an RAF roundel, which I hadn't noticed before. I guessed that it was Clive's way of showing that bombs were dropping on both sides. We moved on: to a rather drab portrait of a worker – narrow and unusually devoid of colour – and then to the other two, one of which was wonderful – vibrant colours, energy and detail; almost surreal. The other was a still life, bright with various shades of red. Ah, the symbolism! They brought me a mobile ladder that I could climb to get a closer look, close enough to touch the paint. There was something wonderful about the way they heaved out these great 10-foot-high sideways shelves – it was almost a two-person job. Each 'shelf' held what seemed a random set of paintings: John Aldridge, Stanley Spencer, Lautrec; all of them treasures but with no guarantee that they would get seen any time soon. At one point they had to move a vast Turner (of the Thames near Kingston); it had a wonderful sky, all variations of grey. After forty-five minutes or so I stepped out into the air, leaving the treasure house for the drab reality of Mandela Way, and leaving Clive Branson permanently locked in high-security safety. Walking away I found myself contemplating his journey from one form of containment to another – Spanish POW camp, Army life and then this final incarceration in a bunker in south-east London, cheek by jowl with an army of other artists similarly confined in cold storage.

<p style="text-align:center">* * *</p>

As wars go, the campaign waged by MI5 and Special Branch over the twenty years from the outbreak of the Spanish Civil War to the Soviet invasion of Hungary was lacking in strategic oversight, clarity of purpose and, thankfully, bloodshed. It rumbled on, buffeted by the changes in political circumstance, and accruing over the two decades a swelling avalanche of paperwork, files and internal memoranda. The full extent

of the surveillance was indeed secret, but the targets of it were often well aware of the shadowy figures watching their houses, or tapping their telephones ('It's the boys in blue!'). There are few examples of artists or writers complaining bitterly about such intrusion; it is as if the government's agencies were behaving exactly as they would have expected. Presumably, such behaviour remains the norm, enhanced by the additional techniques that technology has created, the machines at GCHQ. The slow death of the relationship between the arts and communism has meant that MI5 now deploys its secret methods against other targets, notably terrorists driven by religious beliefs and those pursuing campaigns of extremist hatred.

So, what was the effect of all this surveillance, this secret war, and what did it achieve? What did it all cost in terms both of resources and emotional damage to the victims? There were casualties of the whole process, careers were blighted and the probable trajectory of lives changed for good. Blacklists were drawn up and potential opportunities closed down. Randall Swingler, in particular, was denied the chance to build on his success as a writer and poet that he had achieved before the war. Priestley was taken off air; Clive Branson's commission as an officer never happened; Hogarth was summarily dismissed from the army; Doris Lessing was prevented from returning home to Africa for many years; Auden and Spender were tarred by association with Burgess and Maclean.

As for the cost of all this secret machination, how can you put a figure on the hours devoted by agents to observing suspects; the typing up of transcribed phone calls; the travel and subsistence claims of men and women in the field; the envelopes of cash passed to 'discreet sources'; the hours of filing and clerking; the meetings, travel costs, phone bills; the costs arising from breaking and entering premises, and bugging the phones of allegedly dubious offices? A cost-benefit analysis conducted, say in 1957, would have been highly critical of the shapeless end product gleaned from what must have been a very considerable outlay of resource. All this because government, in its wisdom, had judged that communism was to be resisted – at all costs.

And how did it feel to be subject to such a relentless campaign? One of the characters in Doris Lessing's novel *The Golden Notebook* describes

the disillusion that set in during the 1950s: 'We believed everything was going to be beautiful and now we know it won't.' MI5's surveillance was unavoidable proof that life was anything but beautiful. It was the product of bureaucratic small-mindedness. Moreover, its methods were not far removed from those of any state whose government had targeted a section of the population for special attention. The novelist Geoffrey Household in his book *The Rough Shoot* describes how 'all the weapons of communism were to be used to defeat communism'. This was not true of the war against communist writers and artists, of course, since the worst excesses of Stalinism, for example, were not on the agenda, but to those under surveillance, the repertoire of shadowing, listening, reading of post and house searches must have seemed heavy-handed, threatening, persistent and sinister.

Art and writing sit comfortably with notions of freedom and hope. It is disconcerting to realise that the Intelligence Services felt it necessary to monitor and harass those who practised them. It is fitting, perhaps, to conclude from one such victim who was both artist and poet. When he was imprisoned in Spain during the Civil War, Clive Branson wrote these lines in a book of drawings commissioned by the Italian Camp Commander:

> These drawings needed a little freedom,
> The eye and hand of man enjoying life.
> Great Art demands fulfilment of a dream
> Of human peace and friendship, no more strife.

He might have added:

> Art and writing should be entirely free
> Of this mean and secret pseudo-war
> Against those artists judged to be
> Some kind of threat to this nation's shore.

Dramatis Personae: A Retrospective

Valentine Ackland: poet

'Make yourself SEE the dead people, the imprisoned people, the people under torture, under oppression, under compulsion … At least LOOK: so that you are not self-deceived.' (Valentine Ackland to Sylvia Townsend Warner, 1959)

W.H. Auden: poet

'He was still taking the role of the revolutionary, just as he had in his youth, except that now his opponent was not the existing social order but the present-day revolutionaries themselves.' (Humphrey Carpenter, 1981)

Ralph Bates: novelist

'There were many things that silenced him in terms of writing and being a public figure. His disillusion with the political scene was complete.' (Ralph Bates's wife, Eve)

James Boswell: illustrator and unofficial war artist

'I think the security file on him was probably binned because everyone thought this amiable New Zealander was joking.' (Sal Shuel, Boswell's daughter, 2017)

Clive Branson: painter, poet and activist

'I am proud that Clive Branson was a member of the Communist Party.' (Harry Pollitt, Secretary CPGB, 1944)

Felicia Browne: artist and sculptor

'Felicia dies as she lived – a courageous fighter for the cause.' (Daily Worker, *4 September 1936*)

John Cornford: poet

'I got most of his letters after he had been killed.' *(Margot Heinemann, 1986)*

C. Day Lewis: poet

'The intolerant young man I used to be would view with suspicion the measure of inner peace I have achieved.' *(C. Day Lewis, 1960)*

Margot Heinemann: writer

'I'd do it all again.' *(Margot Heinemann, 1986)*

Paul Hogarth: illustrator

'I think the less we say about the Communist Party the better at this stage.' *(Paul Hogarth in a letter to Andy Croft, 2000)*

Storm Jameson: novelist

'You mean – a writer who wants to be a success and safe must be a communist?' *(Storm Jameson in post-war Poland)*

Doris Lessing: novelist and writer

'If anyone asked later if she'd been a member of the Communist Party, Doris would give a deep sigh at having to tell it yet again, and explain that she was never a party member.' *(Jenny Diski,* In Gratitude, *2016)*

Olivia Manning: writer

'Out of disgust with Edward Heath's failure to settle the miners' strike and put the country back to work, in the 1974 General Election she voted Liberal for the first time in her life.' *(Deirdre David, 2012)*

George Orwell: writer

'I am a great admirer of Orwell, but we have to accept that he did take a McCarthyite position towards the end of his life.' (Paul Foot, 1996)

J.B. Priestley: writer

'We are now living in a society that appears – outside its propaganda and advertising – to dislike itself just as much as I dislike it.' (J.B. Priestley, 1972)

R.D. (Reggie) Smith: BBC producer

'Reggie the Socialist … [was] continuously observed "by the most perceptive eye since Jane Austen".' (Michael Foot at Reggie's memorial service, referring to Reggie's life with Olivia Manning, 1985)

Stephen Spender: poet

'I often thought of saying to my father, "Dad, you think you're a poet but in fact you are a politician, and a brilliant one", but I never did.' (Matthew Spender, 2015)

Randall Swingler: poet

'I think probably a lot of the depression came from the disintegration of the Communist ideal.' (Dan Swingler, 1996)

Julian Trevelyan: artist and poet

'The Minister regrets that it cannot be certified that the disability, Psychoneurosis, is directly related to your service in the Forces.' (Ministry of Pensions, 1943)

Sylvia Townsend Warner: poet and novelist

'I am now like the Sylvia you first knew, for I have reverted to solitude. I live in a house with three cats; and when the telephone rings and it is a wrong number I feel a rush of thankfulness.' (Sylvia to David Garnett, 1970)

Notes

Chapter 1

1. The National Archives, KV4/125.
2. The Branson Archive at the Marx Memorial Library, London.
3. Ibid. This section draws on an unpublished account of Clive's life written by Noreen Branson.
4. The description of Clive Branson's looks is by Margot Heinemann and appears in *No Pasaran! Art, Literature and the Spanish Civil War*, ed. Stephen M. Hart, p. 61.
5. Author's interview with Rosa Branson, 19 April 2017.
6. The Branson Archive at the Marx Memorial Library.
7. *Britain in the Nineteen Thirties*, Noreen Branson & Margot Heinemann, p. 15.
8. Ibid., p. 12.
9. Harry Pollitt's description of Clive Branson in the foreword of Branson's book *British Soldier in India – The Letters of Clive Branson*.
10. *AIA: The Story of the Artists International Association 1933–1953*, Lynda Morris & Robert Radford, p. 44.
11. From an interview with Paul Hogarth by Naim Attallah, available on the latter's blog at quartetbooks.wordpress.com.
12. Ibid.
13. *Drawing on Life*, Paul Hogarth, p. 13.
14. Barbara Niven was a lecturer at the Manchester School of Art. Later, in July 1940, Manchester's Chief Constable would note that Jimmy Miller (Ewan McColl), Joan Littlewood and Niven were 'endeavouring to obtain members from various art schools'. See The National Archives, KV2/2757.
15. Hogarth, op. cit., p. 16.

Chapter 2

1. *Anthony Blunt: His Lives*, Miranda Carter, p. 260.
2. *The Defence of the Realm: The Authorised History of MI5*, Christopher Andrew, p. 160.
3. *The Shadow Man*, Geoff Andrews, p. 50.
4. The support for the Party survived the war years. My father-in-law told me, in 2017 when he was 96, that he had asked his father to vote for him by proxy in the 1945 General Election since he was still to return from service overseas. 'I told him to vote Communist,' he said, 'if there was a candidate.'

5. *Margaret Storm Jameson: A Life*, Jennifer Birkett, pp. 134–5.

6. *Unlikely Warriors*, Richard Baxell, p. 89.

7. Interestingly, there was a similar growth of communism in the United States: some fifty-two prominent American writers, including Sherwood Anderson, Theodore Dreiser, John Dos Passos, Langston Hughes and Edmund Wilson, announced their support for the Communist candidate for President.

8. *The Golden Notebook*, Doris Lessing, p. 82.

9. From a letter to the editor of the *Daily Worker,* 14 February 1957. See *The Letters of Kingsley Amis*, ed. Zachary Leader, p. 503.

10. The National Archives: KV2/4399. It was some fifty years – 2017 – before this file came into the public domain.

11. *W.H. Auden: A Biography*, Humphrey Carpenter, p. 153.

12. Carter, op. cit., p. 101.

13. Carpenter, op. cit., p. 156.

14. The Tate Archive, file 7043/27/3.

15. Branson and Heinemann, op. cit., p. 287. The quotation is from *Left Review.* The exhibition attracted some 6,000 people.

16. Morris & Radford, op. cit., p. 10.

17. According to Montagu Slater, who met him in 1929.

18. *Eyewitness of the Thirties*, Paul Hogarth: see www.jboswell.org.uk

19. *Remembered*, James Friell in www.jboswell.org.uk

20. Ibid.

21. Suspicion of those in the creative arts was nothing new: Wordsworth and Coleridge were tracked as potential secret agents during the French Revolution.

22. *The Black Door*, Richard J. Aldrich & Rory Cormac, p. 46.

23. *MI5*, Nigel West, p. 56.

24. *Empire of Secrets*, Calder Walton, p. 10.

25. The National Archives, KV2/1669.

26. *Blacklist: the Inside Story of Political Vetting*, Mark Hollingsworth & Richard Norton-Taylor, p.128.

27. *British Writers and MI5 Surveillance, 1930–1960*, James Smith, p. 6.

28. *Enemy Within: The Rise and Fall of the British Communist Party*, Francis Beckett, p. 78.

29. *M: Maxwell Knight, MI5's Greatest Spymaster*, Henry Hemming, p. 98.

30. Ibid., p. 167.

31. Ibid., p. 141.

32. She emigrated to Canada to embark on a new life.

33. Beckett, op. cit., p. 78.

34. The National Archives, KV2/1337.

35. *Sylvia Townsend Warner: A Biography*, Claire Harman, p. 141. The quotation is from a letter to Julius Lipton, 3 May 1935.

36. *Edgell Rickword: A Poet at War*, Charles Hobday, p. 161. ,
37. Harman, op. cit., p.141.
38. *Sylvia Townsend Warner in the 1930s*, Maroula Joannou, p. 93, in *A Weapon in the Struggle*, ed. Andy Croft.
39. Harman, op. cit., p. 137.
40. The National Archives, KV2/2337.
41. *The Impact of the Spanish Civil War on Britain*, Tom Buchanan, p. 65.
42. Imperial War Museum, taped interview (11305) with Joseph Fuhr.
43. Buchanan, op. cit., p.66.
44. Ibid.
45. *Maverick Spy*, Hamish MacGibbon, p. 22.

Chapter 3

1. *I Am Spain*, David Boyd Hancock, pp. 1 & 28–9. The 'Spanish writer' was José Luis Castillo–Puche, a friend of Ernest Hemingway, while the remark about the 'catalogue of conservatism' and what follows is from a letter to the US Secretary of State from the US Ambassador in Spain.
2. *Indigo Days*, Julian Trevelyan, p. 57.
3. *The Aid to Spain Movement in Battersea 1936–1939*, Mike Squires, p.10.
4. The British Battalion of the International Brigade went into battle under a banner designed by AIA committee member James Lucas, while in March 1938 it sponsored a cabaret for Spain featuring songs, with words by Auden and music by Benjamin Britten.
5. Events to raise funds continued until well into 1938, long after the tide had turned against the Republic.
6. Boyd Hancock, op. cit., p.31. In 1949, Bone – with *Daily Worker* credentials – went to Hungary where she endured seven years of solitary confinement before being released in 1956.
7. Wintringham was in Barcelona working for the *Daily Worker*.
8. Morris & Radford, op. cit., p. 31.
9. The National Archives, KV2/2367.
10. *A Spy Named Orphan – the Enigma of Donald Maclean*, Roland Philipps, p. 18.
11. Taken from an essay by George Orwell: 'Looking Back on the Spanish War'. See Orwell's *Facing Unpleasant Facts*, p. 159.
12. Baxell, op. cit., p. 69.
13. *The Golden Notebook*, Doris Lessing, p. 151.
14. *Crusade in Spain*, Jason Gurney, p.38.
15. *Proud Journey: a Spanish Civil War Memoir*, Bob Cooney, pp. 29–30.
16. Gurney, op. cit., p. 79. Gurney's career as a sculptor was prematurely ended when one of his hands was severely damaged by an explosive bullet.
17. Harman, op., cit., p. 154.
18. *The Last English Revolutionary: Tom Wintringham 1898–1949*, Hugh Purcell, p. 110.

19. The National Archives, KV2/2338.
20. Ibid.
21. *Harry Pollitt*, Kevin Morgan, p. 124.
22. Ibid., p. 98.
23. The National Archives, KV2/2588; letter to Major Vivian, 20 September 1938.
24. Harman, op. cit., p.159. Ernest Hemingway and Pablo Neruda were among the foreign delegates. Frank Pitcairn was the nom de plume of Claud Cockburn.
25. The National Archives, KV2/2588; the text is from a filed press cutting from the *Morning Post* of 5 July 1937, quoting John Strachey.
26. Hobday, op.cit., p. 189.
27. Ibid.
28. Ibid., p. 190.
29. Croft, op. cit., p.97.
30. *Stephen Spender: the Authorised Biography*, John Sutherland, p. 226.
31. *The God That Failed*, ed. Crossman, pp. 251–2.
32. *World Within World*, Stephen Spender, p. 247.
33. Ibid.

Chapter 4
1. *Nancy Cunard*, Anne Chisholm, p. 308.
2. Ibid., p. 314.
3. See MEPO 38/9 at The National Archives.
4. 'Poets of the World Defend the Spanish People'.
5. See *Their Mad Gallopade*, by Patrick McGuinness, in the *London Review of Books*, 25 January 2018.
6. The phrase is D.J. Taylor's in *Orwell: The Life*, p. 245. Taylor suggests that Orwell was in an 'agitated mental state' as a result of work being turned down on 'ideological grounds'.
7. Taylor, op. cit., pp. 202–203.
8. Boyd Hancock, op. cit., p. 281.
9. Buchanan, op. cit., p. 90.
10. Carpenter, op. cit., p. 213.
11. Ibid., pp. 208–17.
12. The National Archives, KV2/2699.
13. Ibid.
14. *Spanish Diary*, John McNair, p. 15.
15. Croft, op. cit., p. 94.
16. Hogarth, op. cit., p.17.
17. The Marx Memorial Library: Noreen Branson's unpublished memoir.
18. Author interview with Rosa Branson.
19. The description of the 'dreary' train journey is from *The Shallow Grave*, Walter Gregory, p. 28.

20. *Reason in Revolt*, Fred Copeman, p. 78.
21. Imperial War Museum, taped interview, David 'Tony' Gilbert, recording numbered 9157.
22. The Marx Memorial Library: Noreen Branson's unpublished memoir.
23. Ibid.
24. Branson, op. cit. Letter of 12 October 1942.
25. Imperial War Museum, papers of Alexander Clifford, file 5/1.
26. Tate Archive, letter to John Rake, TGA 787.23.
27. Gregory, op. cit., p. 143.
28. Ibid., p. 144.
29. Ibid., p. 144.
30. Ibid., p. 146.
31. Hart, op. cit. See the article 'English Poetry and the War in Spain' by Margot Heinemann, p. 61.
32. Ibid.
33. See *The Penguin Book of Spanish Civil War Verse*, ed. Valentine Cunningham, for a selection of Branson's verse.
34. He helped to organise an 'Aid for Spain' tour around the country, for example.
35. Branson & Heinemann, op. cit., p. 298.
36. 'Three Left-Wing Poets', by Margot Heinemann, p. 117, in *Culture and Crisis in Britain in the Thirties*, ed. Clark, Heinemann, Margolies & Snee.
37. Romilly ran away from Wellington College and later cycled to Marseille before joining the International Brigade in Spain. A file exists on his activities (MEPO 38/61), but, at the time of writing, it is 'retained by a Government Department'. He died in 1941.
38. The National Archives, KV2/1996.
39. Beckett, op. cit., p. 67.
40. Clark, Heinemann, Margolies & Snee, op. cit., pp. 115–16.
41. Letter to F.M. Cornford, 15 or 16 September 1936: see *John Cornford: Understand the Weapon, Understand the Wound – Collected Writings*, ed. Jonathan Galassi, p. 179.
42. The Imperial War Museum Sound Archives: recording of Margot Heinemann, MH 9239.
43. The British Library, recording of Margot Heinemann.
44. *English Poetry and the War in Spain*, op. cit., p. 54.
45. Diary/letter to Margot Heinemann, 16–30 August 1936: see Galassi, op. cit., pp. 168–9.
46. Boyd Haycock, op. cit., p. 64.
47. *History of the Communist Party of Great Britain 1927–1941*, Noreen Branson, p. 230.
48. Galassi, op. cit., p. 182. Letter to Margot Heinemann, 21 November 1936.
49. Special Collections Archive, Goldsmiths, University of London, Margot Heinemann Archive, HEIN 1/1/1/1–3.

50. He may have died the following day, 28 December 1936.
51. Fox, it seemed, had been reluctant to fight in Spain: the Oxford historian A.L. Rowse later wrote that he had 'asked me to get him a job in Oxford', but it was not to be, since, 'The Communist Party, wanting martyrs, insisted on sending Ralph.'
52. *Party Animals: My Family and other Communists*, David Aaronovitch, p. 75.
53. This is the first verse. See *Poems from Spain*, ed. Jim Jump, p. 50.
54. The National Archives, KV2/1996.

Chapter 5

1. The National Archives, KV2/3931.
2. Ibid.
3. Trevelyan, op. cit., p. 79.
4. Morris & Radford, op. cit., pp. 48–9.
5. The National Archives, KV2/3774.
6. Ibid. The file note was written on 19 July 1939.
7. Morris & Radford, op. cit., p. 47.
8. Hogarth, op. cit., pp.17–8.

Chapter 6

1. From Charles McCarry's spy novel *The Secret Lovers*, p. 256.
2. Smith, op. cit., p. 41.
3. *Journey from the North vol.1.*, Storm Jameson, p. 297.
4. Carter, op. cit., p. 167.
5. Birkett, op. cit., p. 167.
6. Carpenter, op. cit., p. 334.
7. Carter, op. cit., p. 258.
8. Morris & Radford, op. cit., p. 56.
9. *Orwell: A Life in Letters*, selected and annotated by Peter Davison, p. 171. Letter to Leonard Moore, 6 October 1939.
10. *Orwell – The Life*, by D.J. Taylor, p. 272.
11. Ibid., p. 273.
12. Ibid., p. 286.
13. Spender, op. cit., p. 263.
14. Sutherland, op. cit., p. 285.
15. The National Archives, KV2/3215.
16. *The Collected Essays, Journalism and Letters of George Orwell: volume 4*, edited by Sonia Orwell & Ian Angus, p. 58.
17. Diary entry for 20 June 1940. See *Diaries*, by George Orwell, p. 257.
18. The National Archives, KV 2/3774.
19. Ibid.
20. *Priestley's Wars*, Neil Hanson, p. 278–81.
21. The National Archives, KV2/2699.

22. The National Archives, KV2/2415.
23. Jameson, op. cit., pp. 294 & 299.
24. *Priestley*, Judith Cook, p. 191.
25. Smith, op. cit., p. 52.
26. *Rosamond Lehmann*, Selena Hastings, p. 189. Evidently, Philipps filled the house with 'ghastly Comrades'.
27. The National Archives, KV2/2366.
28. The National Archives, KV2/2515.
29. The National Archives, KV2/2338.
30. *I'll Stand By You: The Letters of Sylvia Townsend Warner and Valentine Ackland*, ed. Susanna Pinney, p.185.
31. *The Diaries of Sylvia Townsend Warner*, ed. Claire Harman, p. 104; entry for 15 June 1940.
32. The National Archives, KV2/2338. Peel Yates's letter was sent on 13 December 1940.
33. The National Archives, KV2/2338.
34. Ibid.
35. The National Archives, KV2/3215.
36. Hogarth, op. cit., p. 18.
37. Baxell, op. cit., p. 420.
38. Beckett, op. cit., p. 81.
39. Hogarth, op. cit., p. 19.
40. *The Security Service 1908–1945*, Jack Curry, p. 92. Curry was another MI5 officer with a background in the Indian Police.
41. The National Archives, KV2/2157.
42. The National Archives, KV2/2699.
43. The National Archives. KV4/443. This is taken from a report written in early March 1945 by an officer, presumably with time on his hands. He set down the broad nature of the operations of MI5's B6 section during the war years.

Chapter 7
1. MacGibbon, op. cit., p. 33.
2. Ibid., p. 41. See also The National Archives, KV2/1669.
3. Ibid., p. 42.
4. Ibid.
5. Ibid., p. 44.
6. Ibid.
7. Beckett, op. cit., p. 78.
8. *My Silent War*, Kim Philby, p. xxxi.
9. Andrew, op. cit., p. 168.
10. *Stalin's Englishman: The Lives of Guy Burgess*, Andrew Lownie, p. 44.
11. Ibid., p. 356.

12. Ibid., p. 29.
13. Curry, op. cit., p. 20.
14. Carter, op. cit., p. 273.
15. Ibid., p. 118.
16. *Spycatcher*, Peter Wright, p. 54.
17. 'What Sort of Traitors?', by Neal Ascherson, in the *London Review of Books*, vol. 2, No. 2, 7 February 1980.

Chapter 8
1. Harry Pollitt's description in his introduction to Branson's *British Soldier in India*, p. 5.
2. Don Bateman Collection, University of Bristol, Special Collections, Box I.1/2/11. The extracts are taken from *Discussion*, no. 14, April, 1937.
3. He wrote to Noreen on 20 April 1941, for example, declaring that he 'longed to paint so often these days'. This section draws on file 1/1 of the Branson Papers held at the Bishopsgate Institute, London.
4. Imperial War Museum, GP/55/BO-BU.

Chapter 9
1. Tate Archive, file 7923.1. The reference to 'day-to-day time-wasting' is from the first issue of the magazine *Our Time*, February 1941.
2. Imperial War Museum, ART/WA2/03/266.
3. *James Boswell: Unofficial War Artist*, William Feaver, p. 74.
4. 'Land of Dead Ends', by William Feaver, *The Guardian*, 16 December 2006.
5. www.jboswell.org.uk – article written by Sal Shuel, James Boswell's daughter.
6. Hamish MacGibbon in a 'Diary' piece in the *London Review of Books*, June 2011. Hamish is James MacGibbon's son.
7. MacGibbon, op. cit., p. 63.
8. Hamish MacGibbon in a 'Diary' piece in the *London Review of Books*, June 2011.
9. MacGibbon, op. cit., p. 84.
10. Hamish MacGibbon, *London Review of Books*, June 2011.
11. Sutherland, op. cit., p. 297. Rome had fallen to the Allies on 4 June, 1944.
12. Cook, op. cit., p. 187.
13. Ibid., pp. 188–9.
14. The National Archives, KV2/2415.
15. Letter to Irene Rathbone.
16. Birkett, op. cit., p. 166.
17. Ibid., p. 262.
18. Ibid., p.257.
19. Ibid., p. 262.
20. The National Archives, KV2/2415.

Chapter 10
1. The National Archives, KV2/2515.
2. Ibid.
3. *Comrade Heart: A Life of Randall Swingler*, Andy Croft, p. 133.

Chapter 11
1. The Branson Papers at the Bishopsgate Institute, London; file 1/2. The poem is entitled 'Without Time'.
2. Flat 37, 99 Haverstock Hill, London NW3; Margot Heinemann was a near neighbour in the same block of flats.
3. *British Soldier in India*, Clive Branson, p. 9.
4. Ibid., p. 12.
5. I am grateful to Rosa Branson for the loan of much correspondence between her parents.

Chapter 12
1. Andrew, op. cit., p.327.
2. The National Archives, KV2/1669.
3. Hamish MacGibbon, *London Review of Books*, June 2011.
4. Harman, op. cit., p. 204.
5. *This Narrow Place: Sylvia Townsend Warner and Valentine Ackland – Life, Letters and Politics 1930–1951*, Wendy Mulford. The quotation is from a letter to Arnold Rattenbury in 1968.
6. Croft, op. cit., p. 163.
7. Ibid., p. 158.
8. Ibid., p. 173.
9. Birkett, op. cit., p. 224.
10. The National Archives, KV2/2415.
11. *A House in St John's Wood*, Matthew Spender, p. 79.
12. Sutherland, op. cit., p. 306.
13. The National Archives, KV2/3774.
14. *Olivia Manning – A Woman at War*, Deidre David, p. 168. Manning had been in the Middle East and arrived back in Liverpool in mid-summer 1945.
15. David, op. cit., p. 42.
16. *The Strings are False*, Louis MacNeice, p. 210.
17. *Olivia Manning – A Life*, Neville & June Braybrooke, p. 58.
18. The National Archives, KV2/2533.

Chapter 13
1. David, op. cit., p. 225.
2. *Under My Skin*, Doris Lessing, p. 191.
3. BBC Radio, *Desert Island Discs*, 21 November 1993.
4. Lessing, op. cit., p. 25.

5. *Desert Island Discs*, op. cit., Lessing, op. cit., p. 199.
6. Ibid., p. 259. *Going Home*, Doris Lessing, p. 311.
7. The National Archives, KV2/4054.
8. Doris Lessing Archive, University of East Anglia, DL 035. The letter is from Doris Lessing to Pilot Officer John Whitehorn.
9. *Walking in the Shade*, Doris Lessing, p. 52.
10. Doris Lessing Archive, University of East Anglia, DL 037. The letter is from Doris Lessing to Coll Macdonald.

Chapter 14
1. 'Major Johnson' is likely to have been the commander of B Squadron, Major 'Bumper' Johnson, or Johnstone.

Chapter 15
1. Hogarth, op. cit., p. 19.
2. *1946 – The Making of the Modern World*, Victor Sebestyen, p. 73. The observation was by the economist John Maynard Keynes.
3. *The Artist as Reporter*, Paul Hogarth, p. 79.
4. Ibid.
5. The National Archives, KV2/4060.
6. *Drawing on Life*, op. cit., p. 20.
7. Hansard, 8 August 1947.
8. *So Much to Tell*, Valerie Grove, p. 79.
9. Ibid., p. 81.
10. The phrase is Storm Jameson's, who regretted not being there: 'there are people in Poland I'd liked to have seen and I enjoy being with Poles, mad as they are,' see Birkett, op. cit., p. 282.
11. Blog by Naim Attallah, op. cit. Hogarth wrote this much later, with what he described as 'hindsight'.

Chapter 16
1. *The Artist's Dilemma*, James Boswell, p. 64.
2. *The Spanish Civil War*, Paul Preston, p. 322.
3. *Cold War Reports 1947–1967*, Paul Hogarth, p. 13.
4. *A Weapon in the Struggle*, op. cit. Hogarth wrote an afterword from which this is taken, see p. 208.
5. *Drawing on Life*, op. cit., p. 22.
6. *Cold War Reports*, op. cit., p. 13.
7. Naim Attallah, op. cit.
8. Croft, p.176. Letter from Paul Hogarth to Andy Croft, 26 December 1992.
9. Ibid.
10. *A Weapon in the Struggle*, op. cit., p. 207.

Chapter 17
1. *Walking in the Shade*, op. cit., p. 80.
2. Davison, op. cit., p. 417. Letter from George Orwell to David Astor, 9 October 1948.
3. *Never Again*, Peter Hennessy, p. 245.
4. The National Archives, KV2/2366. Winston Churchill had claimed in the build-up to the General Election of 1945 that no Labour government could govern without a Gestapo of its own.
5. Andrew, op. cit., p. 383.
6. *Citizen Clem*, John Bew, p. 462.
7. Hollingsworth & Norton-Taylor, op. cit., p.10.
8. The National Archives, KV2/2757.
9. See the review 'Time for Several Whiskies', by Ian Jack of Edward Stourton's book *Auntie's War* in *The London Review of Books*, 30 August, 2018.
10. David, op. cit., p. 181.
11. Hollingsworth & Norton-Taylor, op. cit., p. 4.
12. Ibid. p. 102.
13. The 'coal production business' was Heinemann's work on 'the mining crisis', which she produced for the Labour Research Department and was published by Victor Gollancz in 1944.
14. The National Archives, KV2/2533.
15. Ibid.
16. Ibid. This is from a letter from C.A.G. Simpkins to G. Saffrey at the GPO.
17. Croft, p. 192.
18. '"A Man of Communist Appearance": Randall Swingler and MI5', by Andy Croft; see www.andy-croft.co.uk
19. Croft, op. cit., p. 199.

Chapter 18
1. *Churchill and Orwell*, Thomas E. Ricks, p. 183. Ricks points out that Soviet Archives reveal that Orwell was 'listed for execution if captured'.
2. *Orwell's Nose,* John Sutherland, p. 39.
3. Taylor, op. cit., p. 358.
4. Ibid., p. 373.
5. Ibid., p. 390.
6. 'Orwell's List', by Timothy Garton Ash in the *New York Review of Books*, 25 September 2003.
7. The list was only made public in 2003.
8. Orwell Archive, University College, London University.
9. Jacob had been at prep school with Orwell.
10. Mitchison was the sister of Professor J.B.S. Haldane.
11. Timothy Garton Ash, op. cit.

12. *Stephen Spender: New Selected Journals 1939–1995*, ed. Lara Feigel & John Sutherland, with Natasha Spender, p. 65.

Chapter 19
1. Mulford, op. cit., p.171.
2. Doris Lessing Archive, University of East Anglia, DL 080; letter to John Whitehorn, 6 January, 1948.
3. It was her second marriage.
4. *Under My Skin*, op. cit., p. 286.
5. Doris Lessing Archive, University of East Anglia, DL 037; letter to Coll Macdonald, 30 August 1945.
6. *Austerity Britain*, David Kynaston, p. 58. On *Desert Island Discs*, Ms Lessing had been asked about her marriages: 'You weren't very good at marriage,' Sue Lawley had prompted; Doris agreed and then remarked, 'I had some very nice love affairs though!'
7. *Walking in the Shade*, op. cit., pp 3–4.
8. Peter was born in 1946.
9. *The Golden Notebook*, op. cit., p. 152.
10. Morgan, op. cit., p. 125.

Chapter 20
1. *The Raj at War*, Yasmin Khan, p.179.
2. Branson, op. cit., p. 61.
3. Letter to Noreen, 21 April 1943.
4. Ibid., 13 April 1943.

Chapter 21
1. Philipps, op. cit., p. 283. Roland Philipps is the grandson of the artist (and communist) Wogan Philipps, whose story is touched on elsewhere in this book.
2. Lownie, op. cit., p. 224.
3. The National Archives, KV2/3216.
4. Lownie, op. cit., pp. 227–8.
5. The National Archives, KV2/2588. This MI6 telegram is dated 12 June 1951.
6. Carpenter, op. cit., p. 369.
7. Hamilton admitted that indeed he did, and that Isherwood would reply with 'all my love Christopher'. The National Archives, KV2/2587.
8. Philipps, op. cit., p. 234.
9. Wright, op. cit., p. 301.
10. The National Archives, KV2/2587.
11. *Rosamond Lehmann*, op. cit., p. 293. Rosamond was closely connected to a number of those involved in the 'secret war against the arts' – married to

Wogan Philipps; lover of C. Day Lewis and Goronwy Rees; friend of Guy Burgess, Stephen Spender and Jean MacGibbon.
12. MacGibbon, op. cit., p. 157.
13. The National Archives, KV2/3216.
14. Lownie, op. cit., p. 79. The National Archives, KV2/4102.
15. Carpenter, op. cit., p. 369.
16. M. Spender, op. cit., p. 111.
17. The National Archives, KV2/3216. The date was 27 September.
18. Sutherland, op. cit., p. 359. He is quoting Spender's Journal from 1982.

Chapter 22
1. The National Archives, KV2/4060.
2. *The Artist as Reporter*, op. cit., p. 6.
3. *Arthur Boyd Houghton*, Paul Hogarth, p. 9.
4. *Desert Island Discs*, 16 January 1998.
5. Aaronovitch, op. cit., pp. 123–4.
6. James Aldridge in the introduction to *Defiant People*, Paul Hogarth, p. 1. He also pointed out that 'napalm was given its first trial in Greece'.

Chapter 23
1. Kynaston op. cit., p. 549.
2. The report was in the *Manchester Guardian* for 14 October 1954.
3. The National Archives, KV2/2587.
4. Smith, op. cit., p. 32.
5. *The Buried Day*, C. Day Lewis, p. 224.
6. Beckett, op. cit., p. 66.
7. The National Archives, KV2/2415.
8. The National Archives, KV2/2338. The equivalent value would be £1.50 (thirty shillings) and 12½ pence (half a crown).
9. Ibid.
10. Smith, op. cit., p. xiv.

Chapter 24
1. *A Man of Communist Appearance*, op. cit.
2. Leconfield House was MI5's headquarters from 1945 to 1976.
3. Croft, op., cit., p. 222.
4. Ibid., p. 183.
5. The National Archives, KV2/2515.
6. Ibid.
7. The National Archives, KV2/2533.
8. Ibid.
9. As late as January 1965, an officer felt it necessary to insist that 'Manning was not a Party member'.

10. David, op. cit., p. 13.
11. The National Archives, KV2/2533.
12. *Walking in the Shade*, op. cit., p. 22.
13. The National Archives, KV2/4056.
14. *The London Lover*, Clancy Segal, p. 33.
15. *Walking in the Shade*, op. cit., p. 61.
16. Ibid., pp. 64, 77.
17. The National Archives, KV2/4054.
18. *Walking in the Shade*, op. cit., p. 80.

Chapter 25
1. Branson, op. cit., p. 35. This letter was written in October 1942.
2. Ibid., p 100.
3. *Drawing on Life*, op. cit., p. 35.
4. The telephone bugs 'produced reams of accurate intelligence from deep inside the Party'. See *M – Maxwell Knight, MI5's Greatest Spymaster*, by Henry Hemming, p. 318.
5. By John Sutherland in a review of *The Illustrated Dust Jacket 1920–1970*, by Martin Salisbury in *Literary Review*, December 2017/January 2018. Betty Reid was responsible for CPGB membership issues from 1946; Hymie Fagan was a journalist, historian and CP election agent.
6. *Drawing on Life*, op. cit., p. 30.
7. Letter from Paul Hogarth to Andy Croft, 25 November 1993.
8. *Drawing on Life*, op. cit., p. 32.
9. Ibid., p. 33.
10. Croft, op. cit., p. 220.
11. The National Archives, KV2/4063.

Chapter 27
1. Wright, op. cit., p.3. Warner had been a friend of both Auden and Day Lewis in the thirties.
2. 'Just Like Cookham', by Neal Ascherson, in the *London Review of Books*, vol. 33, no. 10, 19 May 2011.
3. Wright, op. cit., p.55.
4. *Most of My Life*, A.J. Ayer, p. 107.
5. Naim Attallah, op. cit.
6. Wright, op. cit., pp. 320–1.
7. 'Just Like Cookham' article (op. cit.), by Neal Ascherson, in the *London Review of Books*, 19 May 2011.

Chapter 28
1. *Cold War, Crisis and Conflict, the CPGB 1951–1968*, John Callaghan, p. 62.
2. Felicia Browne's lover Edith Bone spent seven years in prison in Hungary from 1949 to1956, a victim of that country's secret police.

3. *Having it so Good: Britain in the Fifties*, Peter Hennessy, p. 133.
4. *The Diaries of Sylvia Townsend Warner*, op. cit., p.101.
5. Ibid., pp. 223–4.
6. *Walking in the Shade*, op. cit., p.55.
7. Aaronovitch, op. cit., p. 32.
8. *A Small Personal Voice: Essays, Reviews, Interviews*, ed. Paul Schlueter, p. 85.
9. Ibid., p. 81.
10. *Walking in the Shade*, op. cit., p. 151.
11. Hollingsworth & Norton-Taylor, op. cit., p. 14.

Chapter 29
1. *Walking in the Shade*, op. cit., p. 176.
2. Writing about this forty years later, she could not remember if the payment was for £500 or £1,000.
3. *Going Home*, op. cit., p. 9.
4. Ibid., p. 10.
5. The National Archives, KV2/4063.
6. *Walking in the Shade*, op. cit., p. 176.
7. *Going Home*, op. cit., p. 221.
8. Ibid., pp. 221–2.
9. Ruth First was subsequently one of the accused in the infamous Treason Trial in South Africa and underwent 117 days in solitary confinement in a South African jail. She went into exile and was killed by a letter bomb, addressed to her personally, while working in Mozambique.
10. Hogarth, op. cit., pp. 70–1.
11. *Walking in the Shade*, op. cit., p. 179.
12. The National Archives, KV2/3941: the file of the historian Christopher Hill.
13. Soon after the African trip, the writer and art critic John Berger wrote to Hogarth asking whether some of his African drawings had indeed been confiscated and commenting on the 'vivid and disturbing' letters Paul sent from Africa. Manchester Metropolitan University, Special Collections, 48/46.
14. *Walking in the Shade*, op. cit., p. 186.

Chapter 30
1. Hogarth, op. cit., p 73.
2. Letter from Doris Lessing to Paul Hogarth dated 5 November 1997; Hogarth Archive, Special Collections, Manchester Metropolitan University.
3. *Walking in the Shade*, op. cit., p. 195.
4. Segal, op. cit., pp. 34–5.
5. *Walking in the Shade*, op. cit. p. 194. The letter was dated 21 February. 'Frank Pitcairn' was the pen name of Claud Cockburn.

6. Hogarth Archive, Special Collections, Manchester Metropolitan University. The letter was undated.
7. *Walking in the Shade*, op. cit., p. 54.
8. *Under My Skin*, op. cit., p. 321.
9. Sutherland, op. cit., p. 384. The quotation, taken from an article wrote for *Encounter* in September 1956, is not quite what Shakespeare wrote.
10. *J.D. Bernal – The Sage of Science*, Andrew Brown, pp. 399–400.
11. *Stephen Spender: New Selected Journals 1939–1995*, op. cit., p. 250.
12. *A House in St John's Wood*, op. cit., pp. 165–6.
13. Callaghan, op. cit., p.96.
14. *Walking in the Shade* op. cit., p. 83.
15. Letter from Paul Hogarth to Andy Croft, 13 May 1993.
16. *A Man of Communist Appearance* op. cit.
17. Croft, op. cit., p. 227.
18. Croft, op. cit., p. 237.
19. Croft, op. cit., p. 243. The lines are from Swingler's poem 'The Map'.
20. *Having it So Good*, op. cit., p. 531.
21. *A Weapon in the Struggle*, op. cit., p. 207: Afterword by Paul Hogarth. James Boswell had used a similar phrase years before.
22. Naim Attallah, op. cit.
23. Hogarth, op. cit., p. 46.
24. Ibid., p. 49.
25. *A Weapon in the Struggle*, op. cit., p.209.

Chapter 31

1. *The Volunteer for Liberty: Journal of the International Brigade Association*, May 1944.
2. *Burma 1944*, James Holland, p. 360.

Chapter 32

1. Morgan, p. 182.
2. Letter to Jerzy Zaruba, 26 June 1957. Manchester Metropolitan University, Special Collections.
3. *A Question of Loyalties*, Allan Massie, p. 123.

Chapter 33

1. *A Weapon in the Struggle*, op. cit., p. 103.
2. Letter from Paul Hogarth to Andy Croft, 26 December 1992.
3. The National Archives, KV2/2366.
4. Letter to the author from the Metropolitan Police, dated 24 October, 2017.
5. Interview with Mrs Pat Tayler, 17 July, 2017.
6. Hogarth, op. cit., p. 74.
7. Hogarth Archive, Manchester Metropolitan University, Special Collections.

8. Ibid. Letter from Paul Hogarth to Stephen Spender, 28 September 1972.

9. Diana Hogarth's diary entry for 15 April 1991. He had been refused a visa in 1962 when the response from the US Embassy indicated that it had been refused under section 212 (a) (29): 'Persons who are or at any time have been anarchists, communists or other political subversives.'

10. Letter to the author from Diana Hogarth, 17 May 2017.

11. Under section 212 (a) (29).

12. Letter from Diana Hogarth to Andy Croft, 5 October, 1993.

13. Interview with Pat Tayler, 17 July, 2017.

14. Letter to Andy Croft, 14 November 1997.

Acknowledgements

I am grateful to many writers whose work has informed *The Secret War Against the Arts*, not least Clive Branson and Paul Hogarth, two artists who deserve to be more widely known. In addition, I should like to thank the following for their help in the background research: the Marx Memorial Library; The National Archives; the Imperial War Museum; the Tate Archives; the British Library; the Don Bateman Collection at the University of Bristol Special Collections; the Margot Heinemann Archives at Goldsmiths, University of London; the Hogarth Archive at Manchester Metropolitan University (Special Collections); the Bishopsgate Institute, London; the Doris Lessing Archive at the University of East Anglia; the BBC; Dorset County Museum; the Dorset History Centre; Serge Alternês, Jane Bernal, Rosa Branson, Andy Croft, Diana Hogarth, Meirian Jump, Hamish MacGibbon, Jeremy Parrett, Sal Shuel, Simon Shuel and Pat Tayler. My wife, Vanessa, deserves special thanks for her help and support throughout the journey of this book, and indeed all the others. Finally, I would like to apologise for any errors I have made, or sources I have failed to recognise or thank. I hope that the overall story of those artists and writers – and their MI5 shadows – outweighs any unintended inaccuracies.

In a few instances it has not been possible to trace the copyright owner prior to publication, despite my best efforts. If notified, the publisher will be pleased to rectify the omission in any future edition.

Bibliography

Aaronovitch, David, *Party Animals*, Jonathan Cape, 2016.

Aldrich & Cormac, *The Black Door*, Collins, 2016.

Andrew, Christopher, *The Defence of the Realm: The Authorised History of MI5*, Allen Lane, 2009.

Andrews, Geoff, *The Shadow Man*, I.B Tauris, 2015.

Ayer, A.J., *More of My Life*, Collins, 1977.

Baxell, Richard, *Unlikely Warriors*, Aurum, 2012.

Beckett, Francis, *Enemy Within: The Rise and Fall of the British Communist Party*, John Murray, 1995.

Bew, John, *Citizen Clem*, Riverrun, 2016.

Bingham, Charlotte, *MI5 and Me*, Bloomsbury, 2018.

Birkett, Jennifer, *Margaret Storm Jameson: A Life*, Oxford, 2009.

Boswell, James, *The Artist's Dilemma*, Bodley Head, 1947.

Branson, Clive, *British Soldier in India*, The Communist Party, 1944.

Branson, Noreen, *History of the Communist Party of Great Britain*, Lawrence & Wishart, 1985.

Branson & Heinemann, *Britain in the Nineteen-Thirties*, Panther, 1973.

Braybrooke & Braybrooke, *Olivia Manning: A Life*, Chatto, 2004.

Brown, Andrew, *J.D. Bernal: The Sage of Science*, Oxford, 2005.

Buchanan, Tom, *The Impact of the Spanish Civil War on Britain*, Sussex, 2007.

Buckman, David, *From Bow to Biennale*, Francis Boutle, 2016.

Callaghan, John, *Cold War, Crisis and Conflict, the CPGB 1951–68*, Lawrence & Wishart, 2003.

Carpenter, Humphrey, *W.H. Auden: A Biography*, Oxford, 1992.

Carter, Miranda, *Anthony Blunt: His Lives*, Macmillan, 2001.

Chisholm, Anne, *Nancy Cunard*, Penguin, 1981.

Clark, Heinemann et al, eds, *Culture and Crisis in Britain in the Thirties*, Lawrence & Wishart, 1979.

Cobain, Ian, *The History Thieves*, Portobello, 2016.

Cook, Judith, *Priestley*, Bloomsbury, 1997.

Cooney, Bob, *Proud Journey: a Spanish Civil War Memoir*, Marx Memorial Library, 2015.

Copeman, Fred, *Reason in Revolt*, Blandford Press, 1948.

Coppard & Crick, *Orwell Remembered*, Ariel, 1984.

Crick, Bernard, *George Orwell, A Life*, Secker, 1980.

Croft, Andy, *Comrade Heart: A Life of Randall Swingler*, Manchester, 2003.

Croft, Andy, ed, *A Weapon in the Struggle*, Pluto, 1998.

Curry, John, *The Security Service, 1908–1945*, Public Record Office, 1999.

Davenport-Hines, Richard, *Enemies Within*, Collins, 2018.

David, Deidre, *Olivia Manning: A Woman at War*, Oxford, 2012.

Davies, Russell, *Ronald Searle*, Sinclair-Stevenson, 1990.

Davison, Peter, *Orwell – A Life in Letters*, Harvill Secker, 2010.

Davison, ed, *Orwell Diaries*, Harvill Secker, 2009.

Day Lewis, C., *The Buried Day*, Chatto, 1960.

Deakin, Nicholas, ed, *Radiant Illusion: Middle-class Recruits to Communism in the 1930s*, Eden Valley, 2015.

Diski, Jenny, *In Gratitude*, Bloomsbury, 2016.

Driberg, Tom, *Ruling Passions*, Quartet, 1978.

Feaver, William, *James Boswell, Unofficial War Artist*, Muswell Press, 2017.

Feigel, Lara, *Free Woman*, Bloomsbury, 2018.

Galassi, Jonathan, ed, *John Cornford*, Carcanet, 2016.

Gloversmith, Frank, ed, *Class, Culture and Social Change*, Harvester, 1980.

Gowing & Sylvester, *The Paintings of William Coldstream*, Tate, 1990.

Green, John, *Britain's Communists – the Untold Story*, Artery, 2016.

Gregory, Walter, *The Shallow Grave*, Gollancz, 1988.

Grove, Valerie, *So Much to Tell*, Viking, 2010.

Gurney, Jason, *Crusade in Spain*, Faber & Faber, 1974.

Hancock, David Boyd, *I Am Spain*, Old Street, 2012.

Hanson, Neil, *Priestley's Wars*, Great Northern, 2008.

Harman, Claire, ed, *The Diaries of Sylvia Townsend Warner*, Virago, 1995.

Harman, Claire, *Sylvia Townsend Warner: A Biography*, Chatto, 1989.

Hart, Stephen, ed, *No Pasaran: Art, Literature and the Spanish Civil War*, Tamesis, 1998.

Hastings, Selina, *Rosamond Lehmann*, Chatto, 2002.

Heinemann et al, eds, *Culture and Crisis in Britain in the 30s*, Lawrence & Wishart, 1979.

Hemming, Henry, *M. Maxwell Knight: MI5's Greatest Spymaster*, Penguin, 2017.

Hennessy, Peter, *The Secret State*, Allen Lane, 2002.

Hennessy, Peter, *Never Again*, Cape, 1992.

Hennessy, Peter, *Having it So Good*, Allen Lane, 2006.

Hobday, Charles, *Edgell Rickword: A Poet at War*, Carcanet, 1989.

Hobsbawm, Eric, *Interesting Times*, Allen Lane, 2002.

Hogarth, Paul, *The Artist as Reporter*, Studio Vista, 1967.

Hogarth, Paul, *Arthur Boyd Houghton*, Gordon Fraser, 1981.

Hogarth, Paul, *Creative Ink Drawings*, Watson-Gupthill, 1967.

Hogarth, Paul, *Cold War Reports*, The Norwich Gallery, 1989.

Hogarth, Paul, *Graham Greene Country*, Pavilion, 1986.

Hogarth, Paul, *People Like Us*, Dennis Dobson, 1958.
Hogarth, Paul, *Looking at China*, Lawrence & Wishart, 1956.
Hogarth, Paul, *Defiant People*, Lawrence & Wishart, 1953.
Hogarth, Paul, *Drawing on Life*, David & Charles, 1997.
Holland, James, *Burma 1944*, Bantam, 2016.
Hollingsworth & Norton-Taylor, *Blacklist*, Hogarth, 1988.
Hughes, Ben, *They Shall Not Pass!*, Osprey, 2011.
Jacob & Hogarth, *A Russian Journey*, Hill & Wang, 1969.
Jameson, Storm, *Journey from the North* (vols 1 & 2), Virago, 1984.
Jump, Jim, ed, *Poems from Spain*, Lawrence & Wishart, 2006.
Kell, Constance, *A Secret Well Kept*, Conway, 2017.
Khan, Yasmin, *The Raj at War*, Bodley Head, 2015.
Knott, Richard, *The Sketchbook War*, The History Press, 2013.
Kynaston, David, *Austerity Britain*, Bloomsbury, 2007.
Leader, Zachary, ed, *The Letters of Kingsley Amis*, Harper Collins, 2000.
Lehmann, John, *Christopher Isherwood*, Weidenfeld & Nicolson, 1987.
Lessing, Doris, *Under My Skin*, Flamingo, 1995.
Lessing, Doris, *Walking in the Shade*, Harper Collins, 1997.
Lessing, Doris, *Going Home*, Granada, 1968.
Lessing, Doris, *The Golden Notebook*, Michael Joseph, 1962.
Lessing, Doris, *A Small Personal Voice*, Flamingo, 1994.
Lownie, Andrew, *Stalin's Englishman*, Hodder, 2015.
MacGibbon, Hamish, *Maverick Spy*, I.B. Tauris, 2017.
Macintyre, Ben, *A Spy Among Friends*, Bloomsbury, 2014.
MacNeice, Louis, *The Strings are False*, Faber, 1965.
Martin, Simon, *Conscience and Conflict: British Artists & the Spanish Civil War*, Pallant House Gallery, 2014.
McNair, John, *Spanish Diary*, Independent Labour Pub., 1979.
Morgan Kevin, *Harry Pollitt*, Manchester, 1993.
Morris & Radford, *The Story of the Artists' International Assoc. 1933–1953*, Museum of Modern Art, Oxford, 1983.
Mulford, Wendy, *This Narrow Place*, Pandora, 1988.
Orwell, George, *Facing Unpleasant Facts*, First Mariner, 2009.
Orwell & Angus, *The Collected Essays etc.*, Secker, 1968.
Penrose & Freeman, *Conspiracy of Silence*, Grafton, 1986.
Philby, Kim, *My Silent War*, MacGibbon & Kee, 1968.
Philipps, Roland, *A Spy Named Orphan*, Bodley Head, 2018.
Pinney, Susanna, ed, *I'll Stand by You*, Pimlico, 1998.
Preston, Paul, *The Spanish Civil War*, Weidenfeld & Nicolson, 1986.
Purcell, Hugh, *The Last English Revolutionary*, Sutton, 2004.
Ricks, Thomas E., *Churchill & Orwell*, Duckworth, 2018.
Rimington, Stella, *Open Secret*, Arrow, 2002.
Rodden, John, *Scenes from an Afterlife*, ISI, 2003.

Rowse, A.L., *The Poet Auden*, Methuen, 1987.

Samuel, Raphael, *The Lost World of British Communism*, Verso, 2017.

Sebestyen, Victor, *1946: The Making of the Modern World*, Macmillan, 2014.

Segal, Clancy, *The London Lover*, Bloomsbury, 2018.

Smith, James, *British Writers and MI5 Surveillance, 1930–1960*, Cambridge, 2013.

Spender, Matthew, *A House in St John's Wood*, Collins, 2015.

Spender, Stephen, *New Selected Journals*, Faber & Faber, 2012.

Spender, Stephen, *Journals 1939–1983*, Faber & Faber, 1985.

Spender, Stephen, *World Within World*, Faber & Faber, 1977.

Squires, Mike, *The Aid to Spain Movement in Battersea, 1936–1939*, Elmfield, 1994.

Stallworthy, Jon, *Louis MacNeice*, Faber & Faber, 1995.

Sutherland, John, *Orwell's Nose*, Reaktion, 2016.

Sutherland John, *Stephen Spender: the Authorised Biography*, Viking, 2004.

Symons, Julian, *The 30s*, The Cresset Press, 1960.

Taylor, D.J., *Orwell, the Life*, Chatto, 2003.

Thomas, Frank, *Brother Against Brother*, Sutton, 1998.

Trevelyan, Julian, *Indigo Days*, MacGibbon & Kee, 1957.

Trevor-Roper, Hugh, *The Secret World*, I.B. Tauris, 2014.

Walton, Calder, *Empire of Secrets*, Harper Press, 2013.

West, Nigel, *MI5*, Triad Grafton, 1983.

West & Tsarev, eds, *Triplex*, Yale, 2009.

Wright, Patrick, *Passport to Peking*, Oxford, 2010.

Wright, Peter, *Spycatcher*, Heinemann, 1987.

Index